4.95

D1544401

To Rosanna, Roberto, and Silvia
with love and gratitude

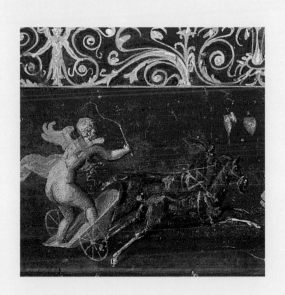

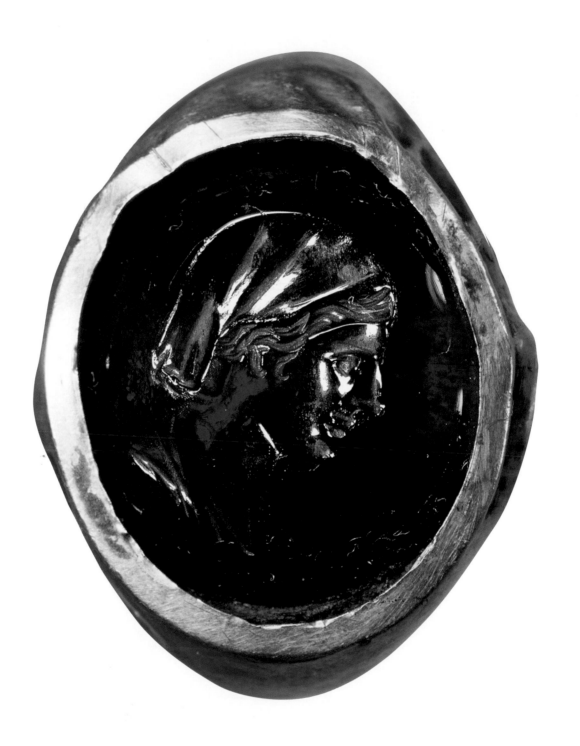

SECRETS OF POMPEII

EVERYDAY LIFE IN ANCIENT ROME

Emidio De Albentiis

Photography by Alfredo and Pio Foglia

ST. JOHN THE BAPTIST PARISH LIBRARY
2920 NEW HIGHWAY 51
LAPLACE, LOUISIANA 70068

J. Paul Getty Museum, Los Angeles

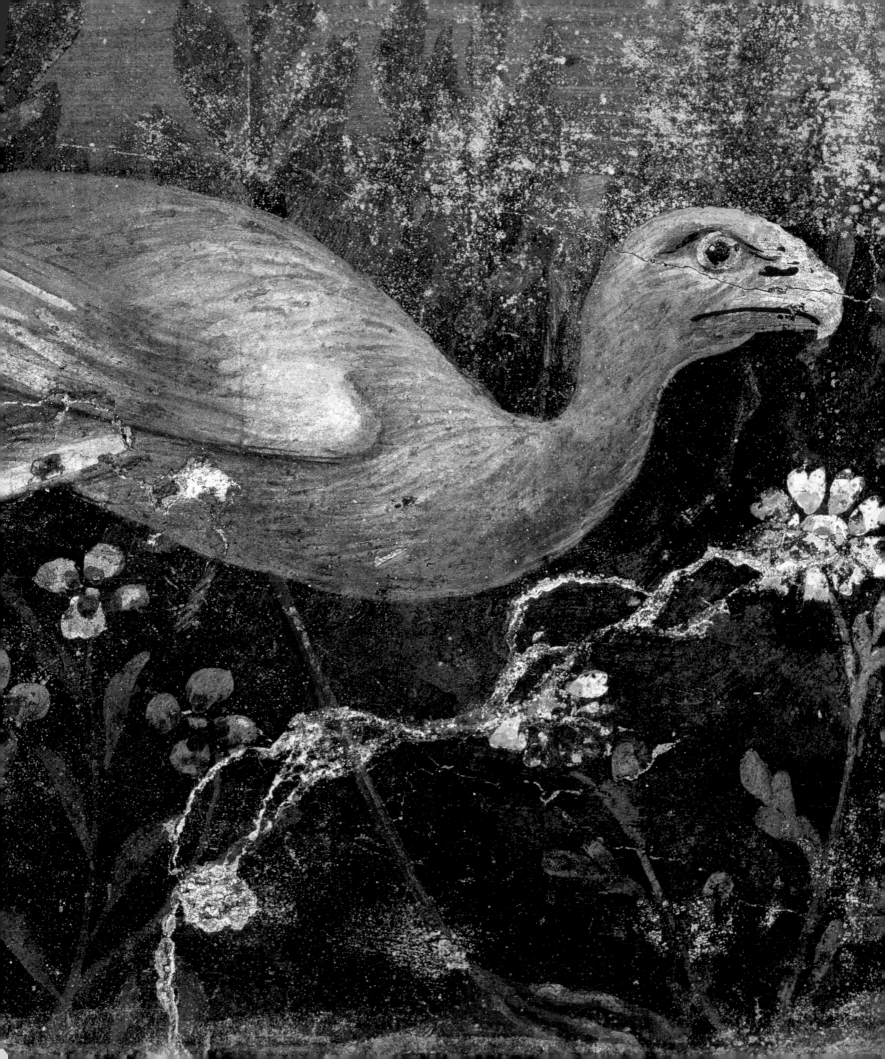

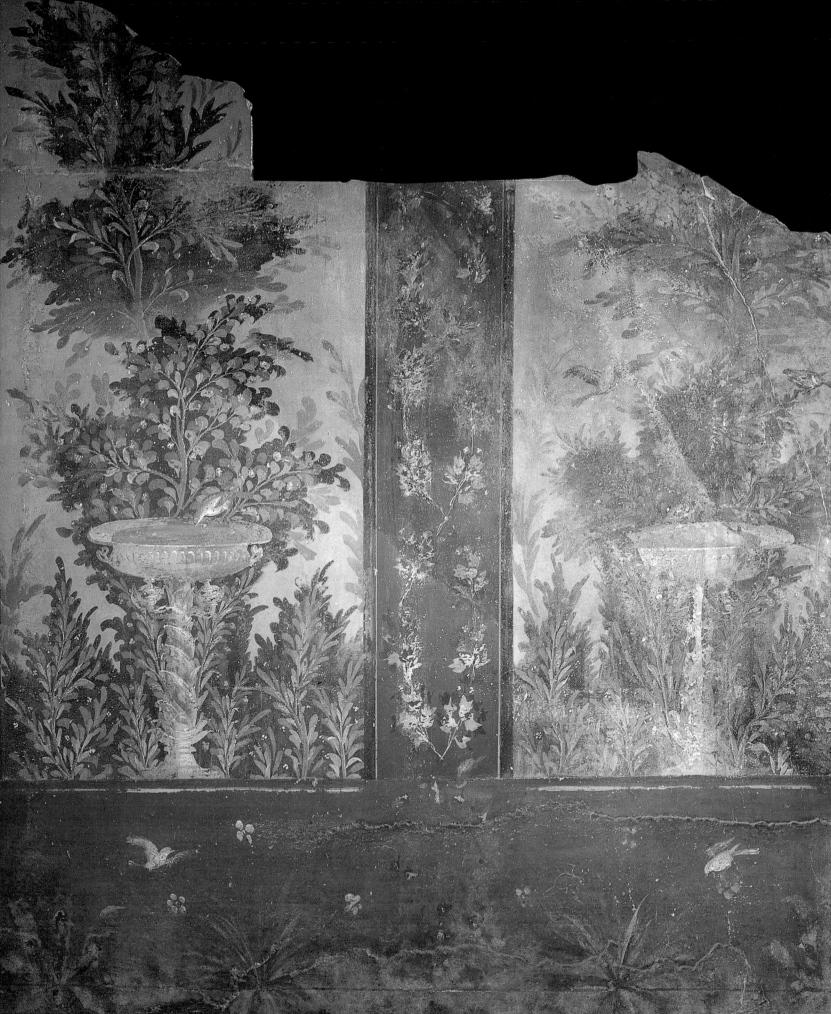

The sumptuous Mediterranean garden of the Villa of Poppaea at Oplontis is concealed behind a high masonry wall. The original complex, dating to the mid-first century B.C., was expanded and renovated several times in the imperial period. In its architecture and decorations it shows the taste for nature, on the exterior, "free and wild" and sweeping toward the horizon, but "controlled and contained" inside the house, thus becoming a paradisical *hortus conclusus*, or enclosed garden.

Page 3:
The marvelous wall decoration in the large reception room of the House of the Painters, with its images of cupids in goat-drawn chariots.

Page 4:
This exquisitely crafted gold ring, set with a carnelian carved with a female bust in profile, reveals the evident Hellenistic roots of the Pompeian goldsmiths' art.

Pages 6–7:
Detail of a mosaic made with glass tesserae and dating to the mid-first century B.C. From the House of Neptune and Amphitrite, it represents the divine couple, rulers of the seas.

Page 8:
Fresco of an imaginary bird in the House of the Golden Bracelet at Pompeii.

Page 9:
Detail of a fresco decoration in an area of the portico surrounding the pool at the Villa of Poppaea. The painting depicts a lush garden embellished by fountains.

Page 12:
Detail of a fresco from the House of the Casti Amanti with a rooster intent on pecking at a pomegranate in front of a lovely still life of a group of fruit.

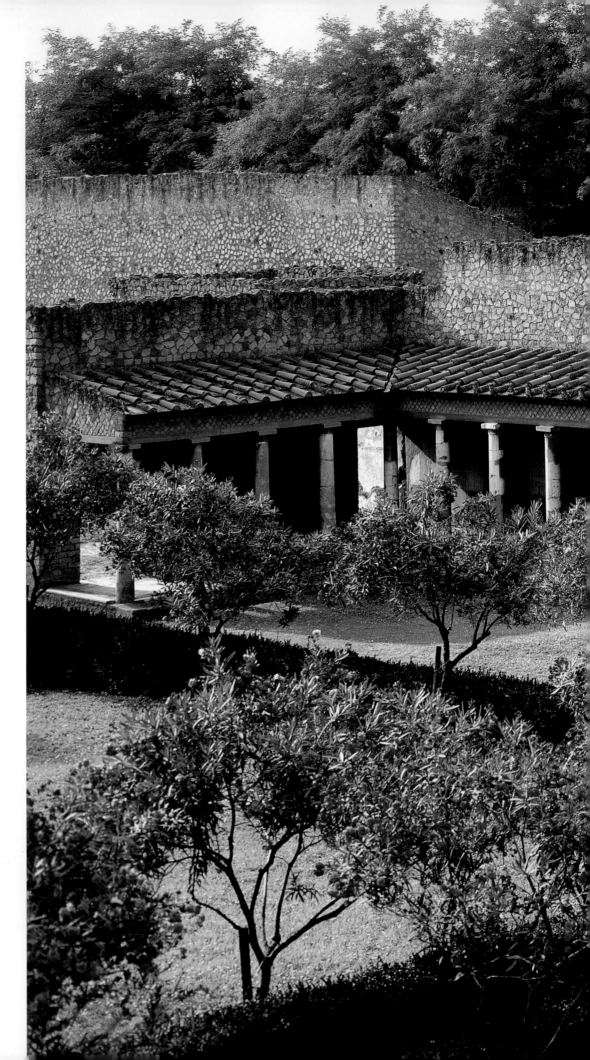

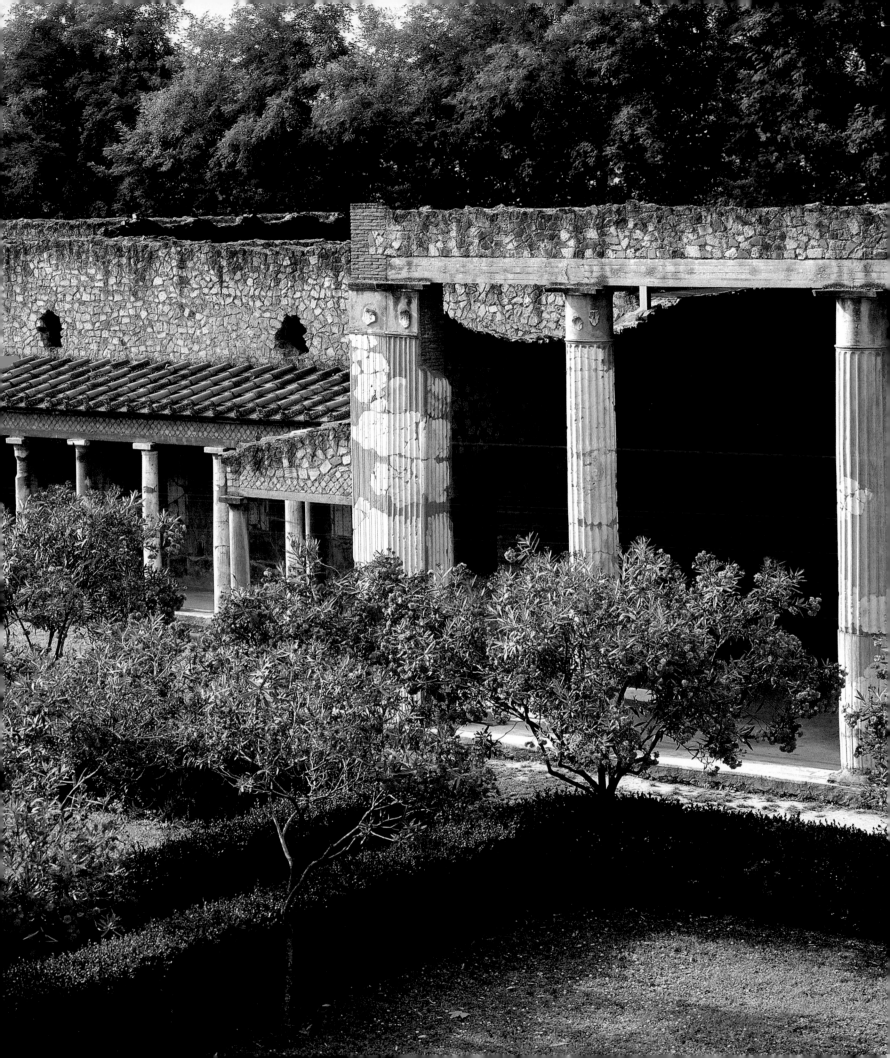

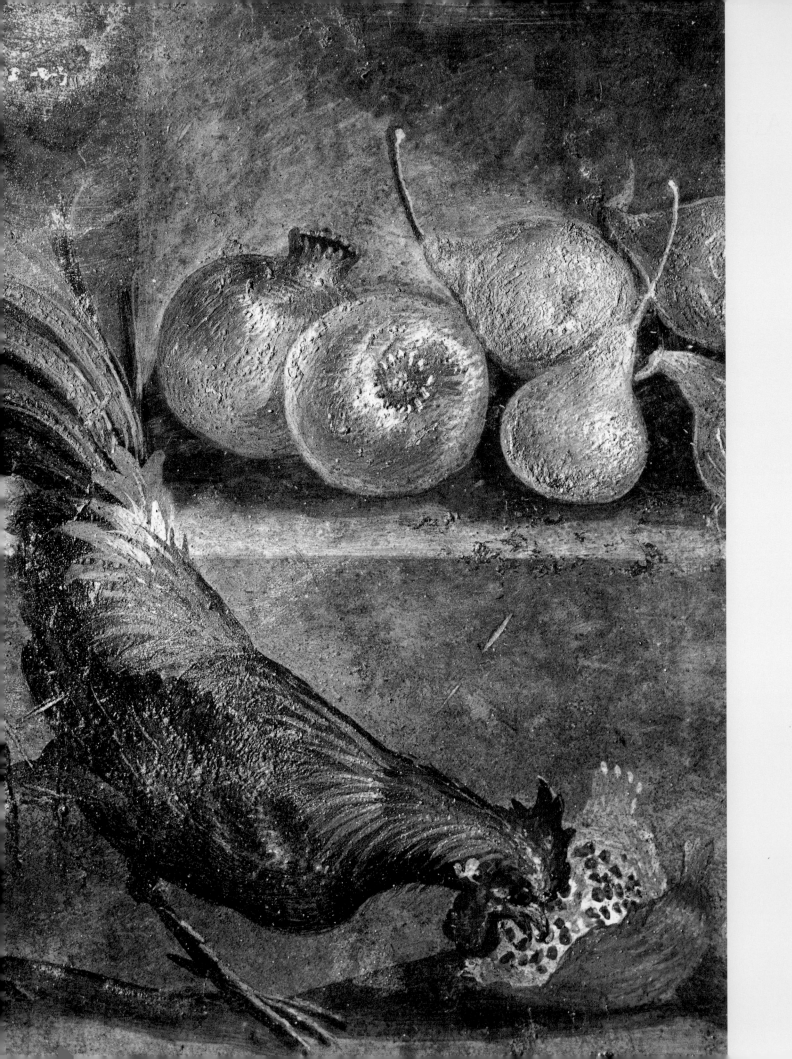

TABLE OF CONTENTS

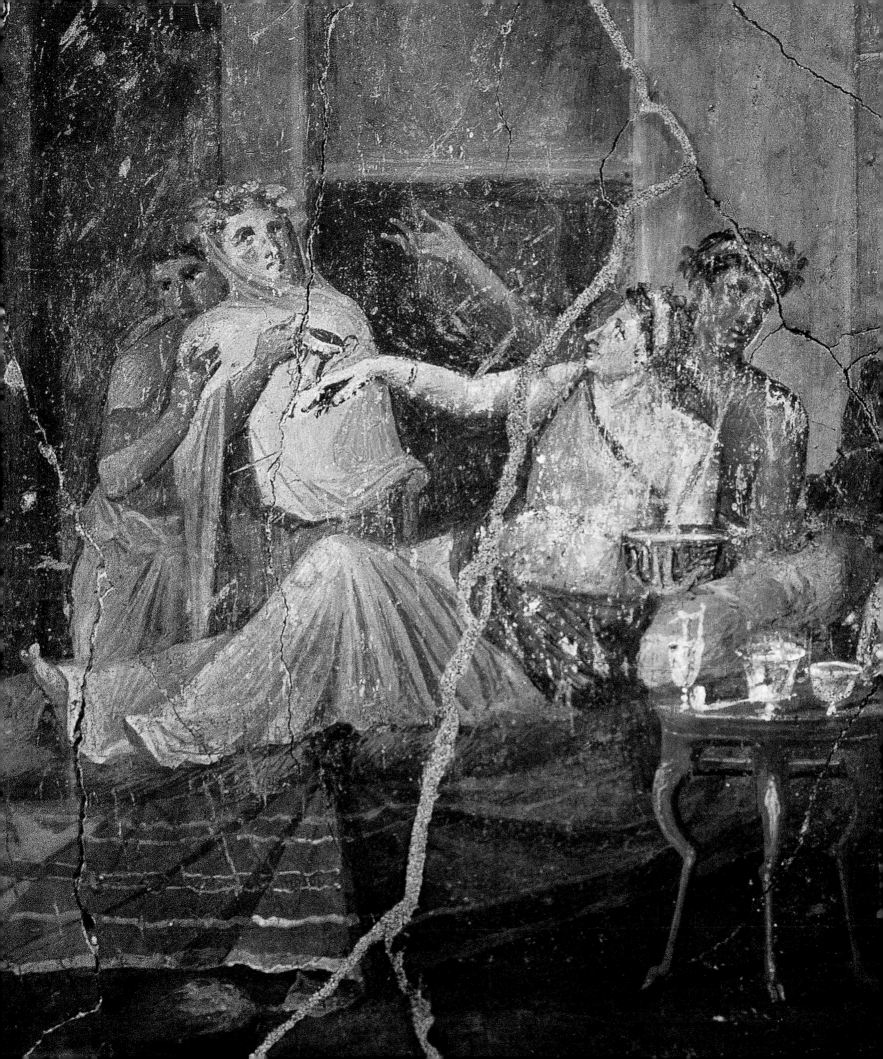

INTRODUCTION

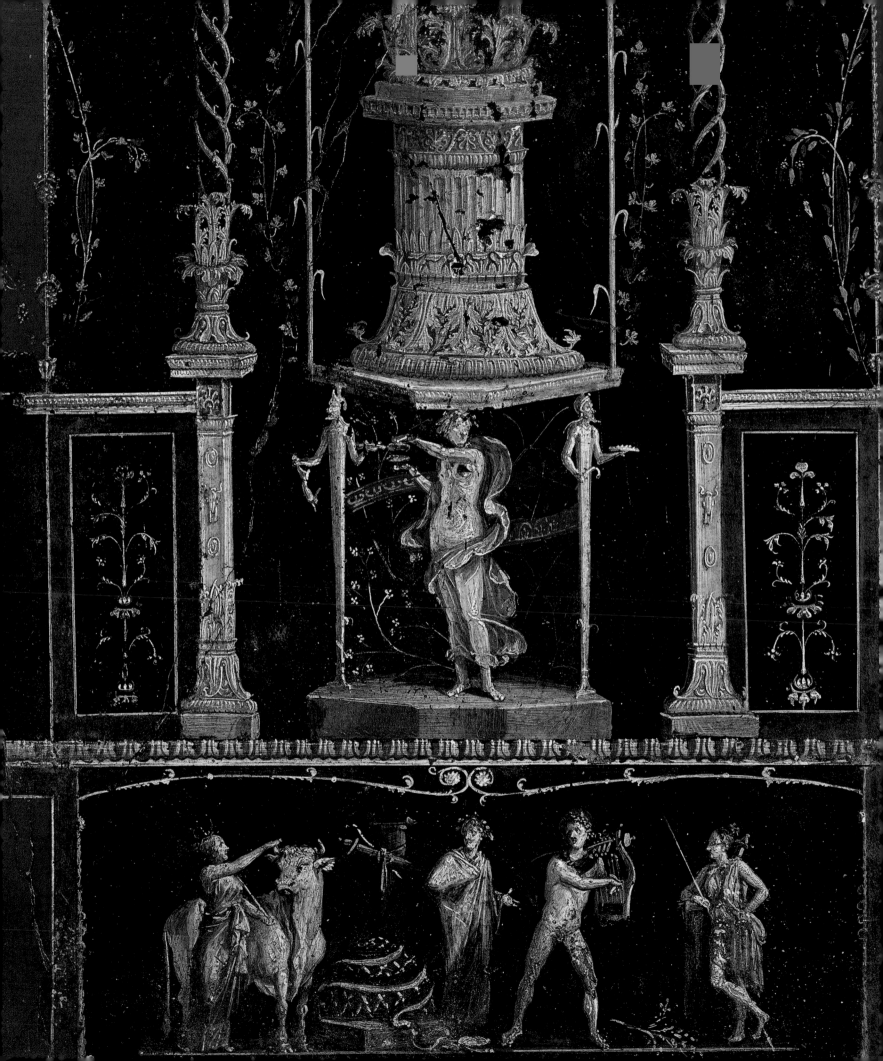

THE DAILY LIFE OF THE ANCIENT ROMANS AND THE REASONS IT FASCINATES US

Life and death are forever linked at Pompeii, and each makes you forget the other.
—Roger Peyrefitte, *Du Vésuve à l'Etna*

Preceding pages:
Detail of a splendid fresco of a winter banquet scene in the late Third Style (A.D. 35–45), from the dining room of the House of the Casti Amanti.

Opposite:
Detail of the refined wall decoration for the triclinium, or dining room, of the House of the Vettii. The lower band of the decoration shows scenes from Euripides' *Iphigenia in Tauris*. The owners of this famous and luxurious residence belonged to the class of freedmen, that is, men who were born into slavery but rose from their lowly status by means of their exceptional entrepreneurial abilities.

Pompeii has so much to offer—and then more. You can wander stone-paved streets and alleyways and see where ancient wagons passed by over and over; explore the intimate spaces of a house as splendid as any Greek palace; enter a humble home with a jumble of small rooms and almost no light. You can sit on the steps in the amphitheater and imagine the chaotic excitement of the crowd as it watched the bloody contests between gladiators, or walk through all the different areas of one of the baths and almost feel the near-daily habits of hygiene and social interaction of the throngs of people who went there. You walk through the Forum, and as you go you take in all the buildings around it that once shaped the city's public life and religious rituals. You can study Pompeii's ingenious water-supply and plumbing systems and admire the refined and sophisticated painted friezes, the elegantly proportioned sculpture, the extraordinary furniture, and the harmonious interior gardens of its noble houses. You might also visit an ancient house of ill repute, with its strange mix of small, squalid spaces and the pagan ability to enjoy fully the drunken pleasures of love. Pompeii is the most famous but by no means the only archaeological site on the slopes of Mount Vesuvius; the richness of the region makes it one of the most visited ancient sites in the world, attracting enthusiastic visitors from every continent.

It is the opportunity to be immersed so immediately into the reality of the streets and houses that were the backdrop to the lives of Pompeii's inhabitants some two thousand years ago that makes any visit to this ancient, unlucky city so unforgettable. These places were their physical and existential reality. Modern visitors feel this strongly, and this leads naturally to reflections on the cultural and symbolic nature of the place. It is, in effect, as if the rediscovery of Pompeii at the end of the eighteenth century—that is, during the Enlightenment, the Neoclassical period, almost seventeen hundred years after the enormous catastrophe of A.D. 79—was in a sense an entirely human victory over nature's tragic unpredictability. For a

17

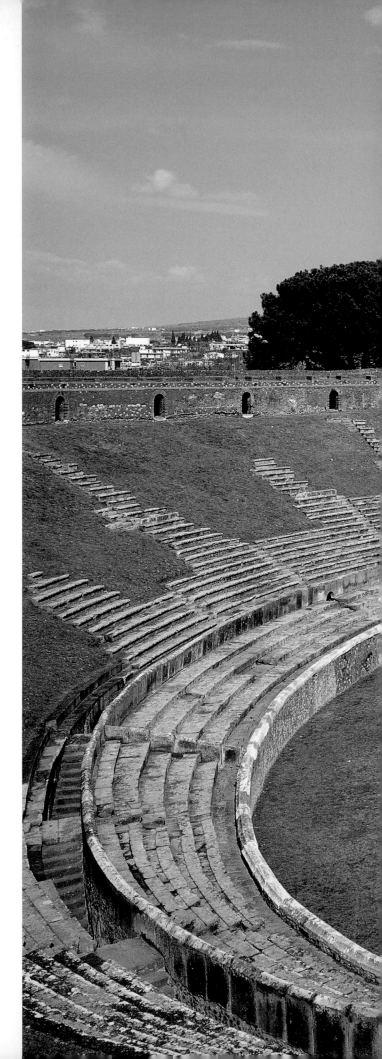

Between its arena and steps, the elliptical amphitheater at Pompeii could hold twenty thousand spectators. It was built in about 70 B.C. and was originally called the *spectacula*, literally, the "building for performances." Only later, in 53–52 B.C., was the Latin term *amphitheatrum* coined; it means a "building with seats all around in order to see."

Following pages:
The extraordinary wall decoration of the dining room in the western part of the residential complex at Murecine, south of Pompeii. The scene represents Apollo with his lyre surrounded by the Muses within a sophisticated architectural scheme on a red ground.

while the ancient Pompeians seem to live on; they are reflected in our enthusiastic admiration and in the comforting conviction, supported by these ruins that seem so easy to read, that the uncertainty of life, then as now, is a fact of human existence that can somehow be overcome.

A longer look, however, reveals another, complementary aspect of a visit to Pompeii. Although everything appears—and to a great extent is—accessible, the notion that one can share the experiences of the lives of the ancients in any real sense, or anything of their emotions, beliefs, dreams, or fears, is just an illusion. What Vesuvius did, essentially, was to freeze, tragically, one single instant in the time–space continuum in which the long-ago residents of Pompeii lived. We can make out a few of their secrets—an extraordinary thing in itself and worthy of our intellectual efforts—but, inevitably, the larger part of their world eludes us, destined to remain as mysterious and inscrutable as, probably, every human life and every one of its adventures. The sense of victory over death, present in every corner of the city, is also illusory. As Roger Peyrefitte so wisely pointed out in the passage quoted above, the most important lesson Pompeii can teach us is to see life and death, like love and death, as a pair in which one is impossible without the other. This was clear to the ancients, and it was also beautifully expressed in the sublime verses of Giacomo Leopardi, one of the first thoughtful visitors to Pompeii.

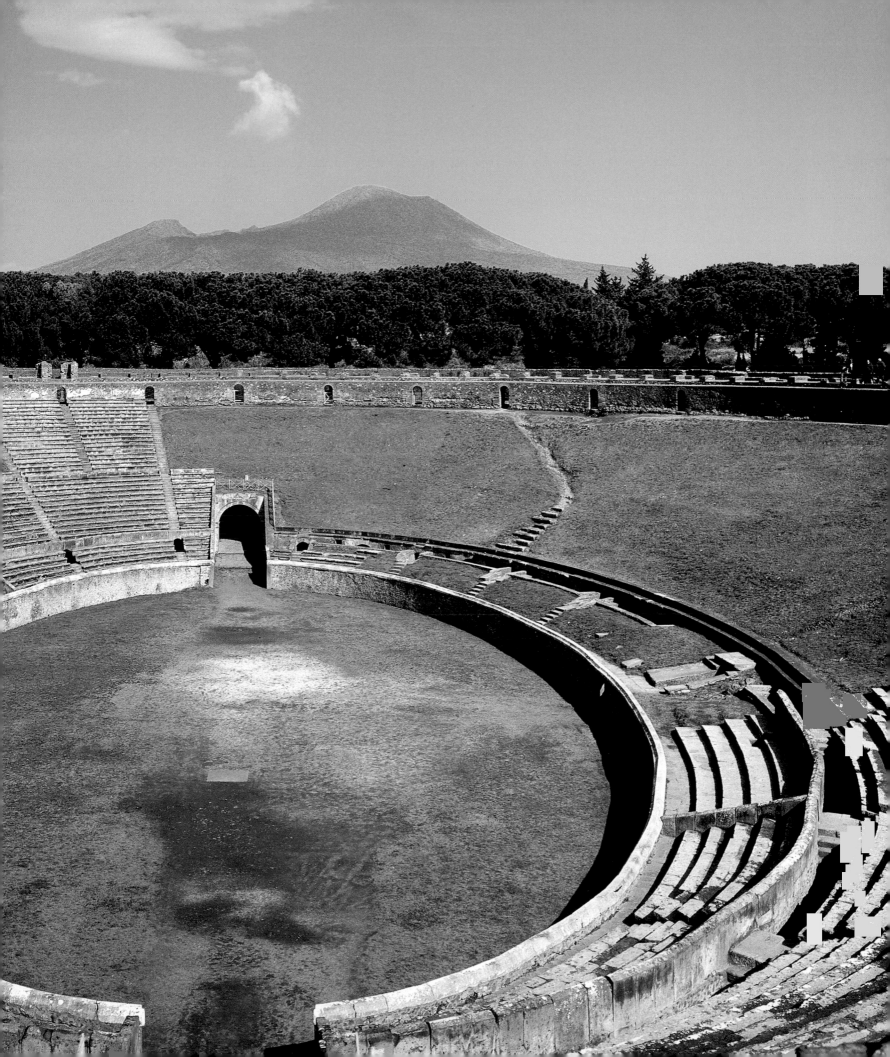

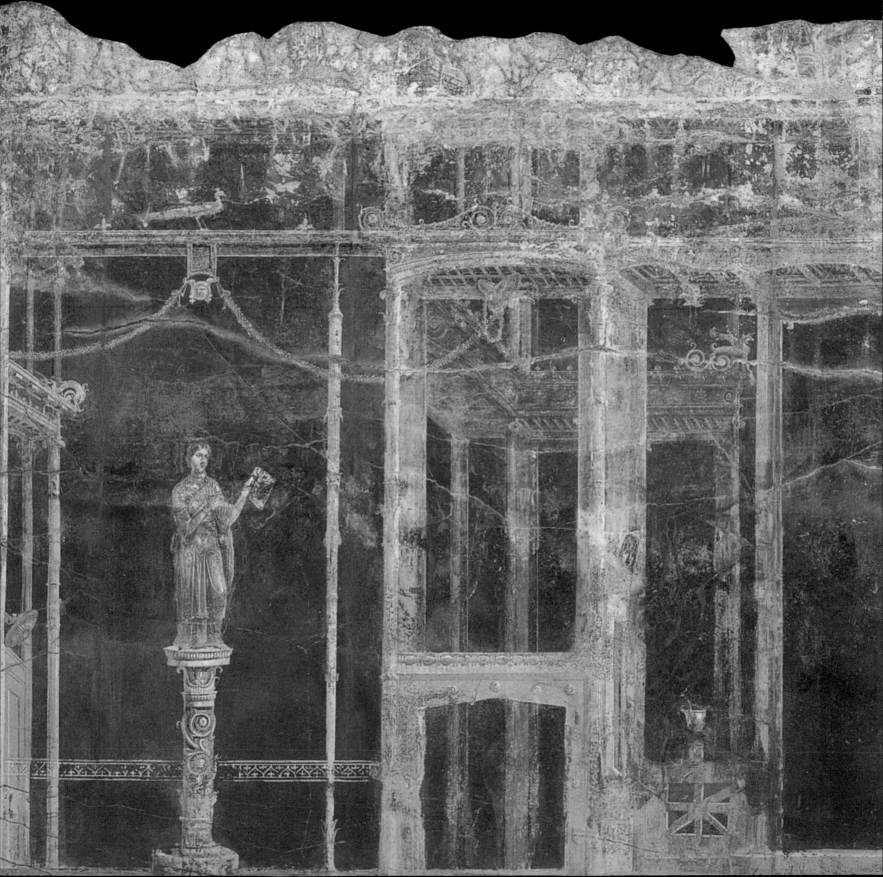

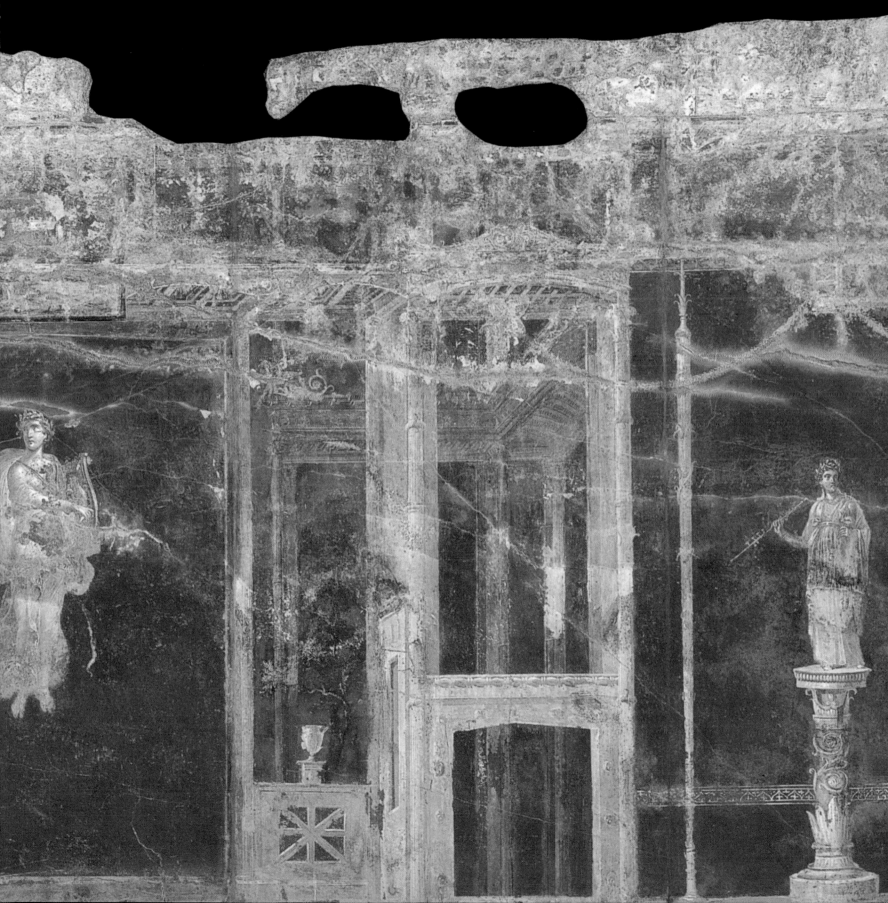

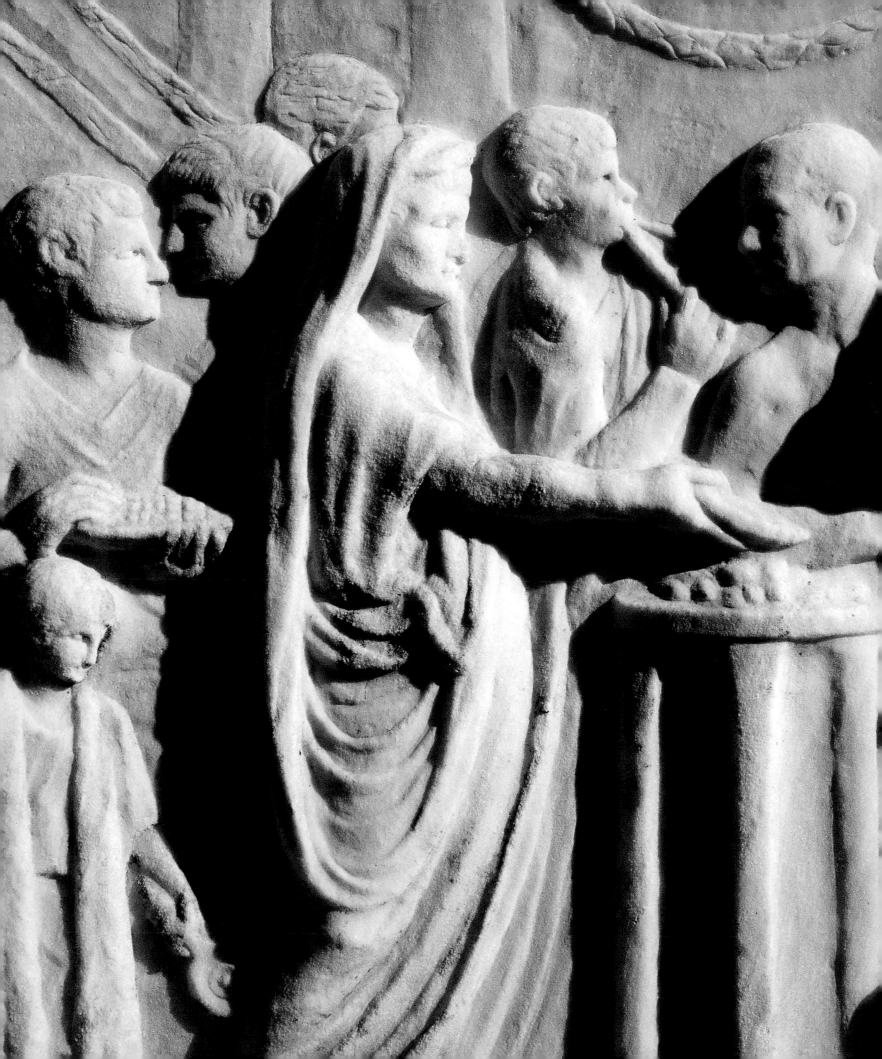

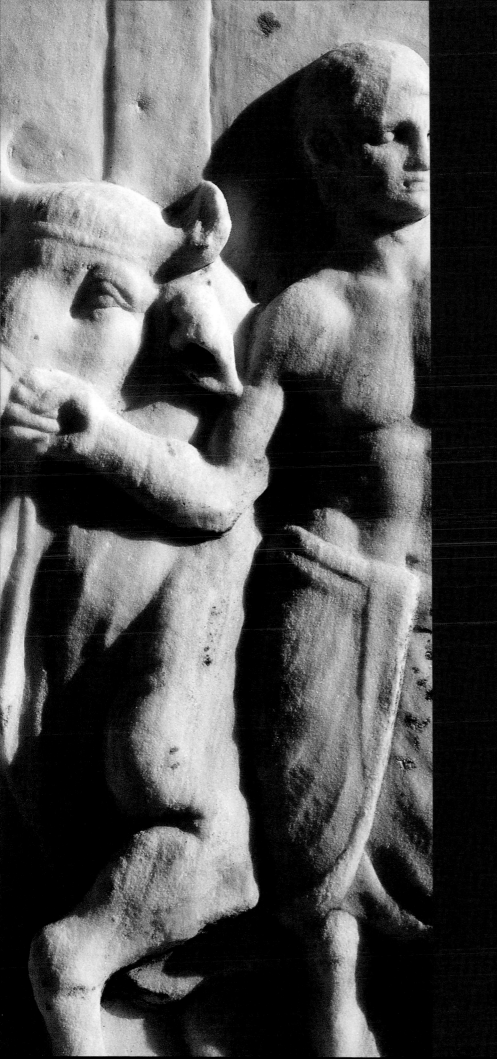

I

THE FORUM

THE POLITICAL,
ECONOMIC, JUDICIAL,
AND RELIGIOUS HEART
OF THE CITY

ELECTIONS AND
ELECTION PROPAGANDA

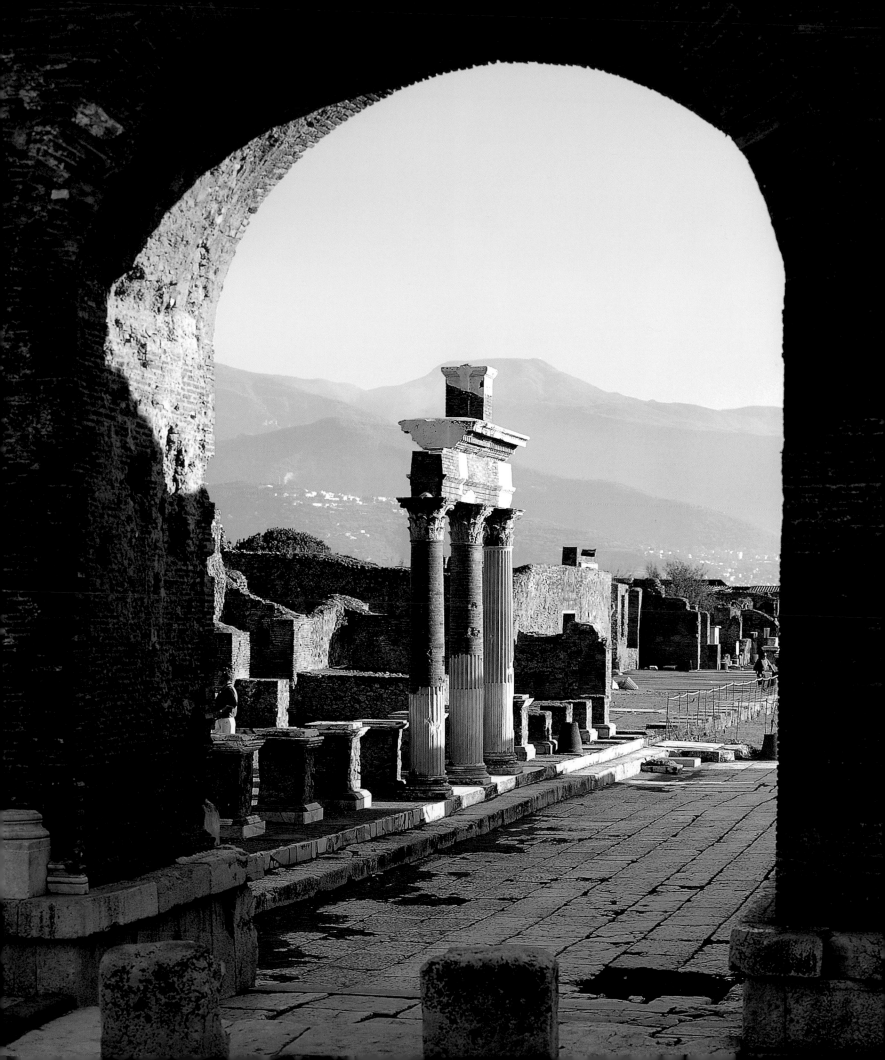

THE POLITICAL, ECONOMIC, JUDICIAL, AND RELIGIOUS HEART OF THE CITY

A portrait of the emperor Augustus with his official titles appears on the recto of this gold aureus, minted in Lyon in 9–8 B.C. and discovered in Pompeii.

Preceding pages:
A relief of a sacrifice decorates a white marble altar in the middle of the court-yard of the Temple of Vespasian. Such sacrifices were not unusual in imperial cults; this one was probably performed when the temple was inaugurated.

Opposite:
View of the Forum from one of the triumphal arches adorning the public space. On the left is the facade of the Macellum. Large blocks placed at the end of Via dell'Abbondanza kept carts from entering the Forum, a meeting place reserved for pedestrians.

One of the many signs of Pompeii's marked hellenization at the end of the Samnite period, that is, between the second century B.C. and Sulla's conquest of the city in 89 B.C. at the outset of the Social War, is the new form taken during that period by the Forum, the center of Pompeian life from its earliest times. Throughout the third century B.C., the Forum had been an irregular, disorganized space, shaped something like a trapezoid that was much wider at its north end, with a hodgepodge of shops along its long sides. Traces of these commercial establishments were discovered in the site's deepest trenches, the ones reaching furthest back in time. This all changed at the end of the Samnite period, when the Forum was given a much more regular shape, becoming a long rectangle with elegant, two-storied colonnades around three of its four sides. The resulting fabric and appearance of this part of the city, enhanced by the construction of monumental public buildings such as the Macellum, which marked the final banishment of public taverns from the Forum, were clearly Greek in inspiration, an influence that one finds repeatedly in the many building projects undertaken in Pompeii up until the eruption of Mount Vesuvius in A.D. 79.

The sophisticated elegance of the Forum is easily explained by the important role it played in the city's life. It was one of the most important meeting places in ancient Pompeii, especially for the bankers who gathered to conduct their business there, sealing agreements and negotiating deals. Yet the Forum, and even more so the Basilica that overlooked it, were also central to the city's judicial system. The Basilica was a refined, late Samnite building consisting of a large hall divided into three sections by tall Corinthian columns. The tribunal, where all public functions of the judiciary took place, was marked by a spectacular, two-storied facade across the hall from the building's entrance. At the same time, the Basilica's comfortable covered spaces were also large enough to accommodate the kinds of business meetings that took place in the Forum.

The Forum also hosted religious ceremonies associated with the temples and sanctuaries surrounding it. The oldest of these, a temple dedicated to Apollo first built in the sixth century B.C., is an early example of the influence of Greek culture in Pompeii. The Temple of Jupiter, at the end of the Forum's north side, was more significant in the life of the city. Originally erected probably in the late Samnite period, the temple was rededicated to the Capitoline triad of Jupiter, Juno, and Minerva after Sulla conquered the city for Rome in 89 B.C. This extension of the cult would have made it clear to all the citizens of Pompeii that they had been politically and ideologically assimilated into Rome, already well on its way to becoming the capital of a state that would encompass the entire Mediterranean world. Another important nucleus of politics and religion on the Forum was the complex dedicated to the cult of the emperor, one of the most effective tools of ideological persuasion ever developed by the Roman ruling class. These two large brick buildings at the east end of the Forum, traditionally identified as the Sanctuary of the Lares Publici and the Temple of Vespasian, are more likely to be a Temple of Augustus and a *sacellum*,

a chapel-like structure dedicated to his genius, respectively. They were certainly used for sacred and political rituals celebrating the person and office of the sitting emperor, as well as the blessed memory of the rulers who had gone before him and were now deified. The clear intention was to create social and ideological consensus and cohesion. Other sanctuaries dedicated to the imperial cult occupied important buildings around the Forum, such as the Macellum and the so-called Building of Eumachia; it has recently been suggested that the latter was a *venalicium*, or slave market. These ancillary sanctuaries did not serve specific religious purposes but represented instead the compulsory homage paid to the central power. That authority was further recognized and celebrated in the triumphal arches that closed the north side of the Forum behind the Capitoline.

Aerial view of the Forum with all its buildings clearly visible: clockwise from left are the Basilica, the Temple of Apollo, the Temple of Jupiter, the Macellum, the Temple of Augustus (or Sanctuary of the Lares Publici), the Temple of the Genius of Augustus (or Temple of Vespasian), the Building of Eumachia, the Comitium, and the three buildings housing the public administration (see p. 32).

Opposite, top:
A bust of Jupiter. The original, dating to the period of the Social War, is now in the Archaeological Museum in Naples. The bust in the Temple of Jupiter in Pompeii is a copy.

Opposite, bottom:
The columns of the Temple of Jupiter, which occupied this entire area of the piazza and which took over the political function formerly served by the Temple of Apollo.

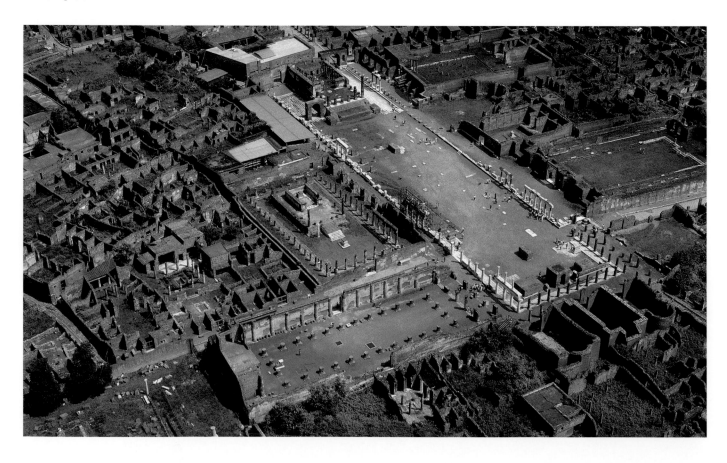

ELECTIONS AND ELECTION PROPAGANDA

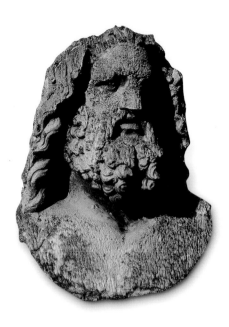

One of the Forum's most important functions was the public administration of the city and the political activities that went with it. Directly opposite the Temple of Jupiter, on the short south side of the Forum and standing amid the dense forest of later monuments dedicated to emperors and influential local figures, are three buildings that certainly served political and administrative purposes, although their specific functions have never been definitively determined. Originally constructed, at least in part, at the end of the Samnite period, these edifices were almost wholly rebuilt at the beginning of the colonial period, in 80 B.C. These rectangular structures with apses at one end can be identified with some confidence. Beginning with the easternmost building—the one closest to Via dell'Abbondanza—the first was the seat of the city's magistrates; the Roman colonial system provided for pairs of these administrators: the *duoviri iure dicundo*, the two highest public officials, who had judicial, administrative, and executive powers, and the *duoviri aediles*, who were responsible for public buildings and streets and oversaw the markets and games. The second structure was the Tabularium, the city's public archive, where the laws were kept, among other holdings. The third building was the meeting hall of the Ordo Decurionum, the local senate, which numbered one hundred members.

The Comitium, at the southeast corner of the Forum, was also dedicated to public administration; in particular, elections were held there. This is apparent

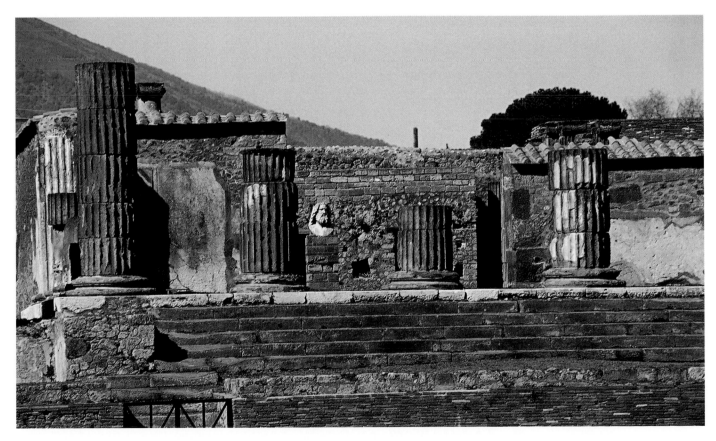

The series of arches behind the Temple of Jupiter.

Opposite:
This statue of Apollo as archer, found in pieces, was reassembled and restored. The version at Pompeii, however, is only a copy; the original is in the Archaeological Museum in Naples.

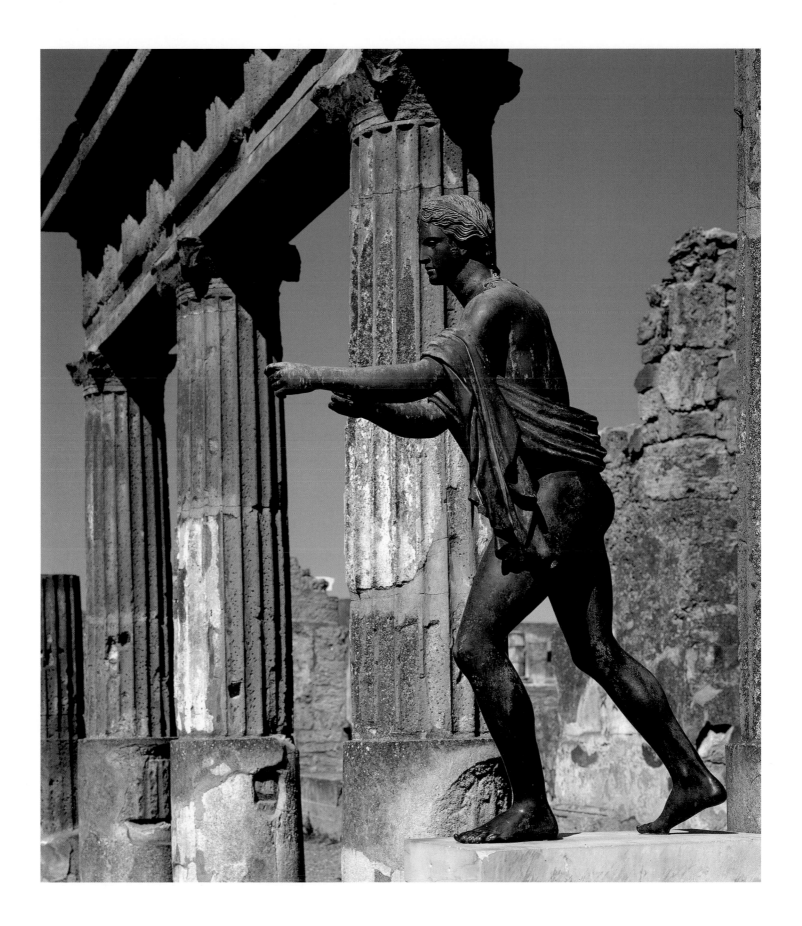

in its design, which comprises a large open area with many entrances from both the Forum and Via dell'Abbondanza that allowed voters direct access to their precincts. With the Roman colonization of Pompeii, annual elections were held to choose the pairs of magistrates. Only male citizens could vote; they were assigned to the five electoral districts into which the city had been divided. It is worth noting, too, that in the Roman world individual votes were counted by district, rather than being tallied citywide. In the final tabulation, these electoral districts cast only one vote each for the candidates who had carried it.

Although the city magistrates had jurisdiction only over local matters—this was especially true after Pompeii became a part of the Roman state—the struggle for power was intense. Surviving political graffiti, scrawled on buildings all over town and even on the tombs in the cemeteries just outside the city gates, offers extraordinarily vivid evidence of this. For obvious reasons, most of these slogans date to the last year of Pompeii's history; it seems the graffiti was whitewashed immediately after each election. Much of what was discovered when the excavations at Pompeii began has since disappeared because of the fragility of the graffiti. Nonetheless, the social and political picture these slogans paint is fascinating. Written by individuals or by associations such as the craft guilds, they naturally underscored the moral qualities of the preferred candidates as well as their qualifications, real or imagined, to hold public office. Much of this campaign propaganda,

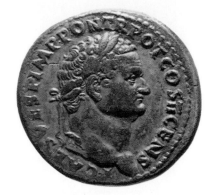

Sesterce with a portrait of the emperor Titus (A.D. 79–81). The construction of Rome's great Flavian amphitheater—also known as the Colosseum—and the catastrophic eruption of Vesuvius that buried Pompeii, Herculaneum, and Stabiae occurred during Titus's reign.

Below and opposite:
A scene of everyday life in the Forum, from the House of Julia Felix. The covered colonnade that ran along three sides of the Forum can be seen behind the figures.

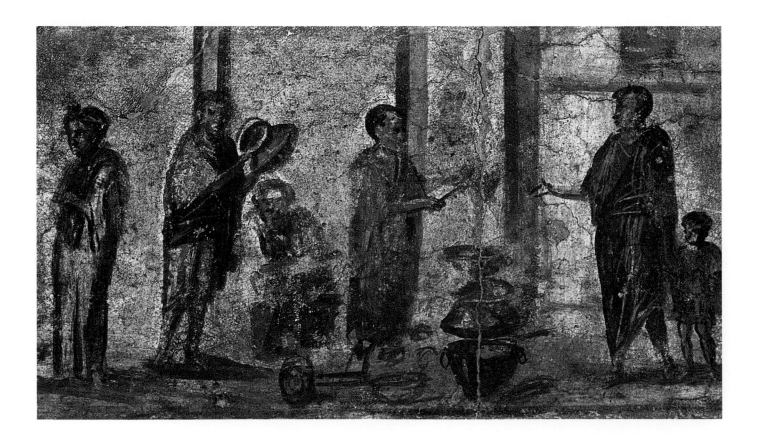

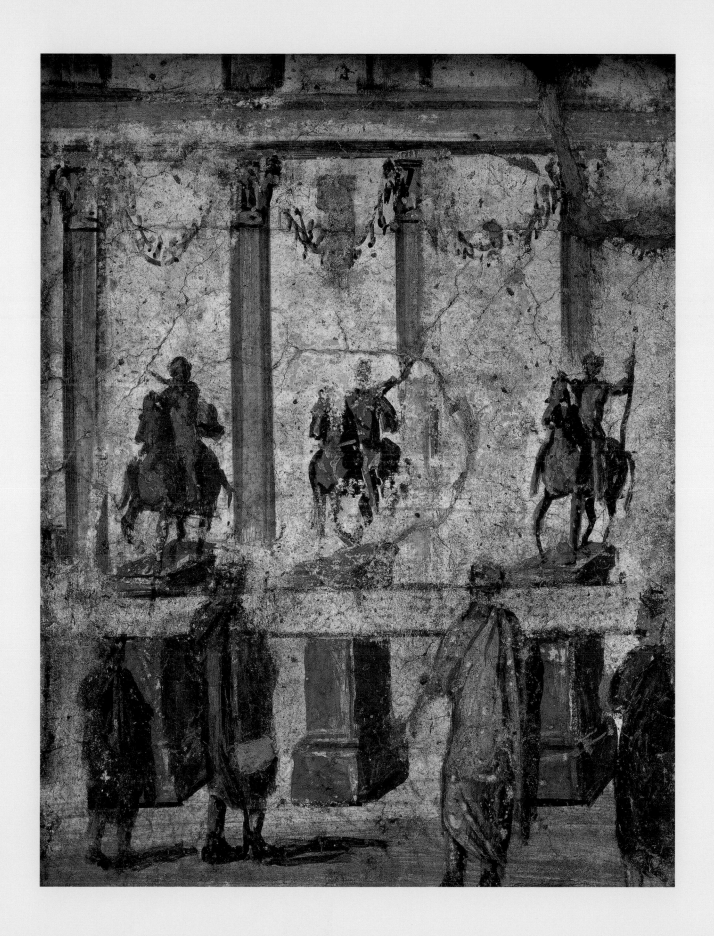

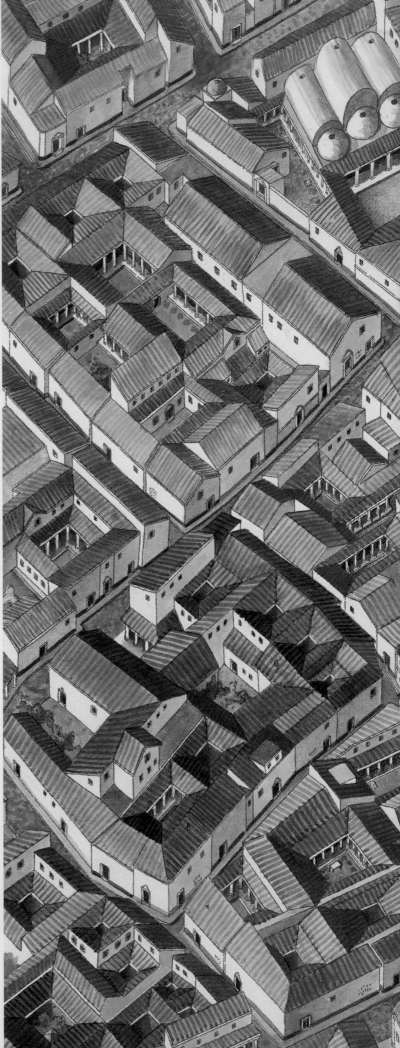

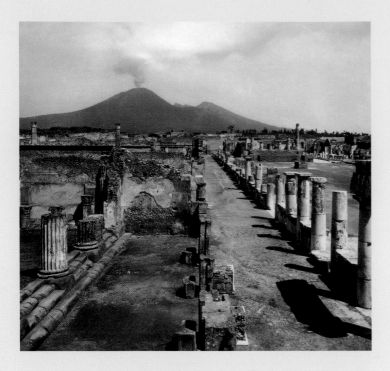

An evocative period photograph from the Alinari Archives shows the ruins of the Forum at Pompeii. In the background is Mount Vesuvius, with its characteristic "plume," which disappeared after the volcano's last eruption, in 1944.

Below and opposite:
Plan and perspective reconstruction of the Forum at Pompeii.

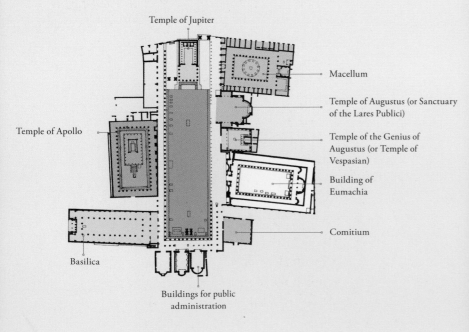

Temple of Jupiter

Macellum

Temple of Augustus (or Sanctuary of the Lares Publici)

Temple of the Genius of Augustus (or Temple of Vespasian)

Building of Eumachia

Comitium

Temple of Apollo

Basilica

Buildings for public administration

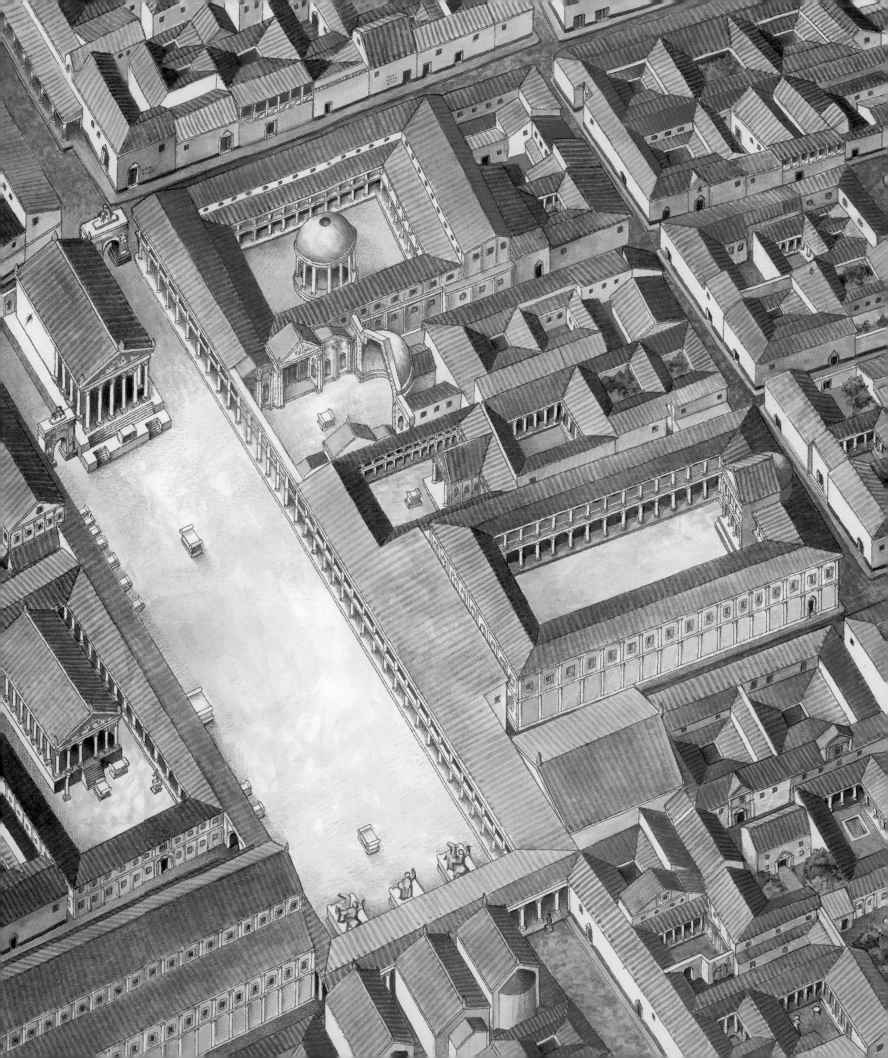

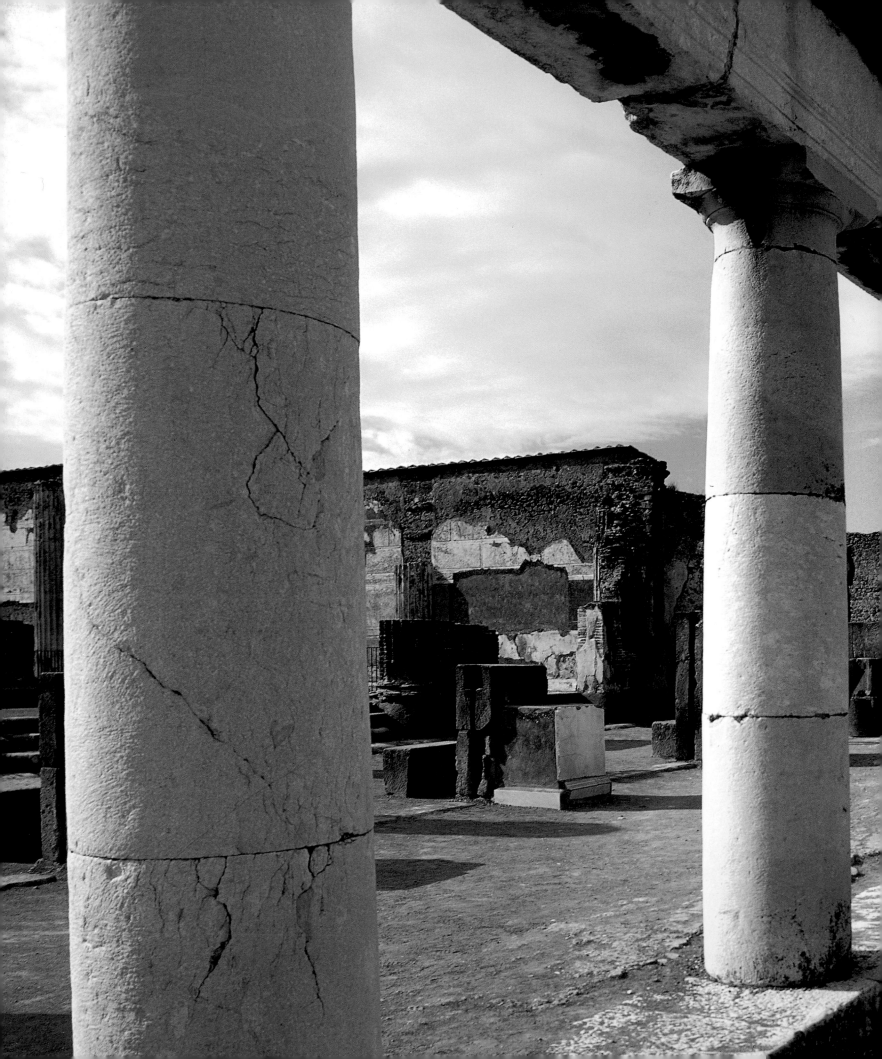

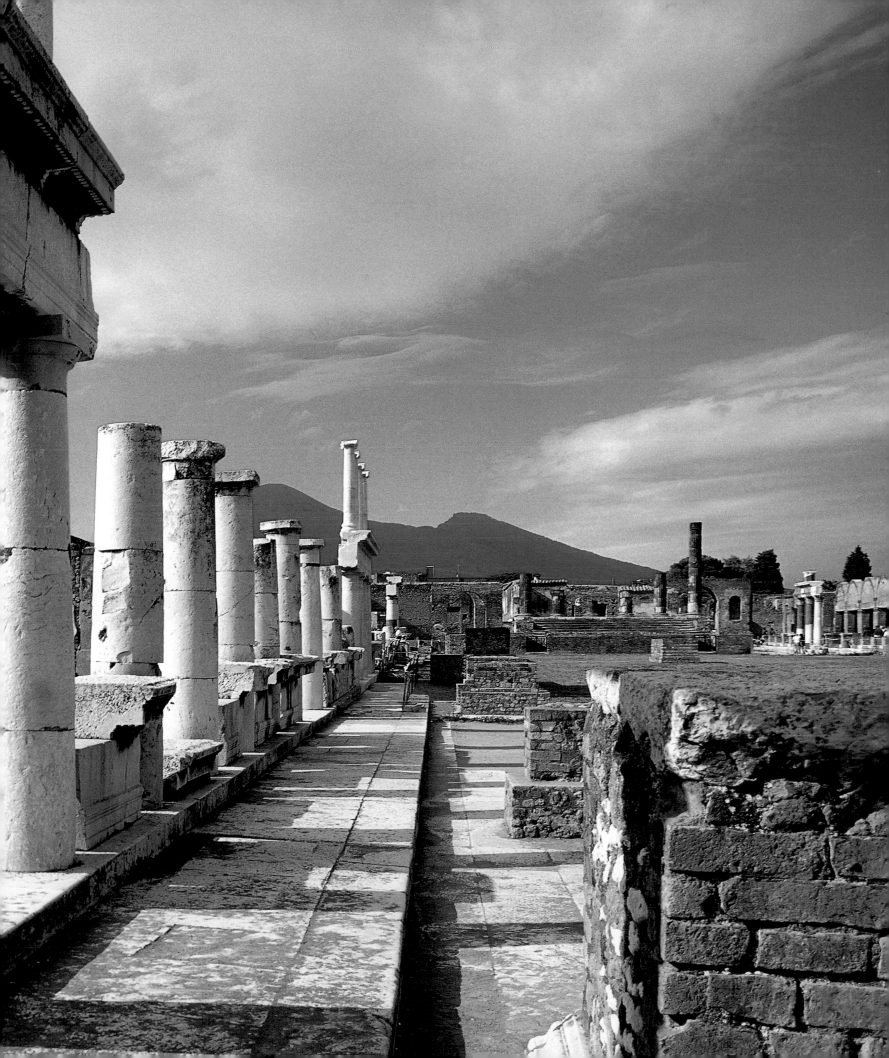

most likely emanating from special-interest groups and shot through with hypocrisy, is predictable, but it is worth citing one bitter and disillusioned comment by an anonymous Pompeian, who scrawled AMBITIONE TOT FRAUDES—"So many lies for the sake of ambition!"

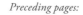

Preceding pages:
A sweeping view of the Forum. The Temple of Jupiter is at the center; atop its great staircase are the columns of the facade. A section of the Basilica can be seen on the left, and visible in the distance on the right is the entrance to the Macellum.

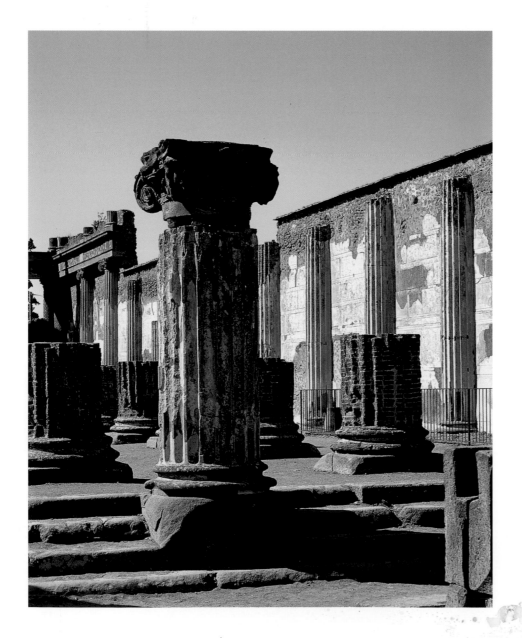

The Basilica, built in the second half of the second century B.C. Like the Forum itself, it served as a site of the administration of justice and commercial activities.

Opposite:
A striking view of Via dell'Abbondanza, showing what was once a seemingly endless succession of shops and houses. In the foreground is the fountain known as the Fontana dell'Abbondanza.

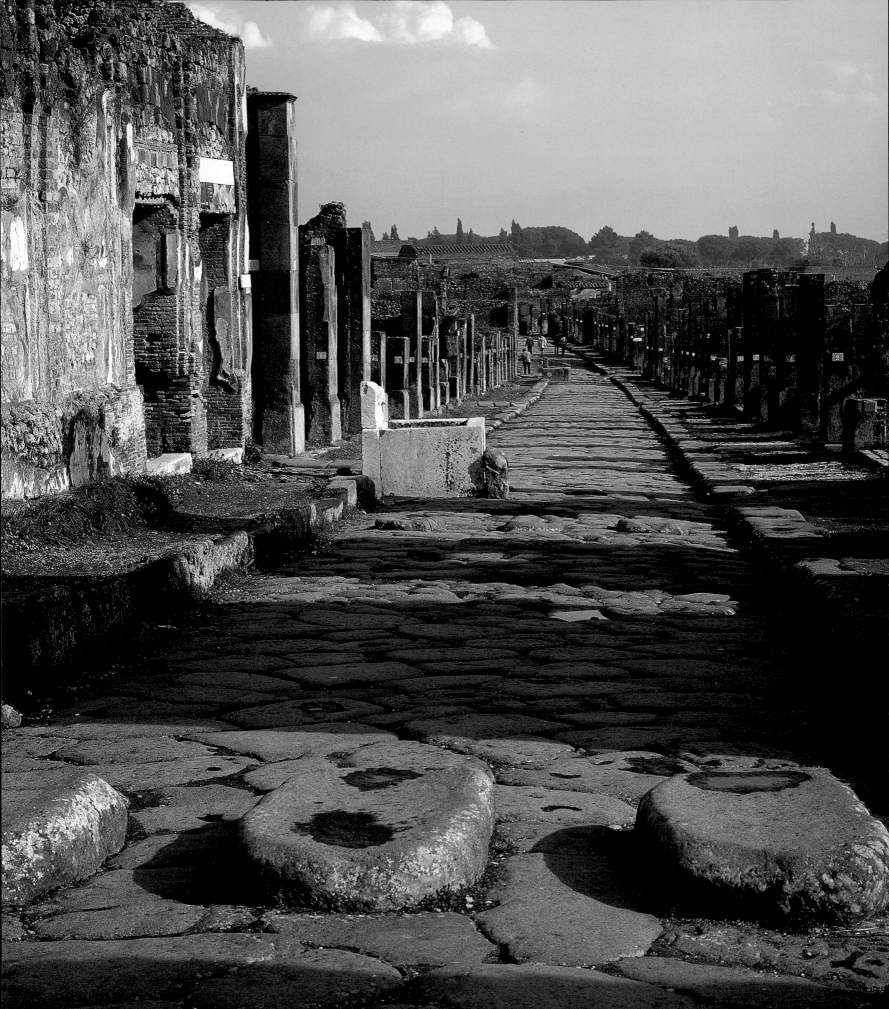

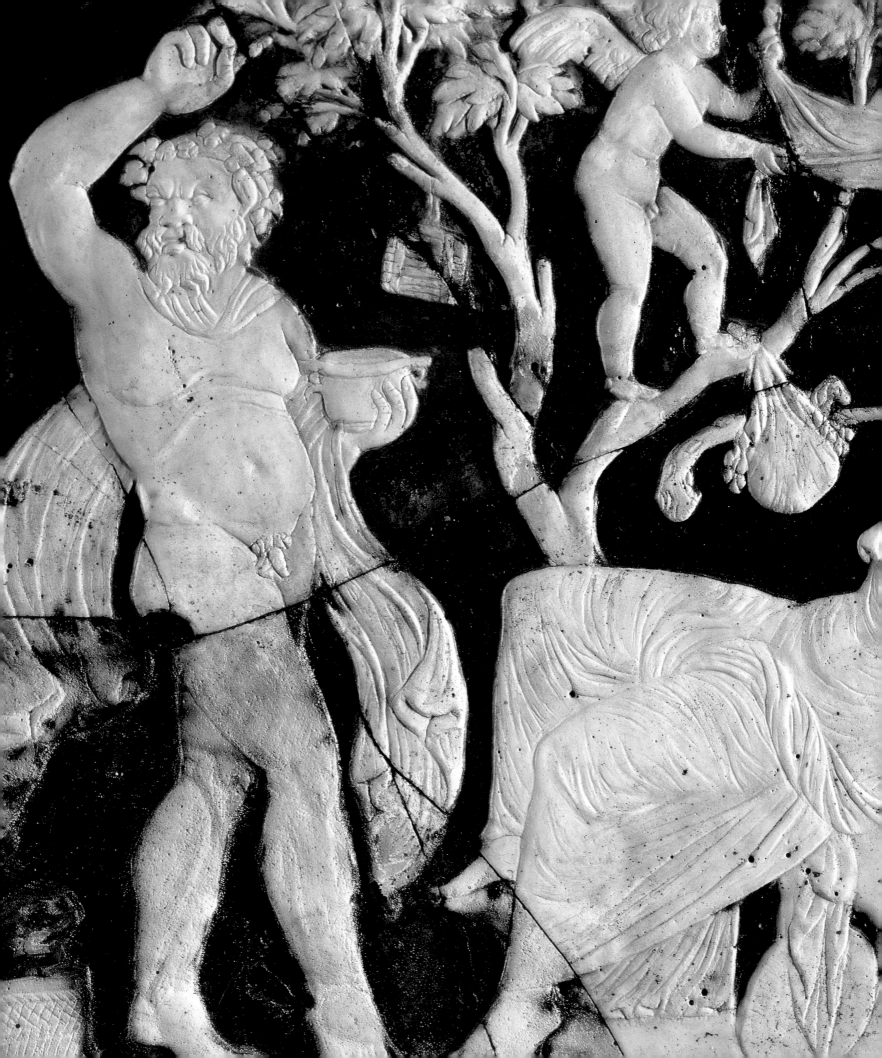

TEMPLES AND THE RELIGIOUS SPHERE

RELIGIOUS REASONS AND
RITUAL METHODS FOR
BLOOD SACRIFICES

THE CULT OF DIONYSOS
AND ITS TRACES IN
POMPEII

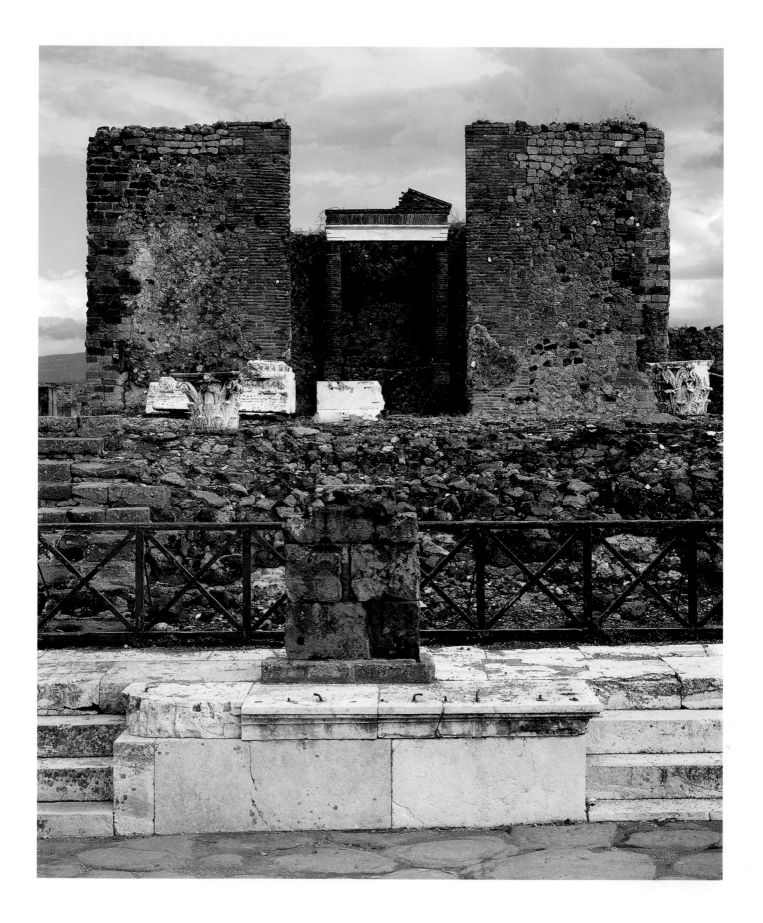

RELIGIOUS REASONS AND RITUAL METHODS FOR BLOOD SACRIFICES

Preceding pages:
A glass-cameo panel representing Ariadne's initiation into the cult of Dionysos; a maenad and a satyr dance beside Ariadne. Objects symbolizing the cult hang from the branches of a tree. The rites associated with the cult of Bacchus were particularly important at Pompeii, a city whose principal product was wine.

Opposite:
Dating to the period of the first emperor, the Temple of Fortuna Augusta was built at the expense of the duumvir Marcus Tullius and on property owned by him. Marcus Tullius belonged to the same *gens*, or clan, as the great orator Cicero.

This handsome nineteenth-century drawing by William Gell reconstructs the Temple of Aesculapius, long misidentified as a sanctuary of Jupiter Meilichios.

Ancient religion is commonly referred to as "paganism," a term that actually encompasses a wide variety of ritual practices and cults inspired by either fear of or love for various aspects of life and nature. These religious practices may be collective, with vast social and political implications, or more esoteric, including initiation rites and sacred devotions carried out in a purely domestic or otherwise private sphere. In very general terms it is worth noting the often practical nature of religious beliefs, with cult practices informed by a series of reciprocal obligations between human beings and gods. The hope was eventually to obtain well-defined benefits from the latter in exchange for the scrupulous observance by the former of ceremonial rituals carefully overseen by priests and followers of the cult. It is impossible, however, to enter fully into the spirit of ancient religion without considering, at least briefly, its intellectual and philosophical dimensions. These underlay the constant questioning of human purpose in the face of all the superindividual forces that were seen as an integral part of the complex and varied nature of existence.

One of the central elements in ancient paganism was the bloody practice of animal sacrifice. It took place everywhere, though the specific rituals might differ. The essential motive of the practice was always the same. We are no longer really familiar with ritual sacrifice, though it has not entirely disappeared: we need only think of the profound importance of the Christian Eucharist, for example. Thus, in order to understand this practice better, a structural-anthropological interpretation of the ancient ceremonies may be useful. The oldest reference to the first blood sacrifice, offered by the Titan Prometheus, appears in a famous passage in Hesiod's *Theogony* (lines 535–616), written at the end of the eighth century B.C. It has been magisterially interpreted by, among others, Jean-Pierre Vernant. The story takes place toward the end of the Golden Age, when gods and humans still dined together, but at the moment when it became necessary to separate what would become food for the gods and what was for human consumption. In this episode, Prometheus, known for his audacity and shrewdness, as well as for his outspokenness on behalf of mortal beings, ran afoul of Zeus, the supreme Olympic deity. Gods and humans were eating together—perhaps for the last time—when Prometheus brought a butchered ox in front of the assembled company. It was divided into two parts, which were packaged differently, a prefiguration of the separation of what was meant for the gods and what would nourish human beings. Zeus was given the honor of first choice between the two. Clever Prometheus had made the first part seem more appetizing, though it hid nothing but the bare bones of the sacrificial beast, while the second part, which looked disgusting, concealed the best portions of the animal.

Although he was perfectly aware of the trap laid for him, Zeus chose the more attractive parcel, which contained nothing but the animal's inedible bones. This surprising passage in the myth explains why the bones of the animals were burned in ancient sacrifices to honor the gods, while humans feasted on the flesh of the sacrificial beast. It also provides the key to the moral and religious significance Hesiod attached

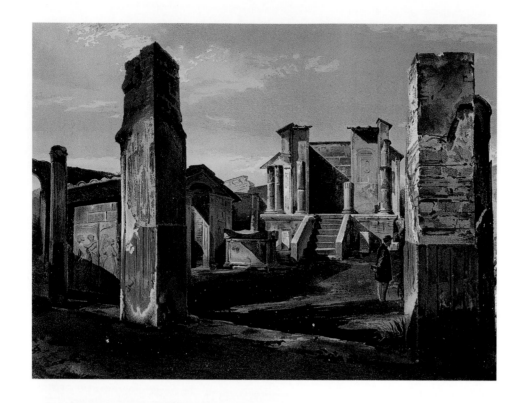

A lovely image of the Temple of Isis in a reproduction by the Niccolini brothers.

The early discovery of Pompeii's Temple of Isis in 1764 had enormous cultural repercussions throughout Europe, greatly expanding both the historical and archaeological understanding of ancient religious cults.

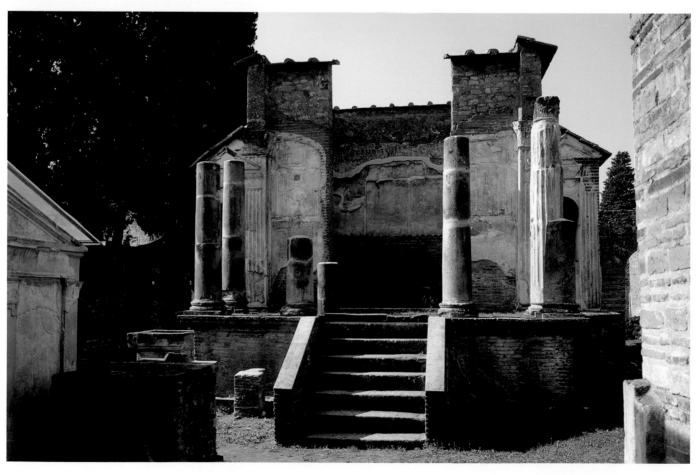

to this myth. Choosing the bones for himself and leaving the meat of the ox for human beings, Zeus underscored the definitive separation between the realm of the gods, who in fact had no need to eat meat, their immortal nature being sated by the smoke from the bones, that is, by their immaterial aromas, and the world of humans, in which it became necessary to eat the flesh of dead animals again and again. This need, which can be satisfied only by repeated and exhausting effort, implies an existence that includes the process of aging and the inevitability of death.

This extraordinary passage in Hesiod's work may illuminate why it was important for the ancients to continue the practice of the ritual sacrifice of animals. It represented for them a residual contact between the human and divine realms, reminding human beings that their place is higher than that of animals but at the same time much below that of the immortal gods, who would never again share their table with humankind. Ancient society, fearing either a real or a symbolic rupture in the order of things established by the gods, thus saw the violence of the sacrifice as an act fundamentally—and apparently paradoxically—of passive submission and of mystical recognition of human inferiority to the gods.

This ivory statue, found in a house on Via dell'Abbondanza, represents Lakshmi, the Hindu goddess of beauty and fertility, and attests to the direct and indirect trade relations that existed with India.

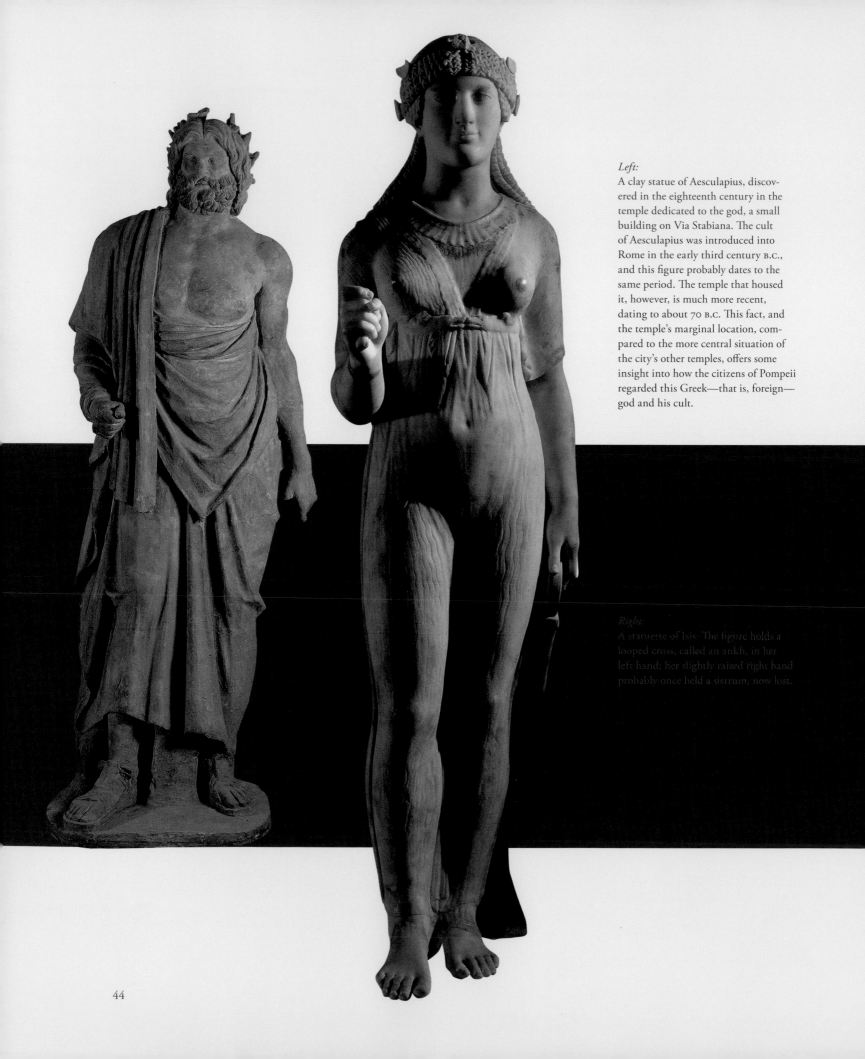

Left:
A clay statue of Aesculapius, discovered in the eighteenth century in the temple dedicated to the god, a small building on Via Stabiana. The cult of Aesculapius was introduced into Rome in the early third century B.C., and this figure probably dates to the same period. The temple that housed it, however, is much more recent, dating to about 70 B.C. This fact, and the temple's marginal location, compared to the more central situation of the city's other temples, offers some insight into how the citizens of Pompeii regarded this Greek—that is, foreign—god and his cult.

Right:
A statuette of Isis. The figure holds a looped cross, called an ankh, in her left hand; her slightly raised right hand probably once held a sistrum, now lost.

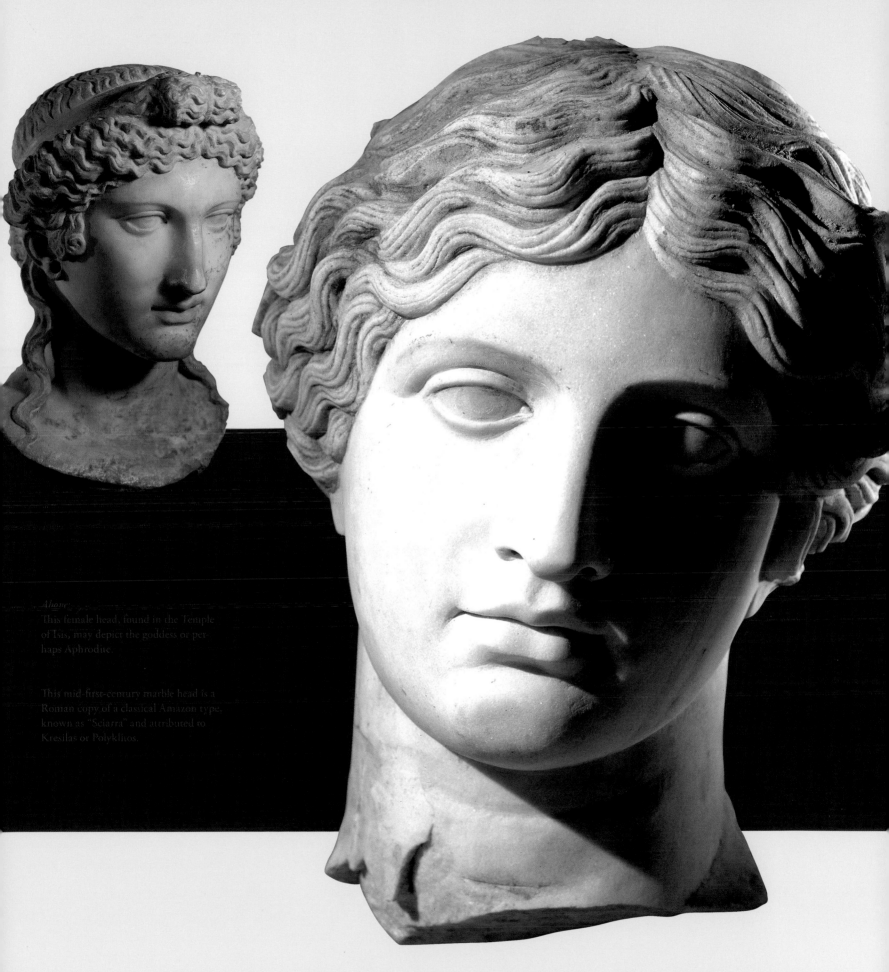

Above:
This female head, found in the Temple of Isis, may depict the goddess or perhaps Aphrodite.

This mid-first-century marble head is a Roman copy of a classical Amazon type, known as "Sciarra" and attributed to Kresilas or Polyklitos.

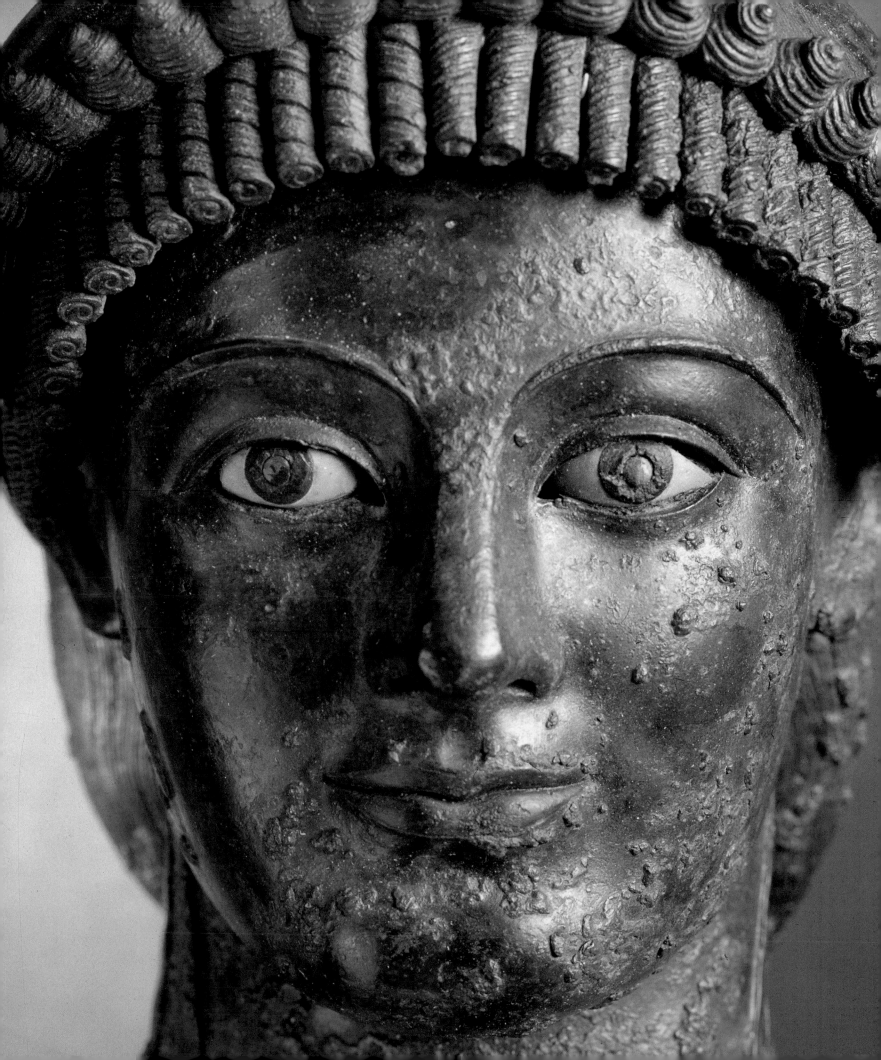

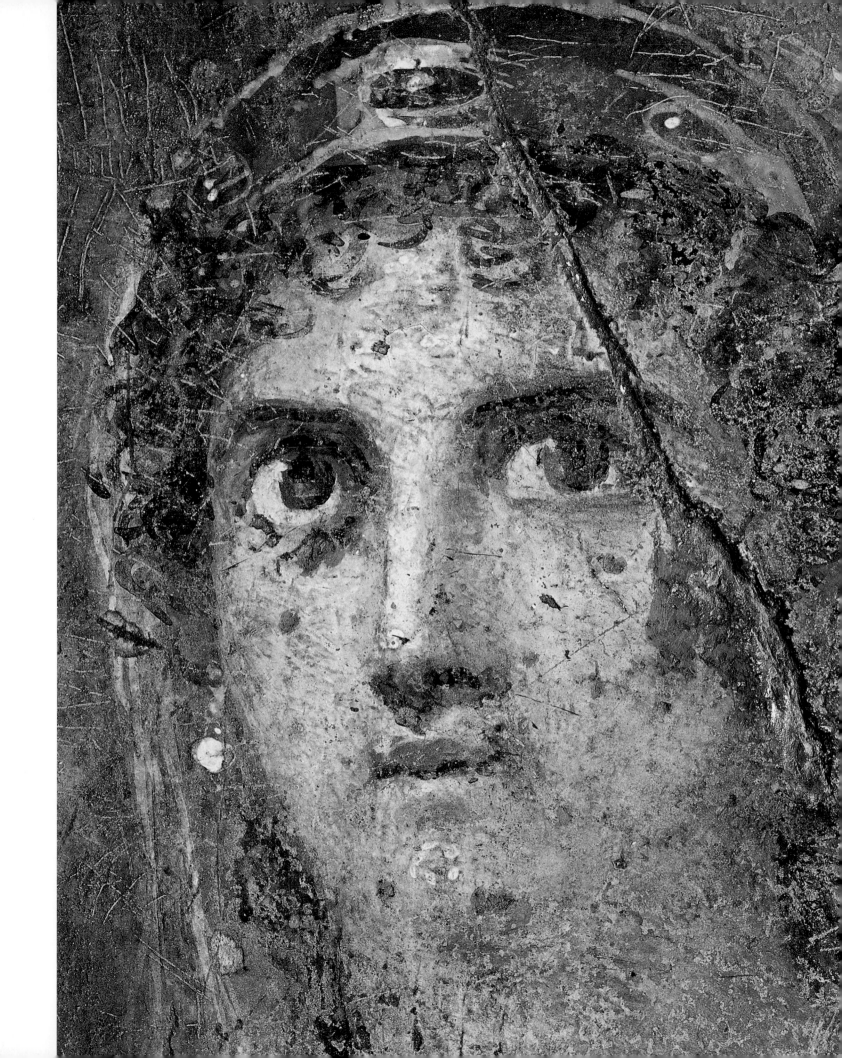

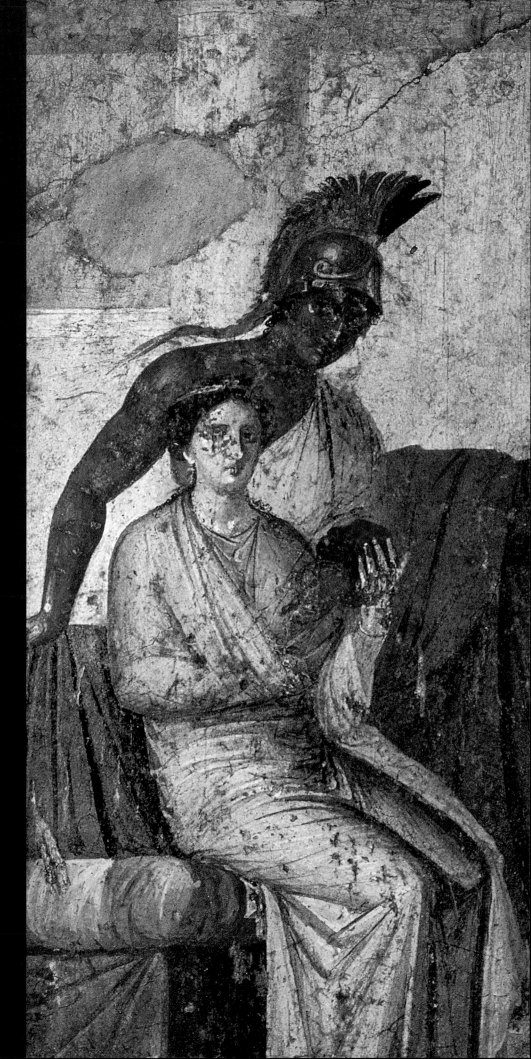

gnificent face of this bronze
f Apollo with its expressive
ste eyes comes from the dining
the House of Julius Polybius,
functioned as a lamp stand.

of the face of Juno from the
f her marriage to Jupiter, on the
all of the atrium in the House
ragic Poet.

nting from the House of
Lucretius Fronto offers a lively
from the passionate loves of
s. Helios, the winged figure at
er, has just discovered the liai-
ween the two lovers, Aphrodite
s. Helios will take it upon
—with dire consequences—
t the affair to Aphrodite's
d, Hephaestus.

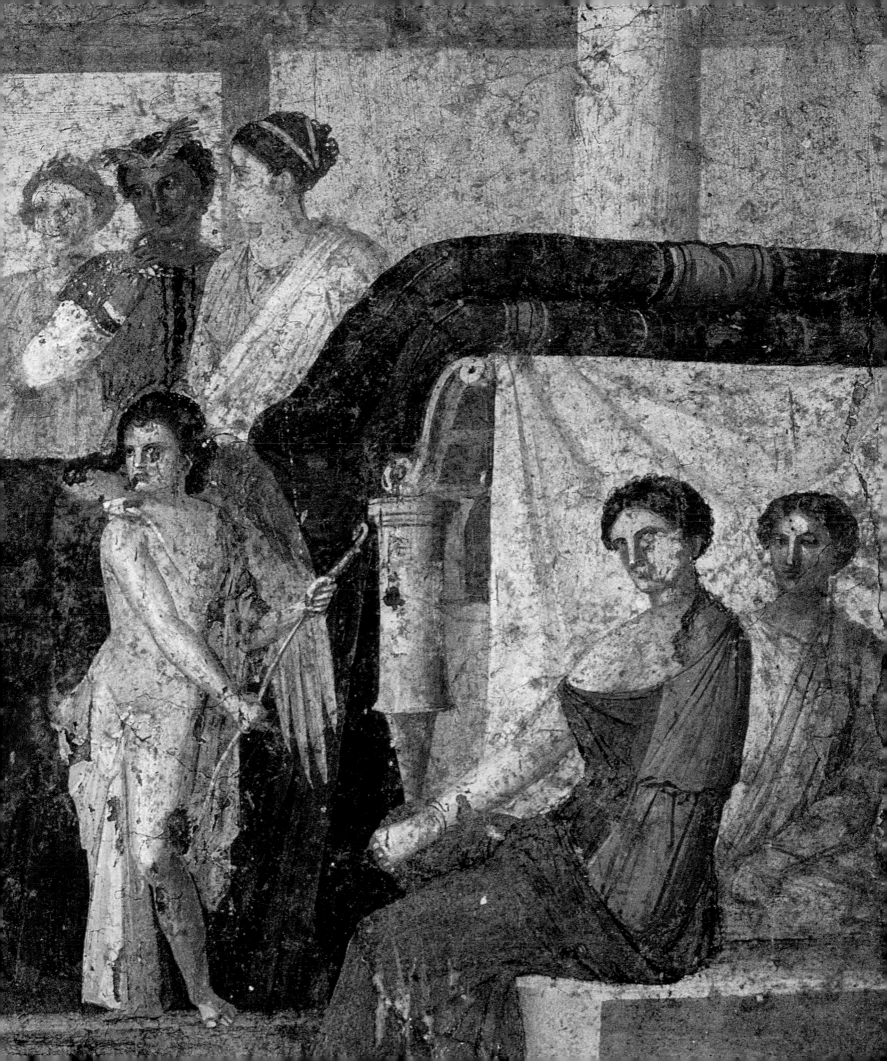

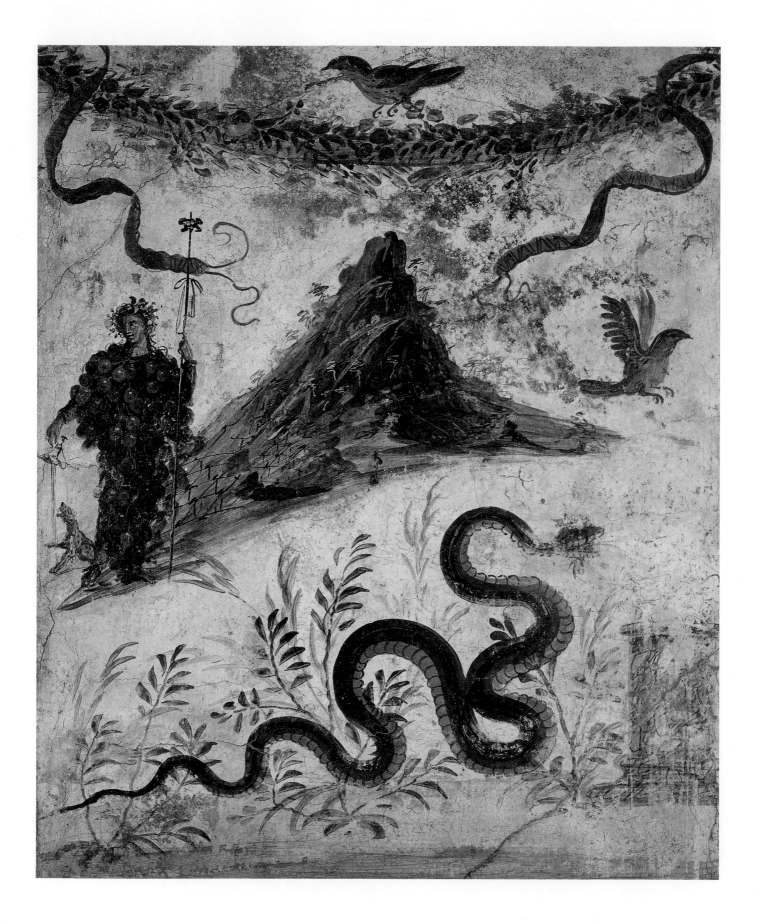

50

THE CULT OF DIONYSOS AND ITS TRACES IN POMPEII

Dionysos, whom the Romans called Bacchus or Liber Pater (Free Father), played a very important role among the ancient gods. He was the god of plants—and especially grapes and wine—and of mystical ecstasy and fertility. His cult was very popular and open to women and slaves, but aspects of it were wild enough to provoke the Roman Senate into passing a famous and long-standing decree against it in 186 B.C. Among his cult's many features was a specific emphasis on the profound value of irrationality as an inalienable aspect of being. Dionysos was for many reasons the necessary counterbalance to rationality, a quality linked to Apollo's radiant splendor and complementing it in a way that nicely illustrates how deeply ancient paganism felt these apparently contradictory characteristics of human nature to be inseparable. It is interesting in this light to note that the myth of Dionysos tells us that the god passed through evident periods of madness, a state recalled in the ecstatic rites and mystical exaltation of drunkenness and dance that were sacred to him. The concept of redemption is equally fundamental to the cult of Dionysos, a god who died but was resurrected, to return alive from the realm of Hades. This complex system of beliefs stands behind the great popularity of Dionysos's cult in antiquity and explains its ties to rituals connected to the regeneration of both humanity and nature.

Opposite:
In this fresco from the House of the Centenary, Bacchus, holding his thyrsus and accompanied by a panther, is portrayed as a luscious bunch of grapes. Beside them is Mount Vesuvius, on whose slopes the Pompeians culti-vated grapes. The serpent symbolizes the fertility of the soil.

The mosaic in the dining room of the House of the Faun shows a Dionysian *genius* drinking from a large, trans-parent vessel while astride a tigerlike animal.

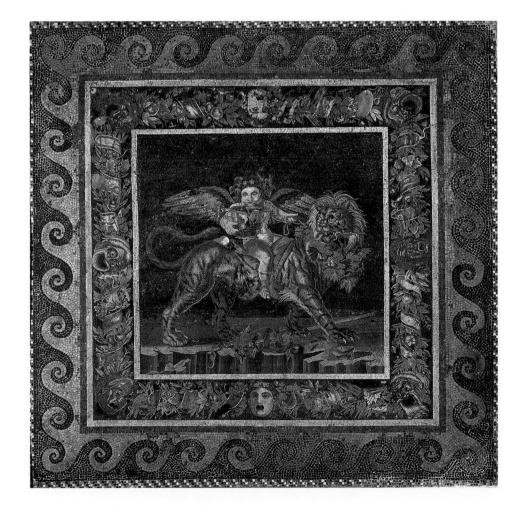

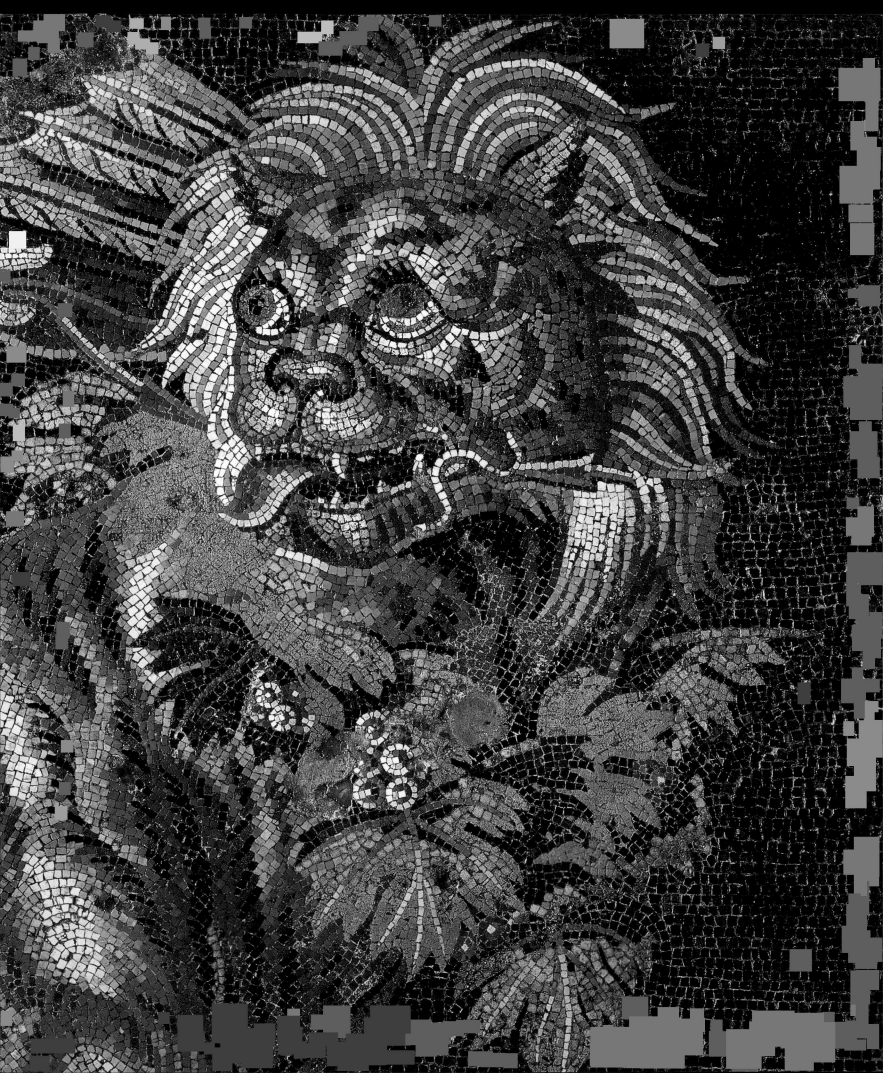

Opposite:
The mosaic in the dining room of the House of the Faun: detail of the head of the tigerlike animal ridden by a Dionysian *genius*.

A three-dimensional reconstruction of the Dionysian sanctuary that was outside the city at what is today Sant'Abbondio.

The bone handle of an unidentified utensil. In front it is decorated with an elegant relief of Dionysos and Pan. The latter can be identified by the long horns sprouting from his head.

There are interesting traces of the cult of Dionysos at Pompeii, though no sacred structures dedicated to the god have yet been discovered within the city walls—it is worth noting, however, that about a third of the city still lies buried. A sanctuary dedicated to Dionysos was found just outside Pompeii, at a place now called Sant'Abbondio. Originally built in the third century B.C., in the middle of the Samnite period, it was restored several times, including well into the imperial period. The sanctuary was connected to the nearby port at the mouth of the Sarno River and to the broader region around it, where grapes were an important commodity. The building represented the desire to secure the favorable influence of this popular mystery cult for an important sector of the local economy, the production and export of wine. A female divinity connected with the erotic sphere, probably a sort of Ariadne-Aphrodite figure, was also venerated at this shrine dedicated to Dionysos. This same divine couple is represented in what is perhaps the most famous fresco cycle at Pompeii—the life-size figures painted in about 60 B.C. in the elegant dining room of the Villa of the Mysteries, just outside the city walls. The frieze, executed by a talented local artist inspired by Graeco-Alexandrian culture, seems to represent the ceremony initiating a young woman into the cult, in a setting that appears to shuttle between reality and the realm of myth. The most important figures in the cycle include a nude dancing Bacchante, apparently possessed by the rhythms of the ancient castanet-like *crotala*, and a group of satyrs drinking *satyrion*, the Bacchic potion thought to allow one to discern the profound nature of reality. The figure of Dionysos, sitting in Aphrodite's lap, is painted near the satyrs, and on the other side of these deities is a significant scene showing the initiate discovering the phallus, the most powerful symbol of the eternal regeneration of life and the only force capable of countering misfortune and the dominion of death.

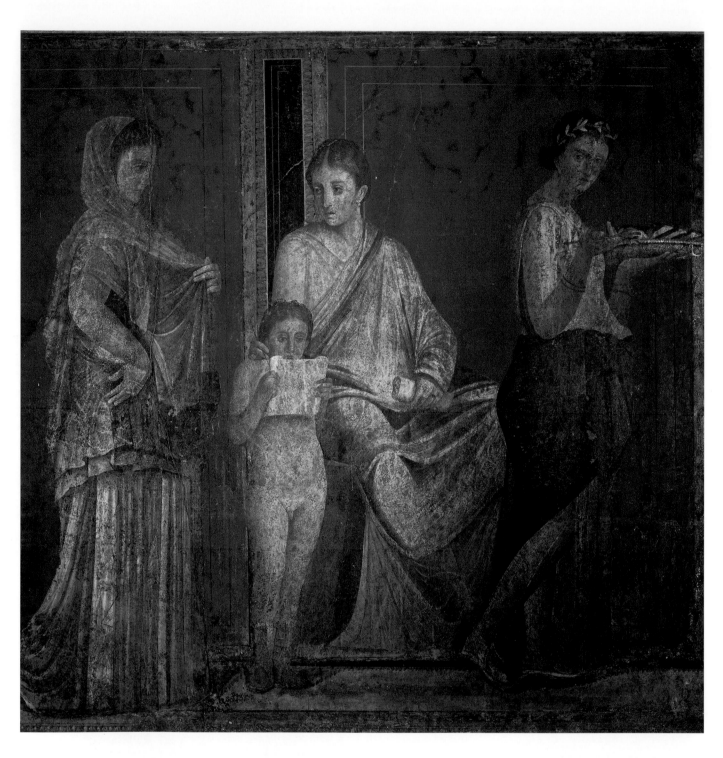

The Villa of the Mysteries. Beside the initiate is the adept of the cult who will guide the younger woman through the ceremony. The initiate listens to a nude child, a symbol of purity, as he reads the ritual from a papyrus scroll.

Opposite:
The Villa of the Mysteries. The climax of the initiation is emphasized by a possessed Bacchante dancing nude to the rhythm of the *crotala* she claps above her head. In a moment of dismay, the initiate retreats to the lap of the adept.

Pages 56–57:
The Villa of the Mysteries. A general view of the triclinium, or dining room, whose lavish decoration inspired the name its discoverers gave the villa.

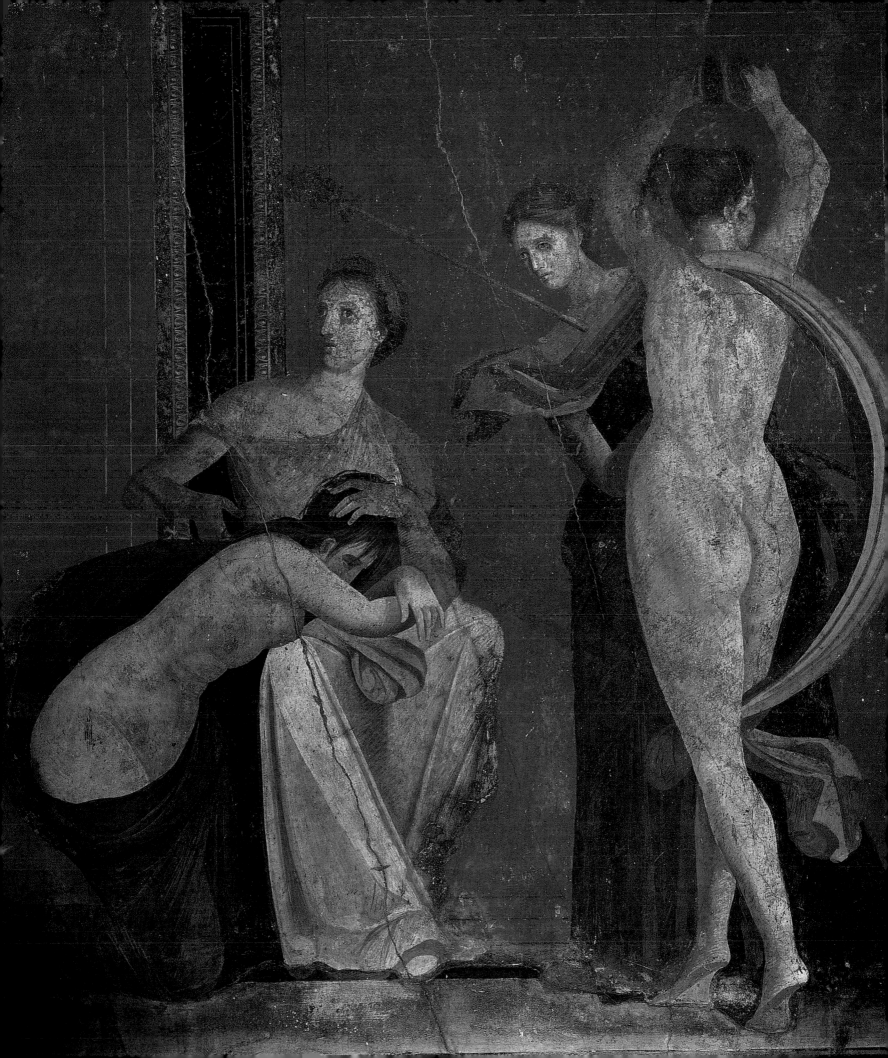

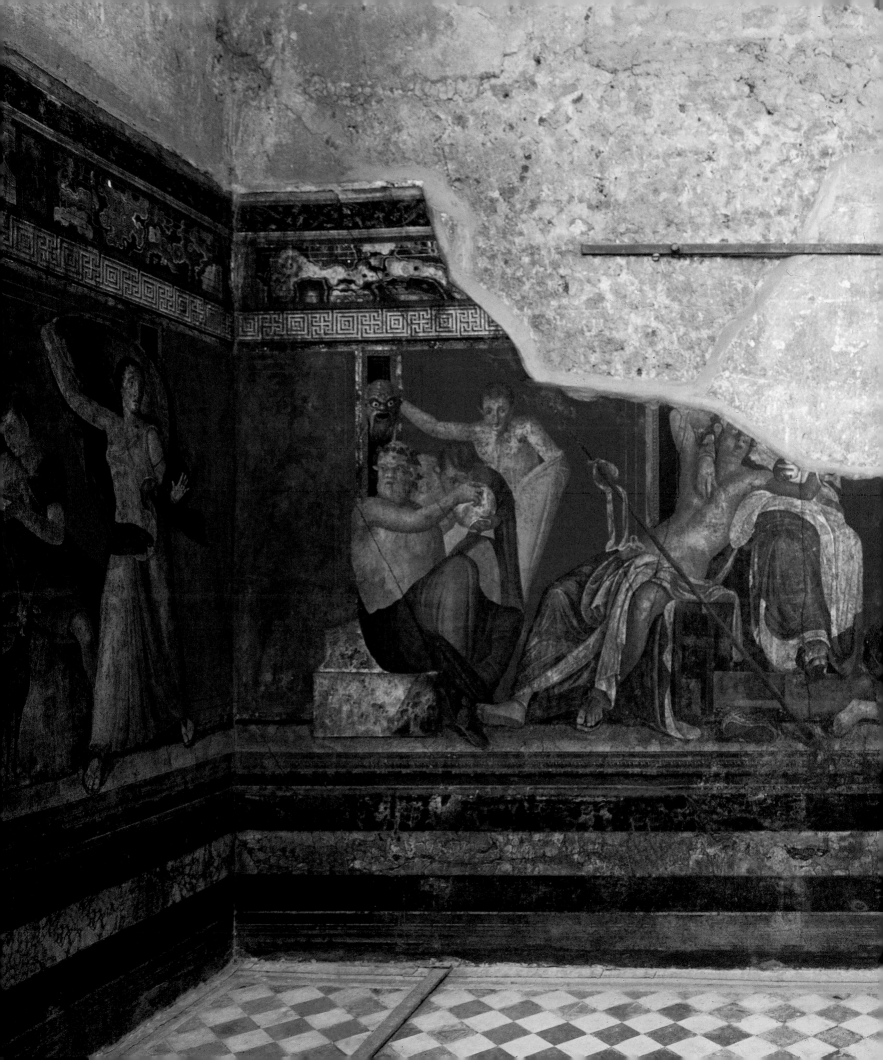

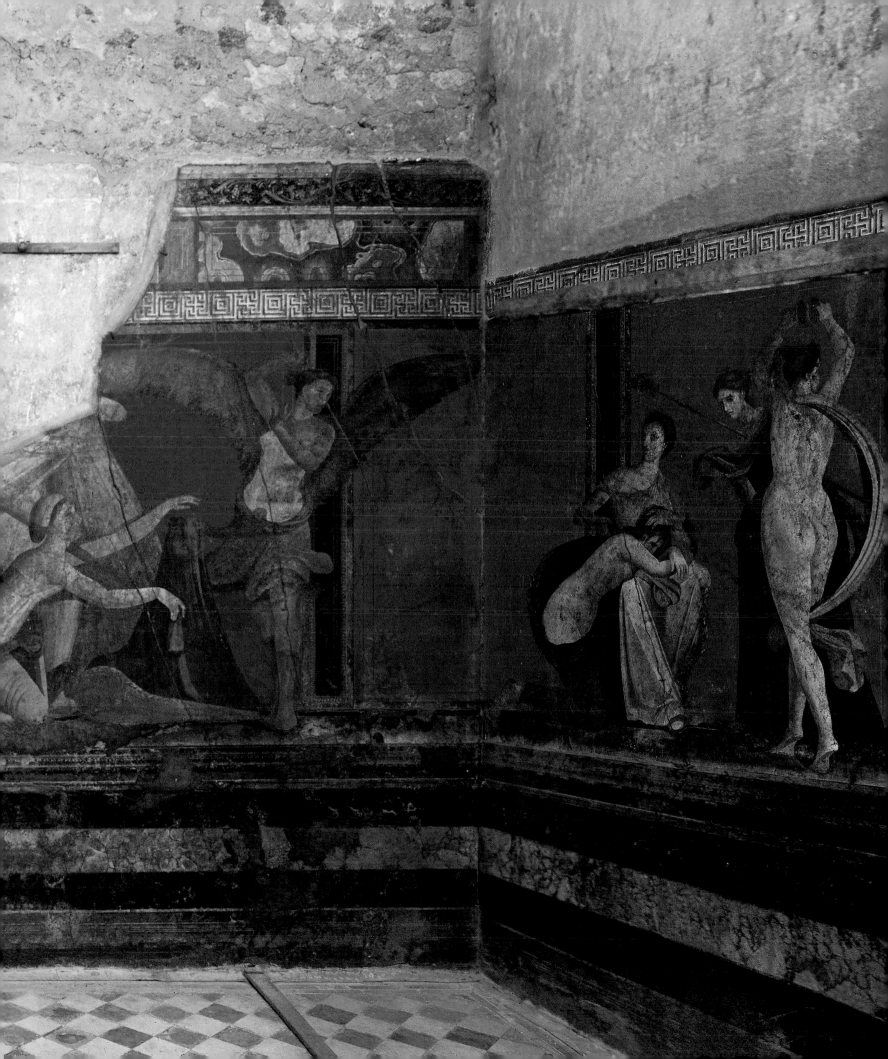

THE
PALESTRAE

SPORTS AND
PHYSICAL FITNESS

GAMES AND GLADIATORS

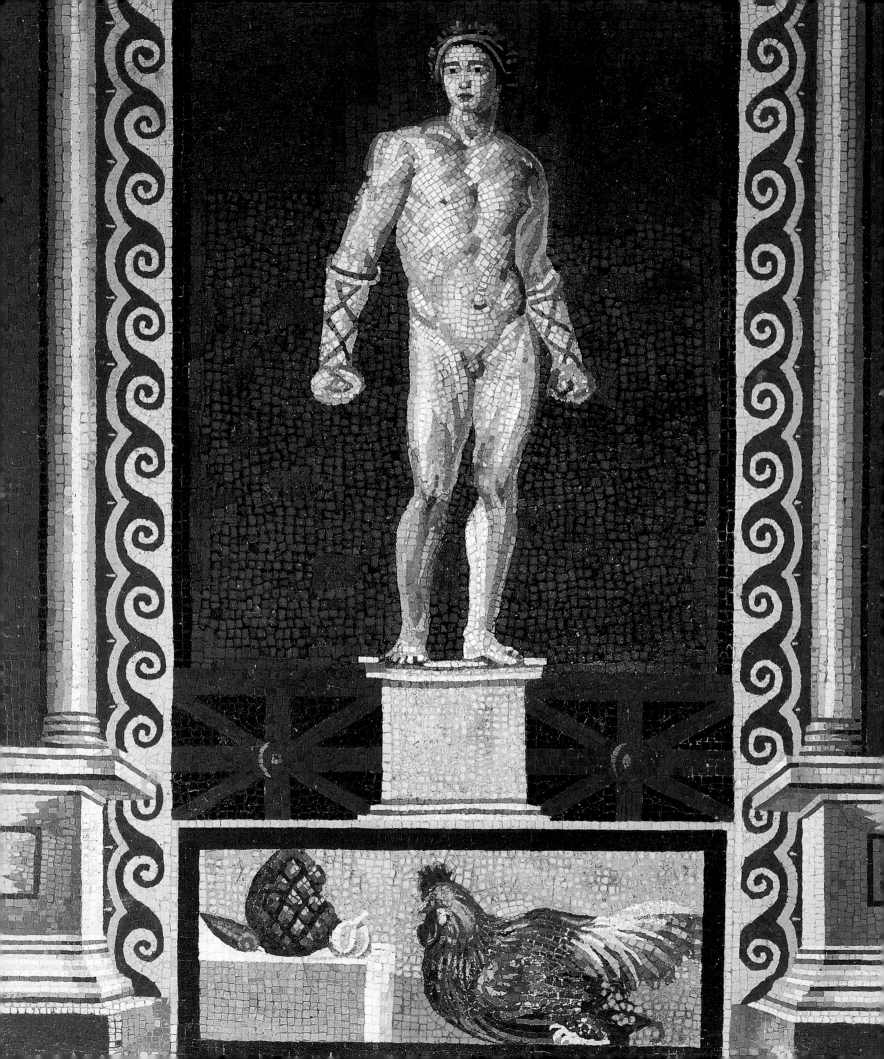

SPORTS AND PHYSICAL FITNESS

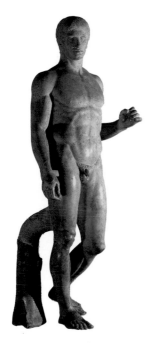

A Roman copy of Polyklitos's *Spear Bearer*. The splendid balance between stasis and motion made it one of the absolute masterpieces of classical Greek sculpture.

Preceding pages:
A remarkable bronze helmet, dating to the Flavian period, from the Gladiators' Barracks. The narrative scenes depict episodes from the Trojan War; in this detail, Ajax and Cassandra are on the left, while on the right Neoptolemus kills Priam.

Opposite:
The athlete portrayed in this Pompeian mosaic is a boxer, as evidenced by his fists and arms, which are wrapped in narrow leather strips. Athletes were very much admired in the Roman world and were often idolized by women for the displays of masculine power associated with their professions.

One of the best-known aspects of classical culture is the notion of a harmony between stimulating intellectual activity and a carefully designed routine of physical exercise. The idea for this particular mind–body connection came from the Greek gymnasiums, where athleticism and profound spiritual and philosophical teachings were intertwined. This cultural model was widespread throughout the Roman world but was practiced really only by members of the upper classes, who had both the time and the means to devote that sort of attention to themselves. Juvenal's famous phrase *mens sana in corpore sano*—"a sound mind in a healthy body" (*Satires* 11.356)—reflecting the Greek ideal of education, entered into popular culture as a proverb. In Rome, however, the emphasis was more on an existing political relationship between physical fitness and preparation for military service.

Sports activities were largely reserved for men, especially young men. They found their natural spaces in both gymnasiums and *palestrae*—we will see shortly how important these function-specific Pompeian buildings were—as well as in bath complexes and the porticoes around the public squares. An interesting example of the kind of space used for exercise and sports in Pompeii is the Triangular Forum, which was designed and built in the late Samnite period. The long eastern portico of this area was flanked by an open passageway of equal length, suggesting that it was used both as a public passageway and for training for running races. Footraces were a very common form of athletic contest in antiquity, along with other field events, such as throwing the discus and the long jump. The latter was done differently than it is today, in that the jumpers carried weights, called *halteres*, which allowed them to jump farther. Other popular events included horseback riding and contact sports such as wrestling and boxing.

The suggestion that the Triangular Forum may have been used also for athletic events is supported by the fact that the Samnite Palestra, built in the second century B.C., opened directly onto it. Sources indicate this building was used for sports activities, and its courtyard might have contained a copy of Polyklitos's celebrated *Doryphoros*, or *The Spear Bearer*. The original figure was carved in the fifth century B.C., at the height of Greek classicism, and Pliny the Elder decreed that every gymnasium should have a copy (*Natural History* 34.10.18). Some of the most important areas of the Samnite Palestra include the *destrictarium*, the room in which athletes applied a sort of firming cream, made of a mixture of oils and stone dust, that was then scraped off with a strigil. An Oscan-Samnite inscription that was discovered seems to suggest, though scholars do not unanimously agree, that the building was also the headquarters of a political and military association in precolonial Pompeii.

The particularly Roman combination of athleticism, military pride, and obedience to authority can also still be seen in Pompeii's other imposing building, the Large Palestra, dedicated to exercise. It was built next to the Amphitheater during the reign of Augustus, the first emperor of Rome, and represents an important shift in the philosophy of educating young men to make them loyal as well as fit candidates for military service. The Large Palestra is centered around a vast, rectangular

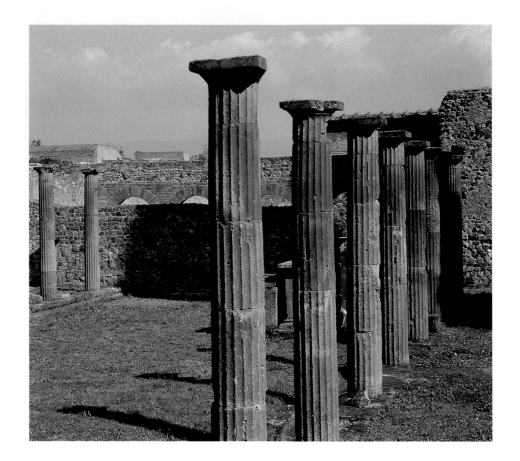

The porticoed courtyard of the Samnite Palestra at Pompeii. The Roman copy of Polyklitos's *Spear Bearer*, one of the most famous statues in the ancient world, was found here.

Opposite page:
A panoramic view of the Large Palestra from the east; the Amphitheater is behind the viewer. The architectural plan of the Palestra is simple and linear. Three sides are porticoed, and there is a large pool in the middle of the courtyard. The Palestra was built in the Augustan period, and it was used for gymnastics and other sports and for paramilitary activities.

courtyard with porticoes around three of its four sides. The courtyard was planted with two rows of plane trees; plaster casts have been made of their root systems. Also in the center of the courtyard, a large swimming pool, the *natatio*, hosted swimming and other aquatic sports. There were no army barracks in the modern sense of the word, but this is the sort of place where we can imagine Pompeian boys in the imperial period busy with physical and military exercises, which probably also included instruction in horsemanship. The Palestra's broad open space, filled with both sun and shade, was also frequented by other citizens of Pompeii, who went there in their free time. They might have engaged in sports, certainly, but they could also walk and watch—as inscriptions there tell us they did—the very popular sport of cockfighting.

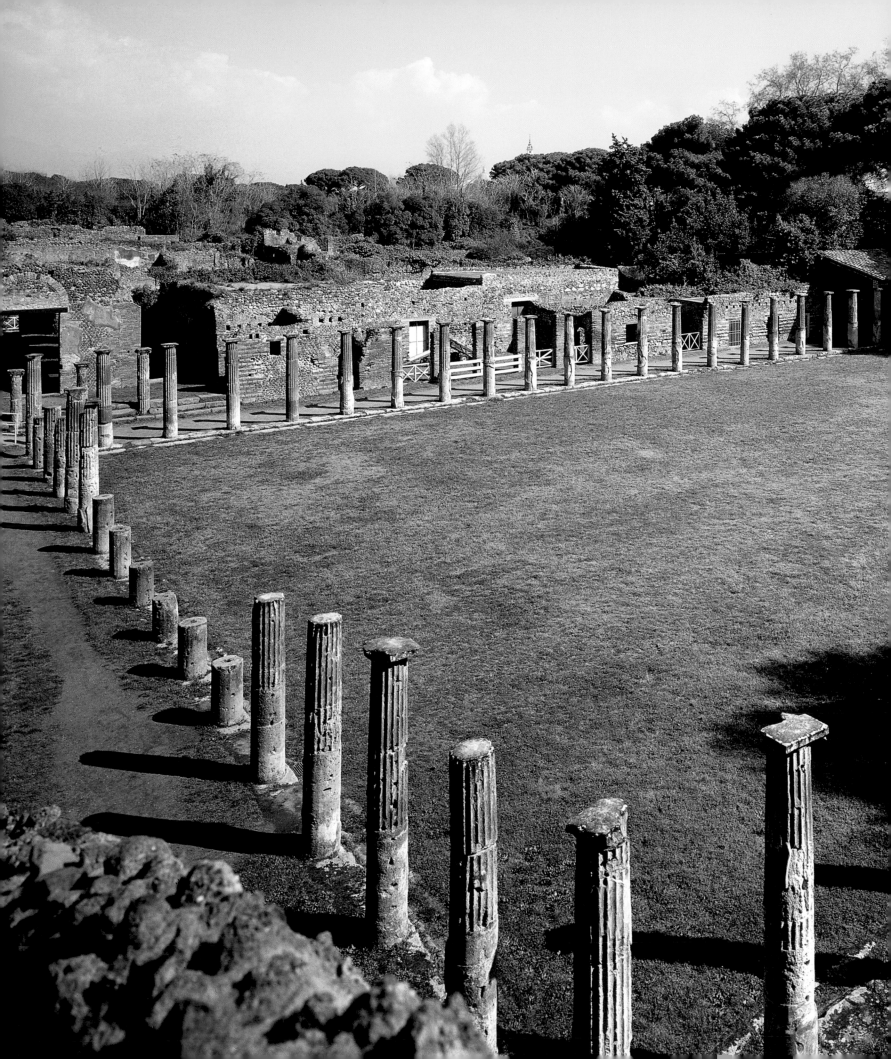

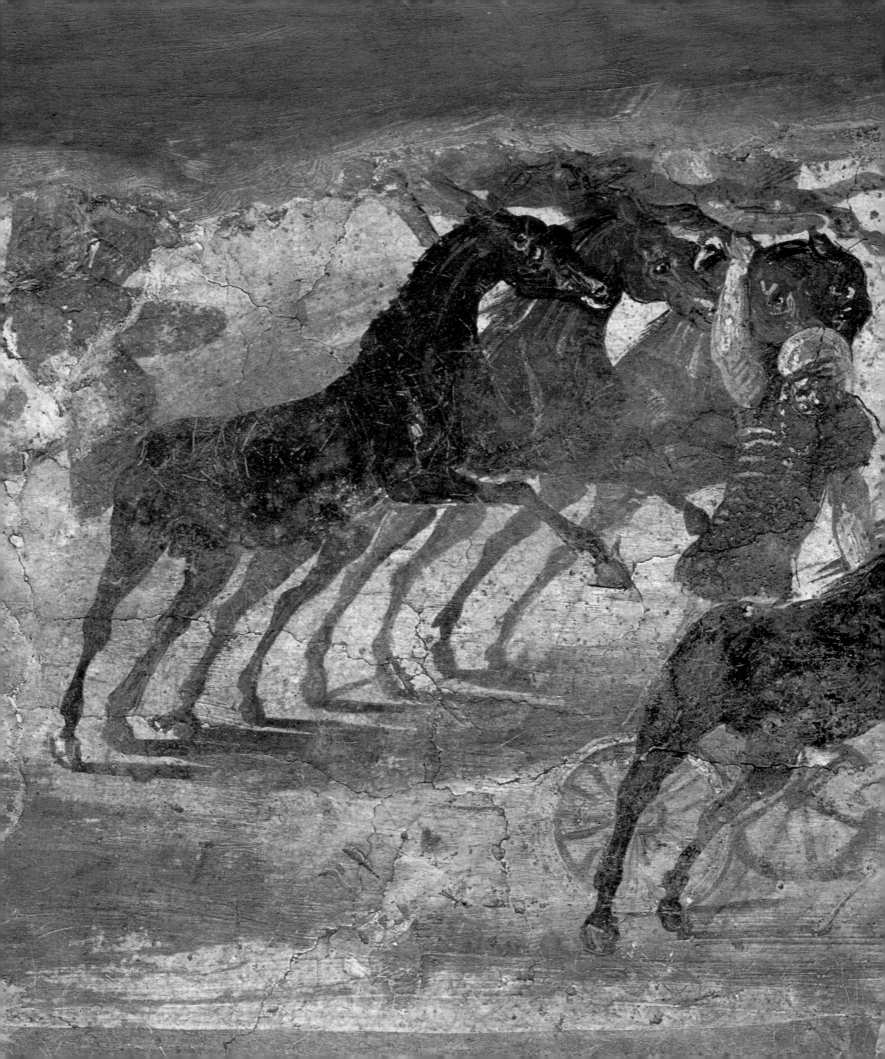

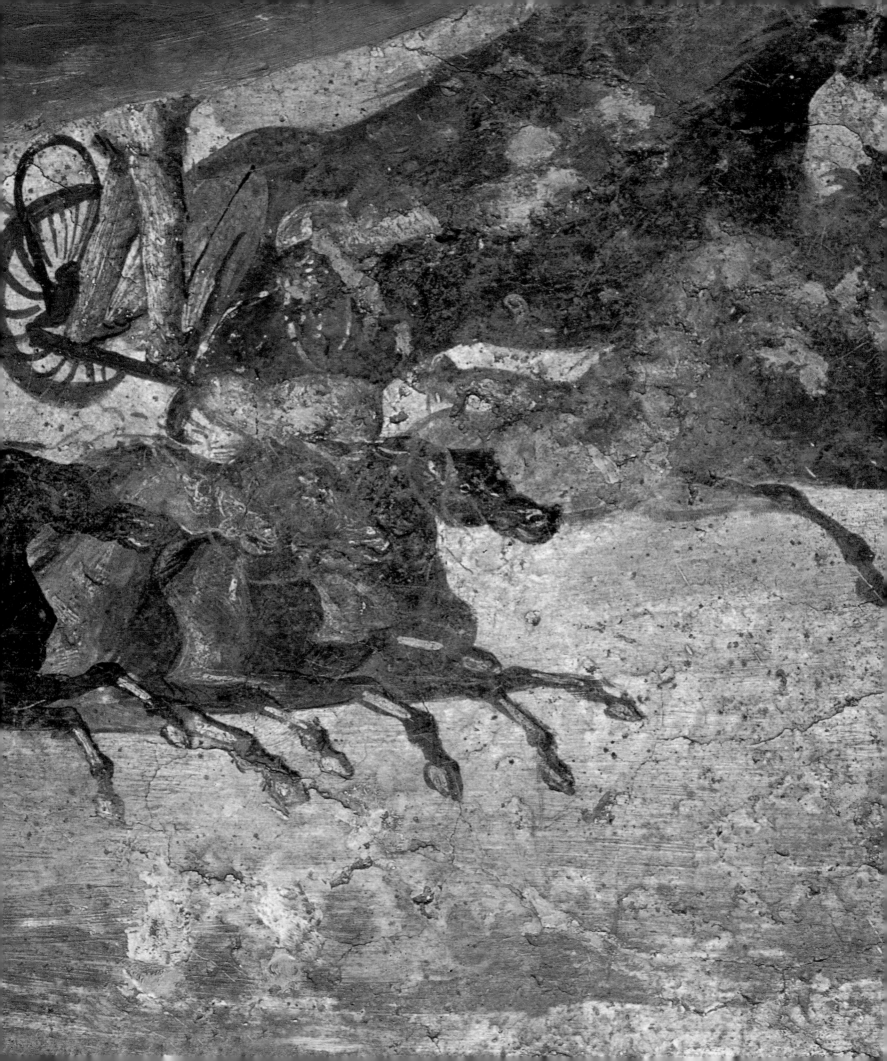

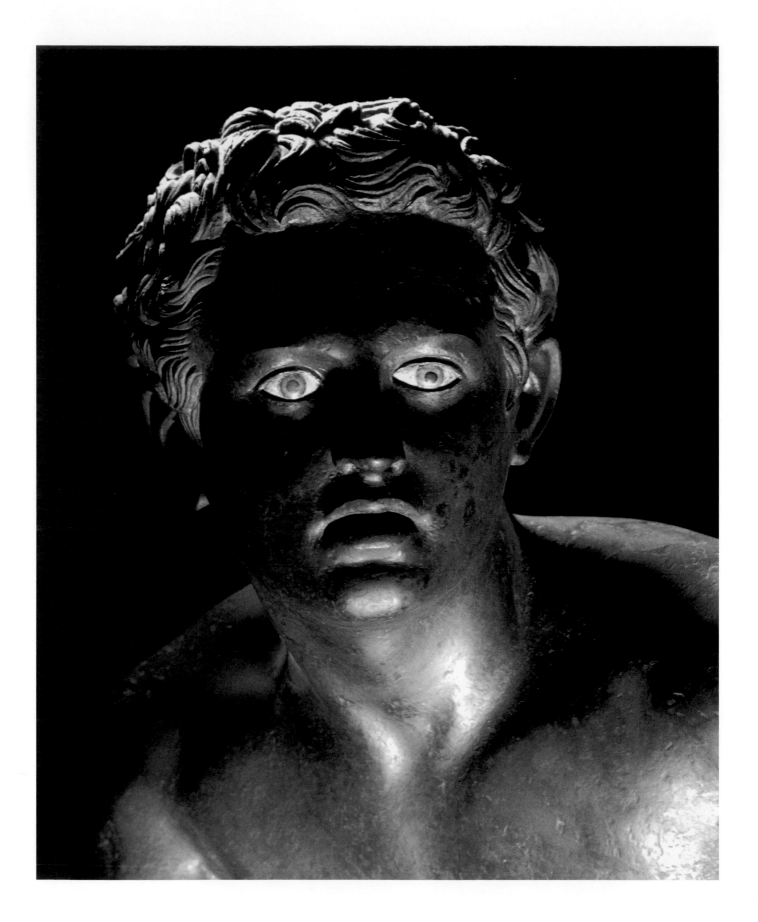

66

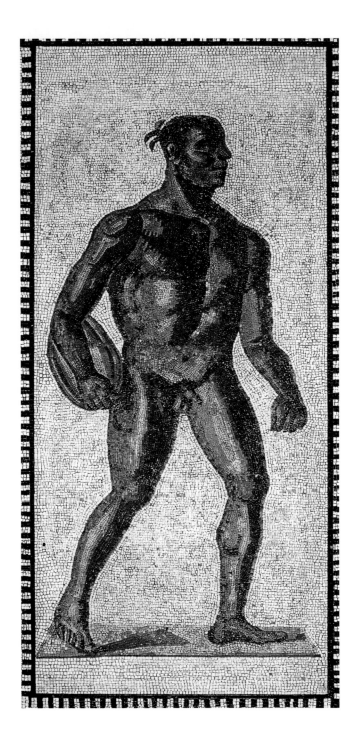

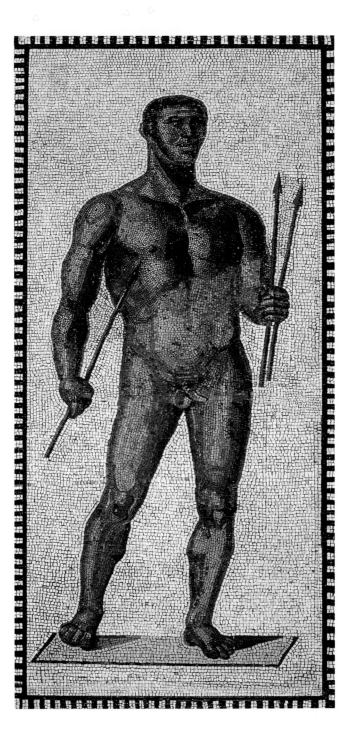

Pages 64–65:
Detail of a Pompeian fresco found in House VII, 2, 25. It shows a chariot race. In this case each chariot is pulled by a team of four horses. In Pompeii races like this were probably held in the Large Palestra.

Opposite:
A runner's face. This bronze statue was discovered in the Villa of the Papyruses at Herculaneum. It is a Roman copy of a Greek original from the fourth century B.C.

A discus thrower and a javelin thrower. The brutish expressions of the athletes represented in these third-century B.C. mosaics from Rome's Baths of Caracalla demonstrate how distant they are from the original ethical and sacred values of ancient Greek sportsmanship.

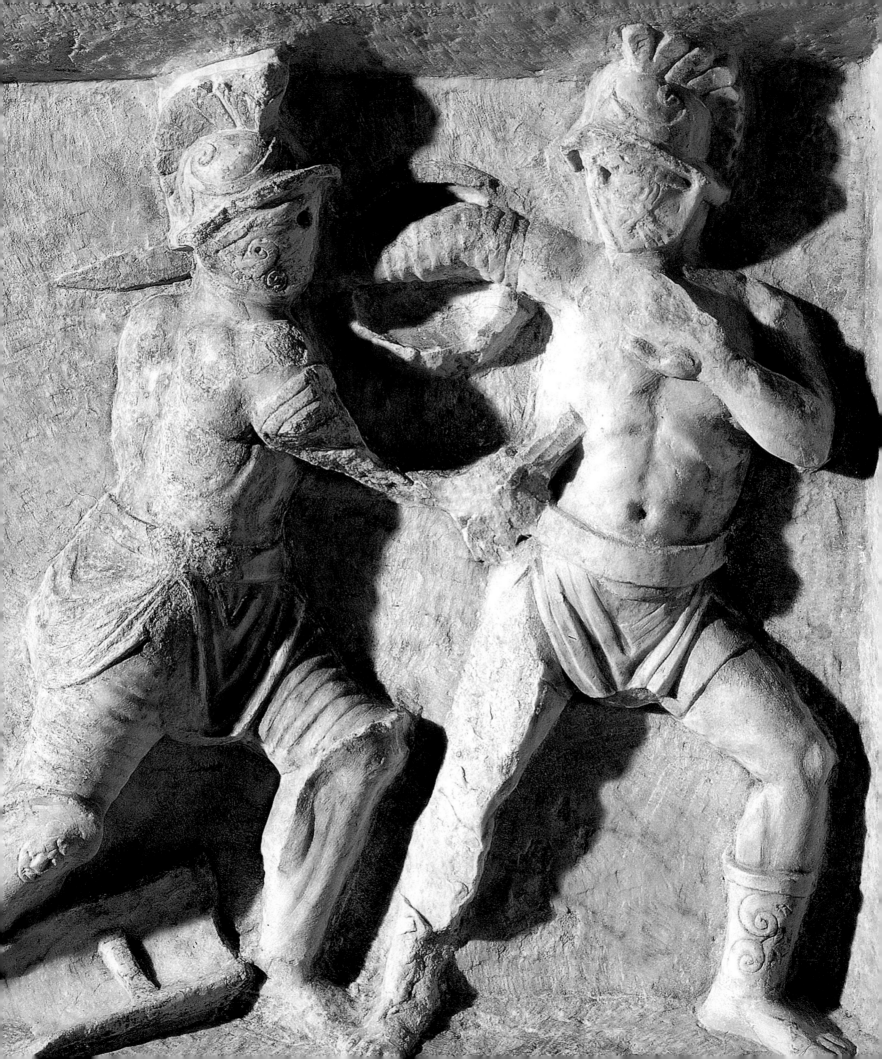

GAMES AND GLADIATORS

Opposite:
Detail of a marble relief from a Pompeian tomb of the Julio-Claudian period. The two gladiators engaged in battle are of the *Hoplomachus* and *Murmillon* types, respectively.

From the tomb of Caius Vestorius Priscus. This interesting painting of bloody gladiatorial contests dates to the Flavian period.

It may be inaccurate to describe as a sport the ancient Romans' enthusiasm for watching the hugely popular gladiatorial contests in the amphitheaters, since merely attending a spectacle in an arena is an essentially passive act. Furthermore, the training of the star performers in these games—slaves who hoped to gain their freedom by their prowess in a brutal, bloody, and dangerous activity—was entirely different from that of athletes engaged in far less vicious sporting events.

Nevertheless, the gladiatorial contests and *venationes* (fights between men and wild animals or between ferocious beasts and domestic animals) were far and away the entertainments most enjoyed by people at all levels of society, not just the uncouth lower classes. The social and political implications of this phenomenon are evidenced by the immense popularity of both the sponsors and organizers of these extremely expensive games. It is also worth noting one of the most famous political aphorisms to survive from ancient Rome: *panem et circensis*—"bread and the shows in the circuses." The phrase, attributed to Juvenal, is a pithy formulation of the close ties between autocracy and demagogy that were essential to ensuring public consensus while providing a safety valve for the many tensions in the social fabric.

Built during the colonial period, around 70 B.C., Pompeii's amphitheater is one of the oldest in the Roman world. It is splendidly preserved and can still evoke with

great immediacy the atmosphere of excited anticipation that must have hung in the air on days when combats were scheduled. The city on the slopes of Mount Vesuvius offers abundant and valuable evidence about the world of the gladiators and their feats. For example, numerous graffiti describe women's reactions to the brawny fighters' virile erotic appeal. Another text recorded in detail two programs from a day of gladiatorial contests in the Amphitheater, including the contests' outcomes, happy or otherwise. The outcomes seem to have largely depended in the case of defeat on the degree of valor and courage displayed by the vanquished combatant. Permission for the final coup de grâce, the privilege of the winning gladiator over the

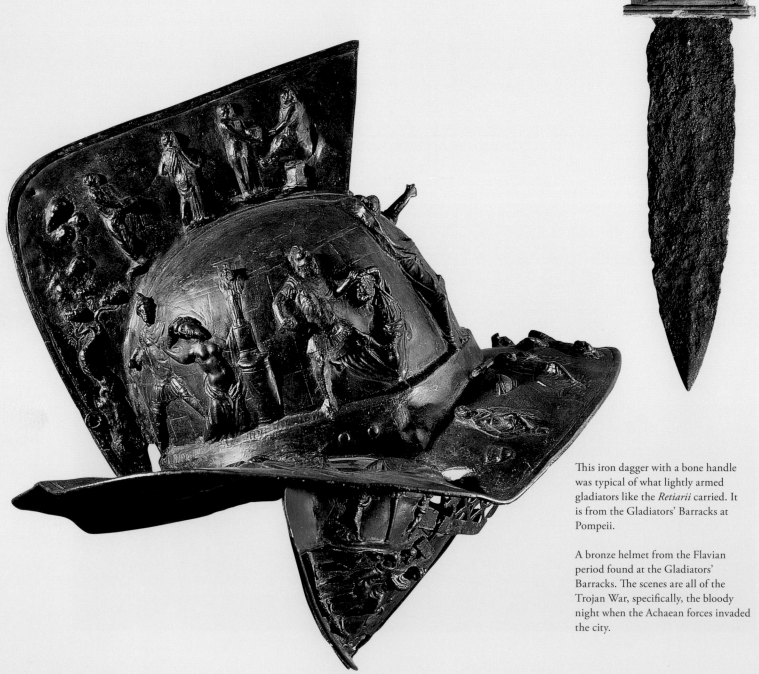

This iron dagger with a bone handle was typical of what lightly armed gladiators like the *Retiarii* carried. It is from the Gladiators' Barracks at Pompeii.

A bronze helmet from the Flavian period found at the Gladiators' Barracks. The scenes are all of the Trojan War, specifically, the bloody night when the Achaean forces invaded the city.

70

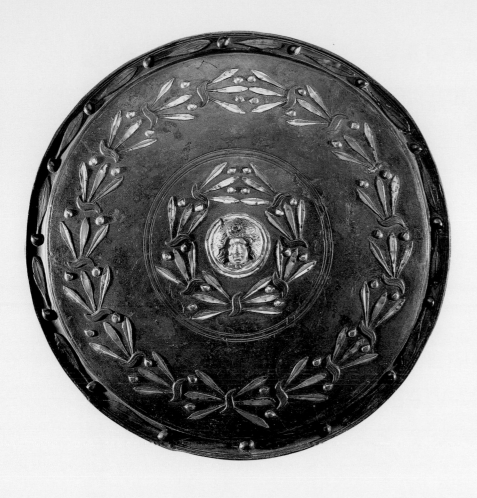

A circular shield with a head of Medusa at its center surrounded by two wreaths of olive branches. It was discovered in the Gladiators' Barracks at Pompeii.

Detail of a bronze greave from the Gladiators' Barracks. The allover decoration includes a head of Dionysos, thyrsi, and other symbols of the god of excess and drunkenness.

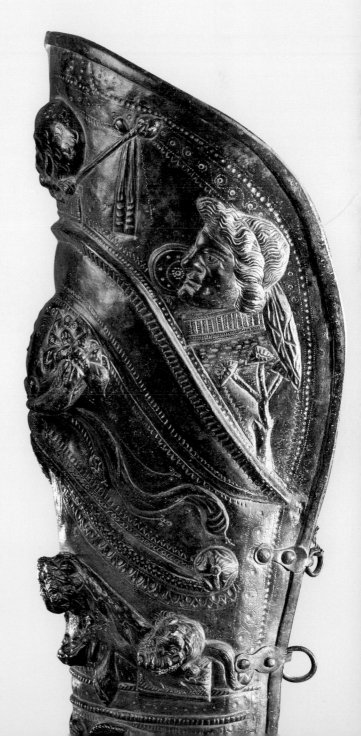

loser, was traditionally left to the judgment of the spectators in the arena. The National Archaeological Museum in Naples contains splendid examples of gladiatorial arms, such as daggers, shields, and helmets adorned with rich and lively figural decoration. The most vivid evidence, however, is a stucco relief (today lost but known to us from a nineteenth-century drawing) from the so-called Tomb of Aulus Umbricius Scaurus in the necropolis at Porta Ercolano. This relief offers an unmediated vision of the ruthless dialectic between prowess in these combats and the necessary risk of death. These images also allow us easily to identify several categories of gladiators by the offensive and defensive weapons they bear. We can distinguish among others the lightly armed Thracians, with their small, round shields and curved swords; the heavily armored *Hoplomachi*; the *Retiarii* with their nets and tridents; and the *Essedari* and *Equites*, who fought from chariots and on horseback, respectively.

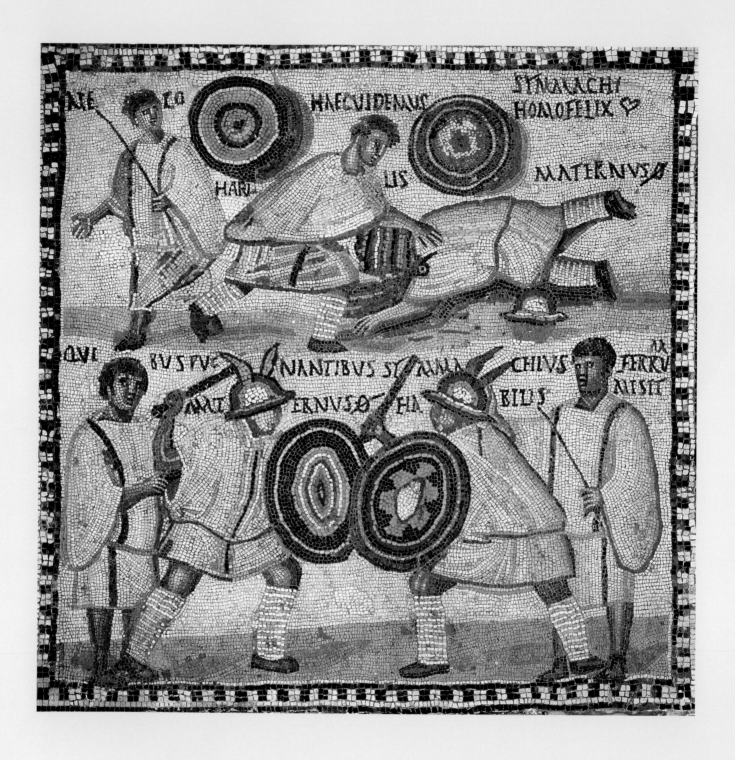

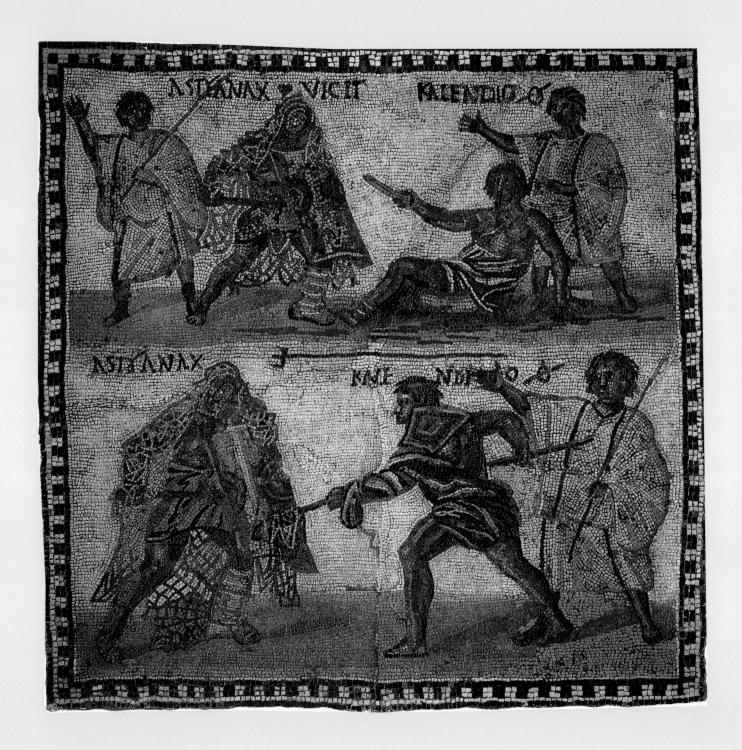

These two lively third-century mosaics
(originally from Rome and now in the
Archaeological Museum, Madrid) illus-
trate with great immediacy the raw vio-
lence and athletic skills of the ancient
gladiators, who were hugely popular
throughout the Roman world.

IV

THE BATHS

A DAY AT THE BATHS

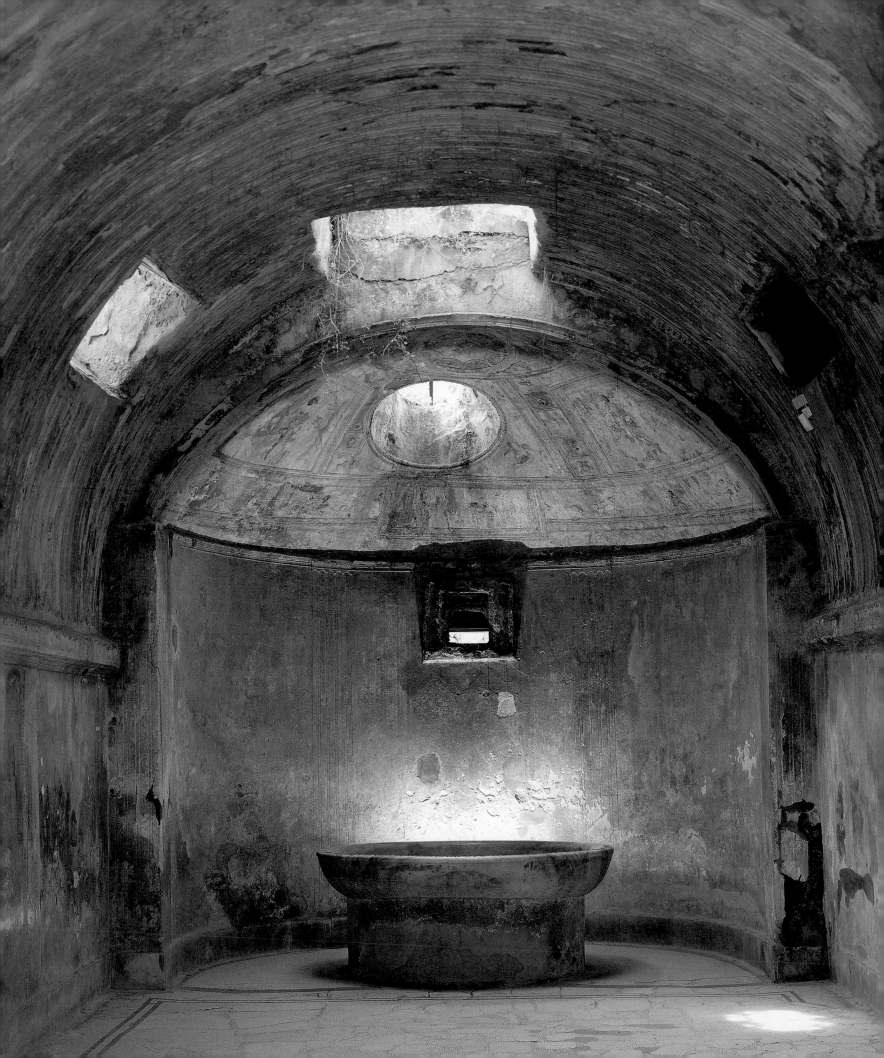

A DAY AT
THE BATHS

The presence of baths in the Roman world, one of the most typical features of its cities, owes much to the influence of Greek culture. Rome's military expansion in the middle of the republican period, beginning in the second half of the third century B.C., brought it into even closer contact with the civilizations of the eastern Mediterranean. The Greek customs of building structures for bathing, and more generally of caring for the body, began immediately to penetrate Roman society and then spread surprisingly rapidly. Washing the entire body was a practice rarely indulged in earlier in Roman history; as Seneca tells us in a famous passage from his *Epistulae morales*, written to his friend Lucilius, usually it happened only nine days a year (86.12). The Latin word for the baths was *thermae*, though they were not necessarily fed by thermal springs, which the Romans loved because they also provided hot water. When visiting the baths became a common practice, the Romans developed a building specifically for the purpose and would thenceforth constantly improve its technology and its architectural design and decoration.

The excavations at Pompeii offer one of the best sources of archaeological information about these bath complexes, in terms of both the evolution of this particular type of public building and the possibility, thanks to their excellent state of conservation, of picturing how they were used on a daily basis. The history of the public baths at Pompeii can be traced in the oldest complex, the Stabian Baths: they were originally constructed in the Samnite period, the third century B.C.; were completed at the end of the following century; and subsequently underwent renovations. The Suburban Baths, built in the middle of the Julio-Claudian period, the first century A.D., were the most technically advanced complex of their time.

The Stabian Baths, originally built as a *palestra*, were laid out around a large, trapezoidal central courtyard surrounded by porticoes housing a number of small

Preceding pages:
Detail of the splendid Fourth Style fresco from the suburban bath complex at Murecine, near Pompeii's Porta Stabia. The fresco belongs to a cycle representing the Muses and is noteworthy for its colors and the quality of its execution.

Opposite page:
The southern end of the men's *caldarium* at the Forum Baths. This thermal complex dates to Pompeii's early colonial period. A marble basin (*labrum*) stands at the center of the room; jets of cold water originally spouted from it.

Two of four semicircular niches in a room in the Stabian Baths. The domed room, originally a *laconicum*, or steam room, was later converted into a *frigidarium*.

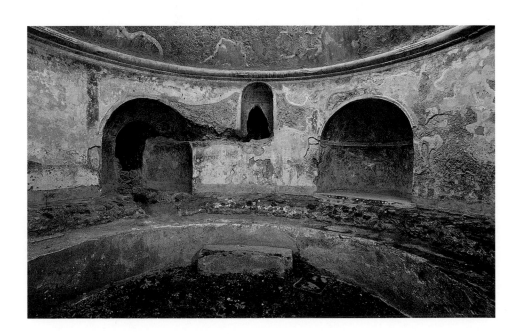

spaces for individual baths. The complex was a few blocks from the Forum, at the intersection of Via dell'Abbondanza and Via di Stabia. It was completely remodeled into a bath complex at the end of the Samnite period, at a time when much of Pompeii's urban fabric was being reworked. Sports activities were always held here, but over time more space was dedicated to bathing, as evidenced by the addition of a large *natatio* on one of the long sides of the courtyard, allowing for swimming in the open air. The baths themselves were added on the side of the courtyard across from the *natatio*. A single system of boilers heated both the water and the air for the two separate sections provided for men and women, each with its own entrance and

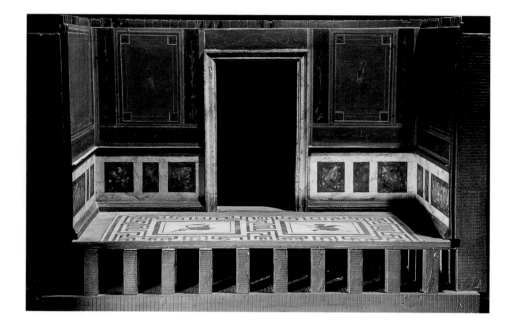

This model, made in the 1930s and now in Rome's Museo della Civiltà Romana, shows how the rooms in the baths were heated. The floor was elevated on short, evenly spaced brick piers (*suspensurae*), which allowed hot air from a boiler to circulate freely in the spaces between. This system was soon improved by the use of *tegulae mammatae*, which permitted hot air to heat the room through the walls as well.

facilities. The way high temperatures were maintained in the specific rooms that required them was particularly ingenious. The heated air circulated in ducts along the walls and beneath the floor, where they were supported on small brick piers called *suspensurae*, invented by Caius Sergius Orata, a clever engineer who worked in Campania at the beginning of the first century B.C. Special tiles with breast-like projections—hence their name, *tegulae mammatae*—served as vents. The section reserved for men was the best maintained. Its airier and more comfortable rooms were laid out in a sequence that began with the dressing room, or *apodyterium*, followed by the *frigidarium*, a round room with a central basin, four semicircular niches, and a conical vault with a central opening to allow light in. The *frigidarium*, which was not included in the women's baths, provided the opportunity to plunge into cold water; in the original, precolonial configuration of the Stabian Baths, the room had been used for steam baths. The *tepidarium* and the *caldarium*, the rooms that followed the *frigidarium*, were meant for warmer baths. The *caldarium* had a pool and a basin, the *labrum*, used to evaporate water to ensure bathers enjoyed a

Opposite:
A series of telamones placed along the walls of the *tepidarium* in the Forum Baths alternate with cubbyholes for the bathers' personal possessions and support the architrave from which the room's barrel vault springs. The vault is elegantly decorated with polychrome stucco reliefs.

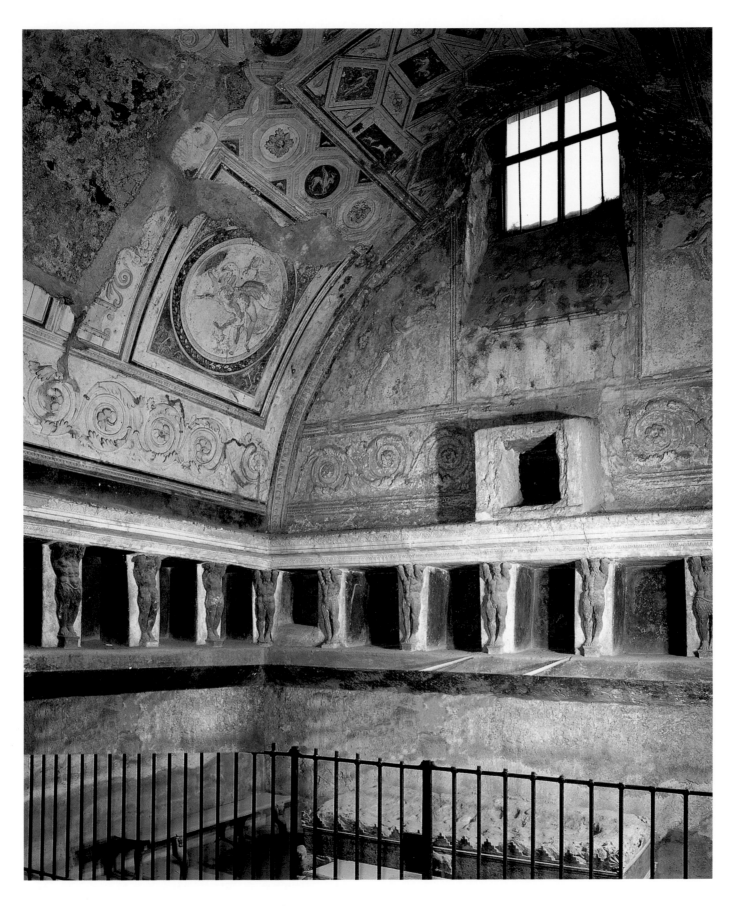

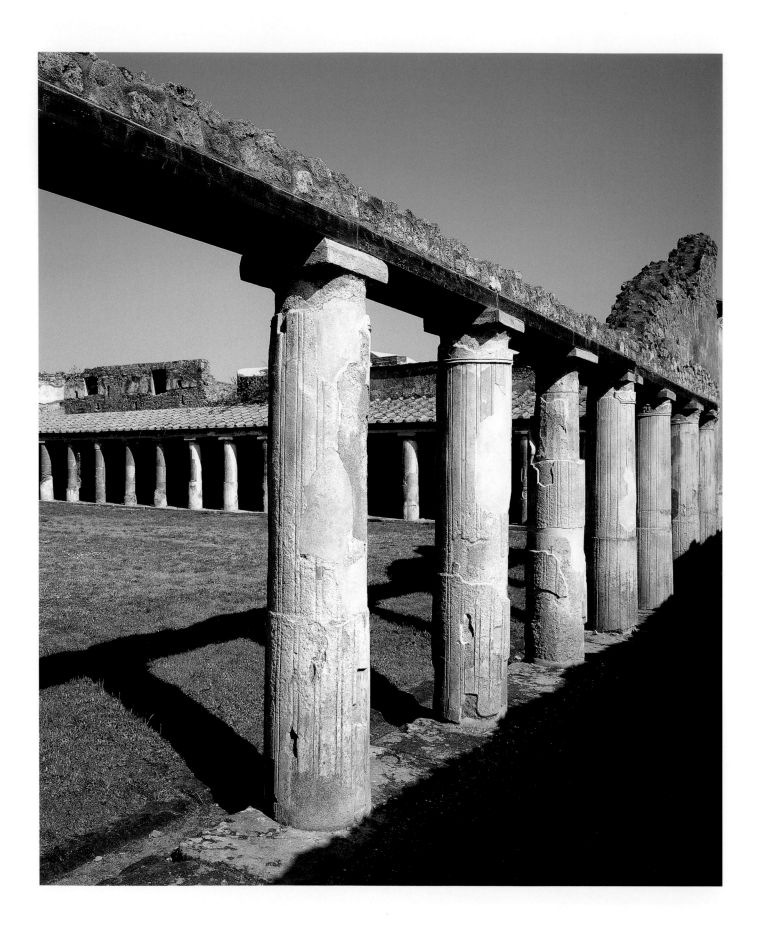

Opposite:
The vast colonnaded courtyard of the Stabian Baths displays Hellenistic influences. It was originally built in the late second century B.C. and renovated several times.

Right:
Plan of the Stabian Baths.

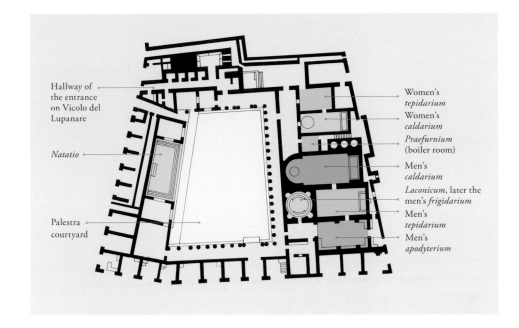

Hallway of the entrance on Vicolo del Lupanare

Natatio

Palestra courtyard

Women's *tepidarium*

Women's *caldarium*

Praefurnium (boiler room)

Men's *caldarium*

Laconicum, later the men's *frigidarium*

Men's *tepidarium*

Men's *apodyterium*

This elegant pyx, with its polychrome glass and gold bands, represents great technical virtuosity. It is from the House of the Four Styles and was most likely made in Aquileia in the Julio-Claudian period.

beneficial sweat. Among the several rooms with specialized functions, the Stabian Baths had a small space where a well and a water wheel, operated by slaves, provided the building's hydraulic system with all the water it required.

The Suburban Baths were located outside the walls but close to the Porta Marina, one of the city's several gates. It displays some interesting differences from the Stabian Baths. One of the most significant was that the separate men's and women's areas were here combined into a single unit. In making their architectural decisions, the planners of this later complex were also clearly more concerned with aesthetic considerations than with purely functional ones. An excellent example of this is the elegant design of the *caldarium*, which had a semicircular apse with large windows that looked out over the surrounding countryside. This feature certainly helped the room retain heat, but at the same time, it was an inspired choice if the goal was to provide a sense of harmony with the natural world around the building. The decorations in the Suburban Baths were particularly sumptuous, confirming a more general tendency toward ornament in architecture. Even so, the sixteen small erotic scenes inserted into the fresco in the *apodyterium* at the Suburban Baths are highly unusual. Perhaps they were meant as a kind of visual or symbolic prelude to the pleasant prospect of attending to the well-being of the body as well as the spirit, a function of the baths implicitly understood by every inhabitant of Pompeii, as by the residents of every city throughout the Roman Empire.

The almost daily ritual of going to the baths was one of the most popular pastimes in the classical period, and one of the easiest on the pocketbook. While the baths were not completely free of charge, a powerful politician looking for easy votes would be "honored" to pay the entrance fees of all bathers for a fixed period of time.

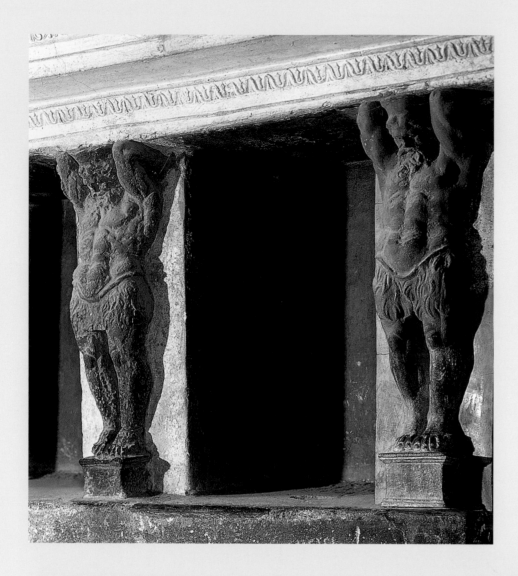

Opposite:
One of the splendid figures of the Muses from the fresco cycle of the Muses discovered at the complex at Murecine.

Detail of the refined terracotta decoration of about 80 B.C. at the Forum Baths. The telamones ran along the walls of the *tepidarium*.

Detail of the famous erotic frieze from the *apodyterium* of the Suburban Baths. Most likely executed during Nero's reign, it is in effect an illustrated handbook of sexual positions, perhaps inspired by similar subject matter in literary works such as Ovid's *Ars amatoria*.

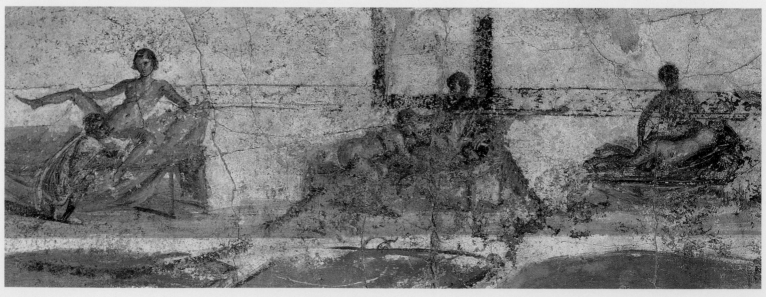

Usually the baths opened about midday and closed at nightfall, though some were open in the morning or evening. Even leaving aside the segment of the population that could afford private facilities, class differences were readily apparent inside the baths, since the better-off were usually surrounded by a group of attendants who furnished a variety of necessities, such as massages, depilation, or anything else associated with immersing oneself in water. The Romans had the habit of alternating between baths of different temperatures, a practice now almost entirely lost. With some exceptions: this principle of health and hygiene is still followed in some places, such as the famous baths of Budapest—called Aquinum in Roman times—and seems to offer genuine psychophysical benefits.

Going to the baths was also a way for people to spend their leisure time, allowing them to do a variety of things beyond the simple pleasure of bathing. Social relationships were strengthened at the *thermae*; one could exercise, have refreshments, get one's hair cut and styled, and engage in other activities that constituted the real appeal of spending time at the baths. The flip side of the coin, as Seneca tells us in a famous passage in one of his letters to Lucilius (56), was chaos, a constant din, and noises of every kind, and all this must also have been a real part of the experience of these incredibly popular establishments.

Opposite:
The exquisite execution of the architecture of Campanian bath complexes is evident in the bold cupola of the first-century Baths of Mercury at Baia.

Following pages:
Herculaneum also boasted well-designed and -constructed baths. This Julio-Claudian mosaic representing a Triton with a rudder, a cupid with a whip, and a variety of sea creatures decorated the women's *apodyterium* at the city's Forum Baths.

Although they were unfinished at the time Vesuvius erupted, the Central Baths were undoubtedly Pompeii's most technologically and architecturally advanced thermal complex. This view of the courtyard, for example, shows the series of large windows designed to let in a great deal of natural light.

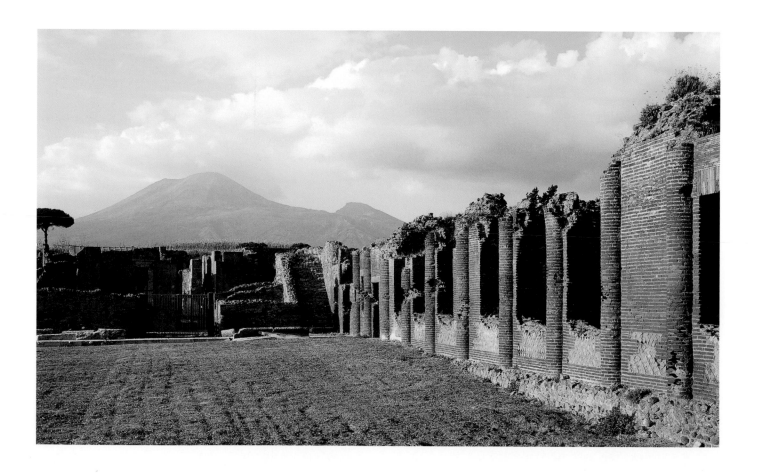

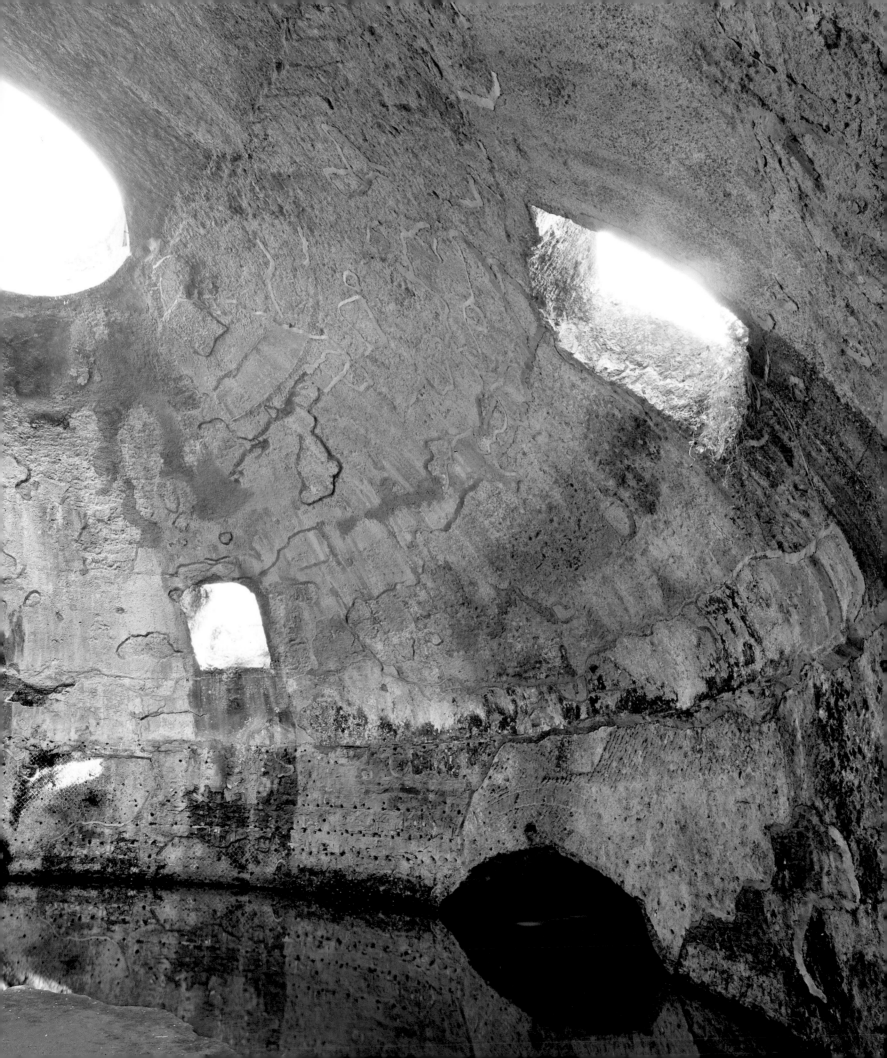

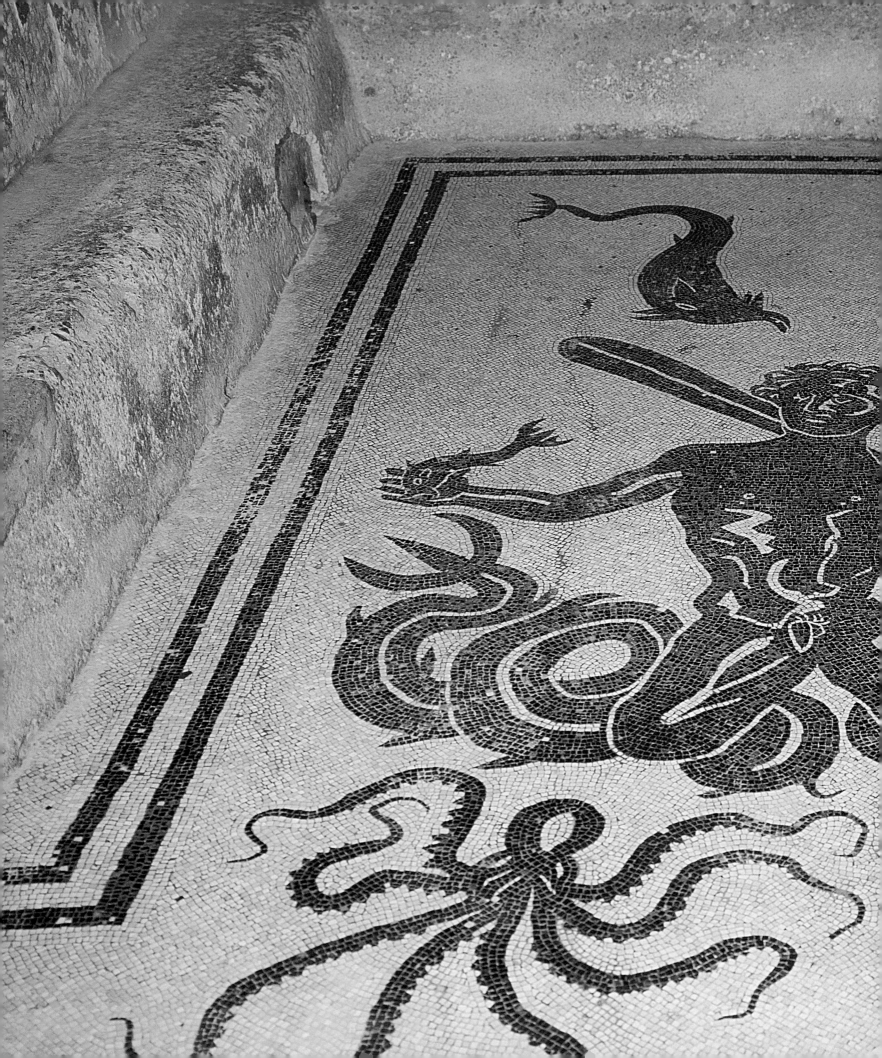

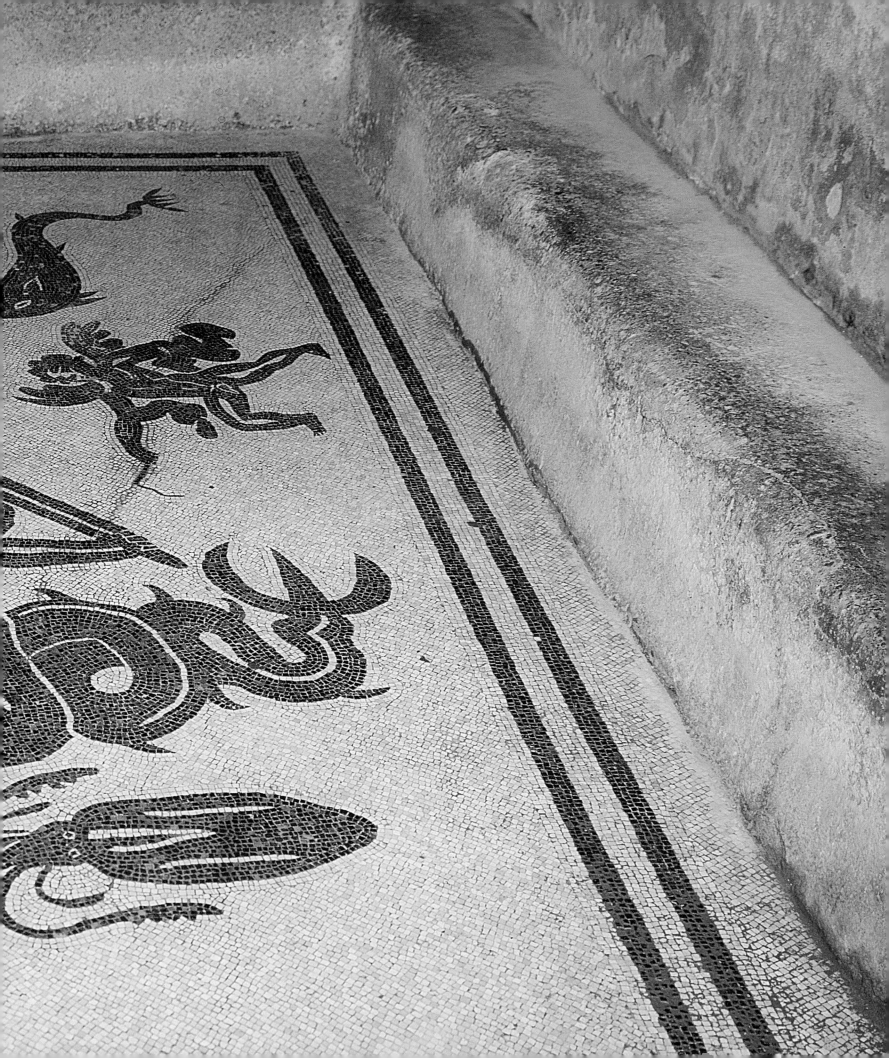

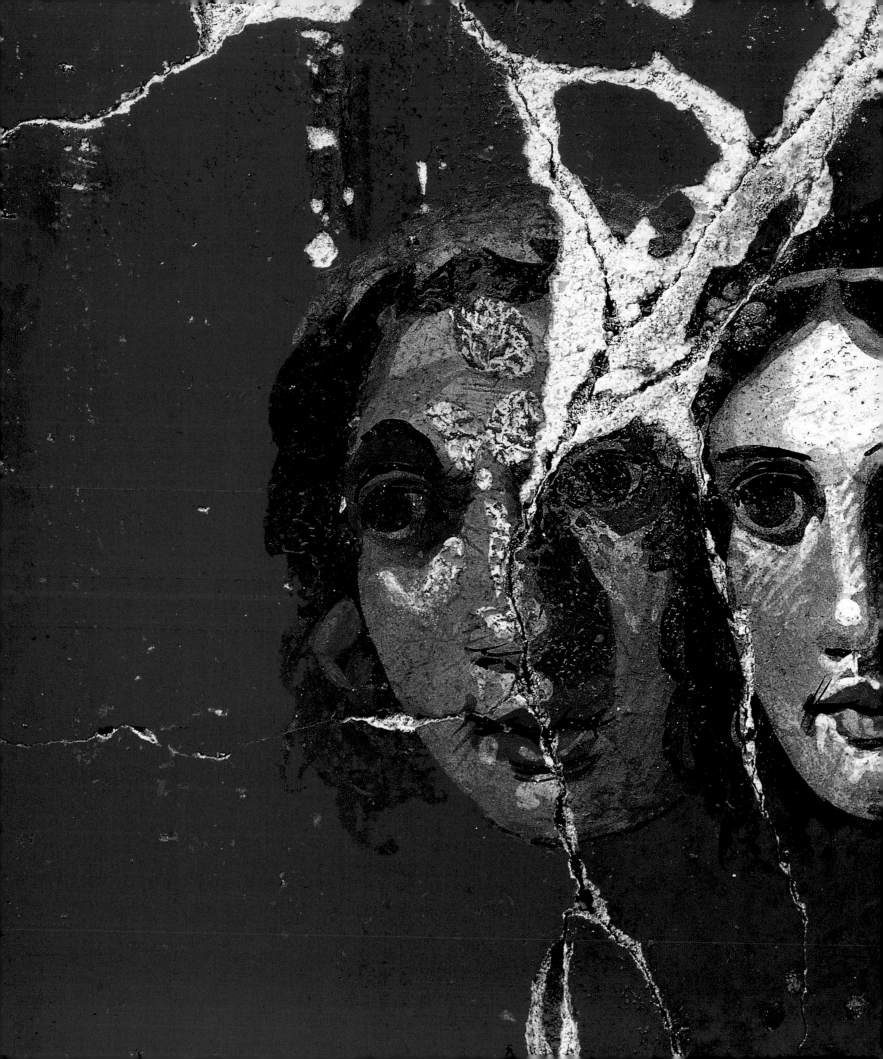

V

THE
THEATERS

THE THEATER AND
ITS GENRES

MUSIC IN DRAMATIC
SPECTACLES AND IN
EVERYDAY LIFE

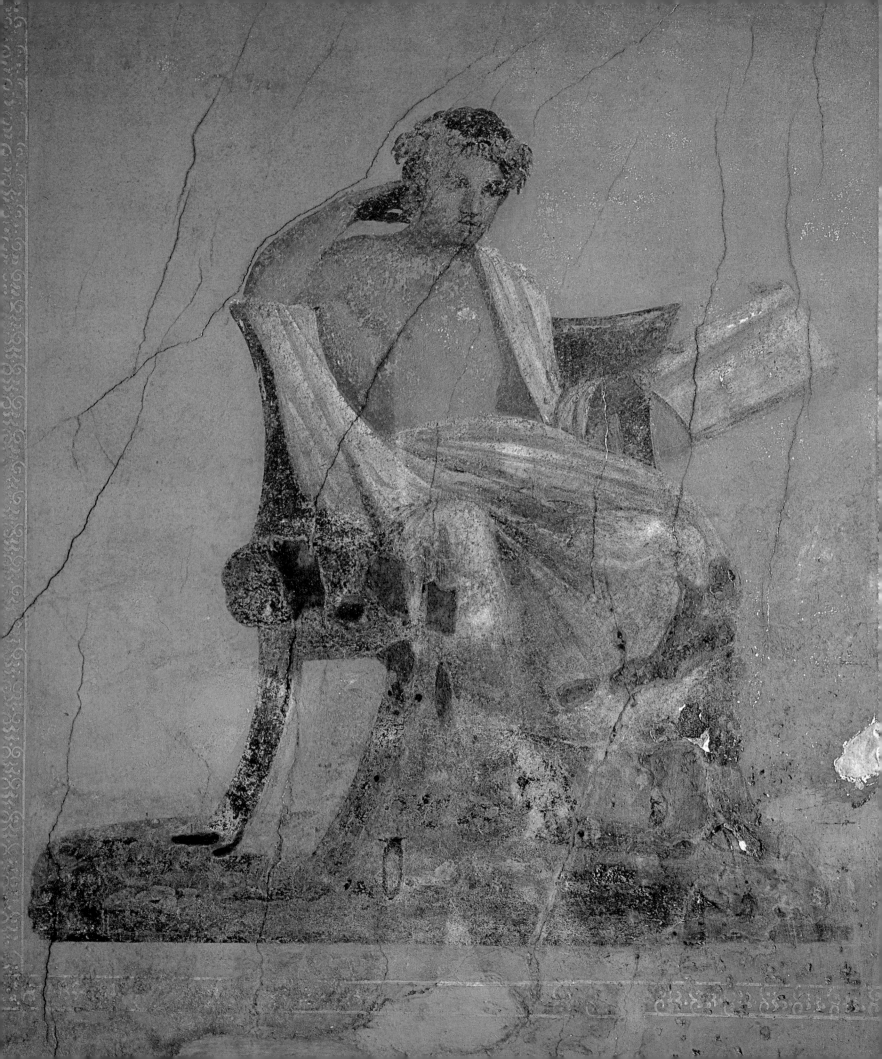

THE THEATER AND ITS GENRES

Preceding pages:
Fresco of a pair of female theatrical masks in a room at the House of the Golden Bracelet.

A Second Style mosaic image of a mask, from the House of Ganymede and dating to the late second century B.C.

Opposite:
This portrait of the Athenian playwright Menander (late fourth century B.C.), seated in a meditative pose and holding a scroll, dates to the late Julio-Claudian period. It gave its name to the sophisticated house where it was found, in a niche in the peristyle. The painting attests to the enduring interest in Greek theater on the part of Romans of the imperial period; it had already been an important inspiration in the republican period on Latin-language authors such as Plautus and Terence.

Friedrich Nietzsche's *Birth of Tragedy* (1872) is a controversial work, but his ingenious theory about the origin of Greek tragic theater is of primary importance in the debate over this question. His view is that this fundamental form of cultural expression and especially its origins are closely related to the cult of Dionysos and its fertility and regeneration rites. That the original religious roots of theater were never wholly forgotten in antiquity is demonstrated by a specific type of structure—the temple-theater. According to Filippo Coarelli's recent brilliant observations, there was one of these at Pompeii, an Archaic Doric temple. The Large Theater, built at the end of the third century B.C. and later added on to, and the nearby Odeon, constructed in the colonial period, were closely related both functionally and culturally to the temple noted by Coarelli. The middle-to-late-period Samnite designers of the theater area—certainly inspired by their close ties with Greek culture—underscored its relationship with the older temple by connecting them via a long staircase, still visible even though part of it was destroyed during the restoration work that followed the earthquake of A.D. 62. These stairs allowed the development of solemn sacred processions (*pompa*), which further highlighted the religious and ritualistic dimensions of theatrical spectacles. Such processions must have started at the sacred precinct of the Doric temple and then proceeded to the stage of the Large Theater.

But what sort of theatrical entertainments did the ancient residents of Pompeii attend? The abundant frescoes and reliefs of theatrical subjects that appear in a number of Pompeian houses of various social classes offer us some idea of what was produced in that long-ago time. A famous marble relief from the House of the Golden Cupids includes representations of masks from tragedy, comedy, and satyr plays, as well as musical instruments. Judging from these, we might certainly argue that Pompeians, following normal practice in the ancient world, went with equal enthusiasm to different kinds of dramatic productions—tragedies by Greek authors and by Latin tragedians such as Nevio and the more popular Seneca; comedies; and satires.

In terms of the comic genre, works by the Athenian author Menander, the founder of New Comedy who lived at the end of the fourth century B.C., were especially popular in Pompeii. His plays were comedies of manners that mirrored everyday events in the lives of the Greek middle class. There is a famous painted portrait of this great Attic comedic writer in a luxurious Pompeian house, which, because of this picture, is named after the playwright. In the painting, Menander is seated on a throne, crowned with laurel and holding a scroll with an inscription recording his role as the founder of the New Comedy genre. It is not surprising that in addition to the oeuvre of this clever Greek author, the works of several Roman comic writers, including Plautus and Terence, were often produced at Pompeii.

Ancient satire was closer to what we think of today as farce. Ancient Campania, the region of Naples and Pompeii, was the home of Atellan farce as early as the middle of the republican period. This specialized form of popular satire features fixed types and recurring characters such as the Villain, the Glutton, the Gold Digger, and others, and such productions must often have provided great entertainment to audiences in ancient Pompeii. By the late republican and early imperial period, Atellan farces began to replace mime and pantomime. In the former, actors performed without masks and followed scripts that lent themselves to rich improvisations that included vulgar jokes, sharp-witted banter, and even political allusions. By contrast, pantomime was a sort of silent performance that relied entirely on a single actor's gifts for mime and dance; it was accompanied by music and portrayed subjects that were almost always comical or licentious. Sometimes a second actor might come out with the protagonist to narrate what was being represented on the stage so that its meaning was clear to the audience.

Opposite:
Pompeian frescoes very often include scenes inspired by the theater. Here, an actor is portrayed preparing to go onstage; the mask he is being brought indicates he is playing a tragic role.

This Fourth Style marble bas-relief found in the peristyle of the House of the Gilded Cupids shows a group of theatrical masks—tragic, comic, and satyric—as well as a lyre and panpipes, musical instruments that accompanied the action onstage.

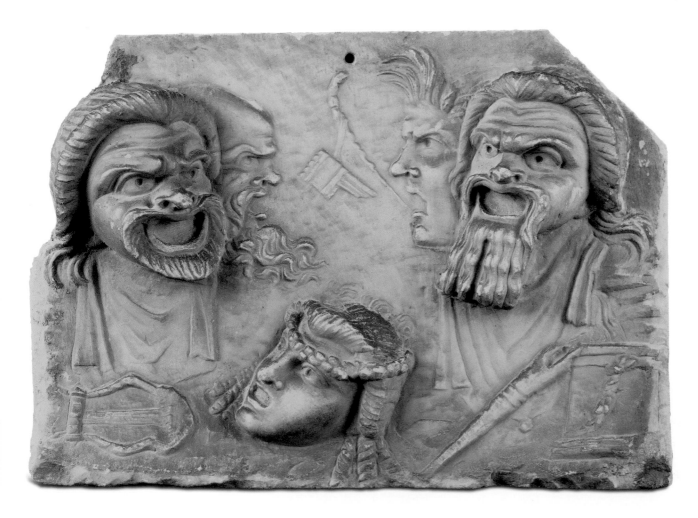

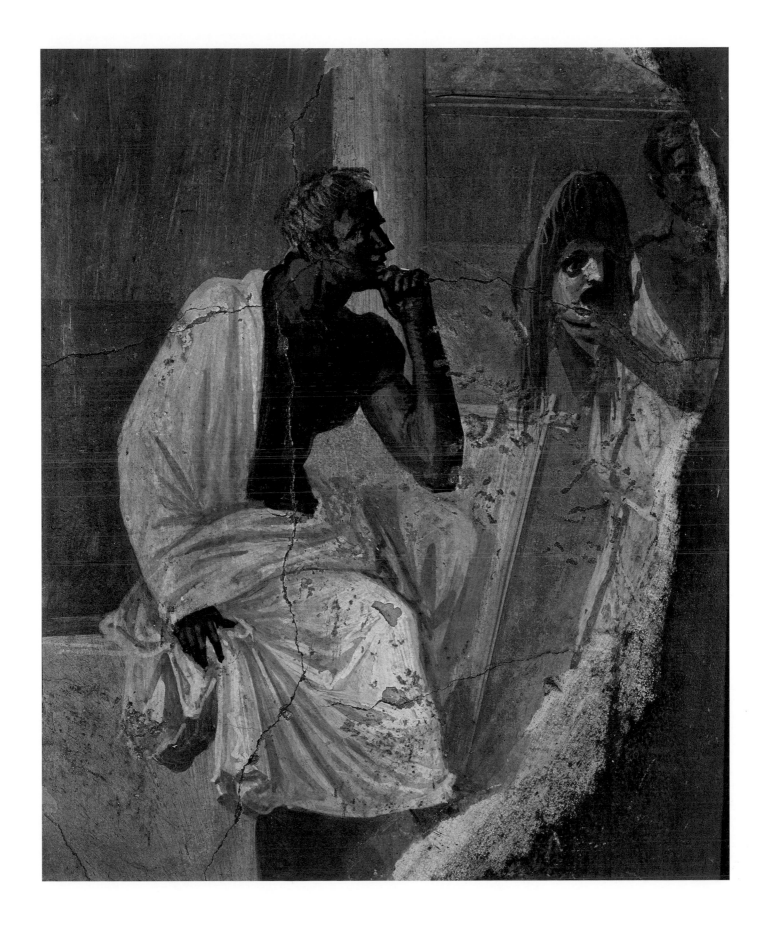

Plan of the Large Theater in Pompeii.

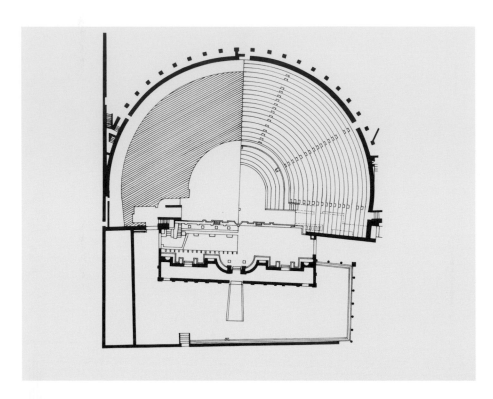

Below:
The impressive ruins of the Large Theater at Pompeii, with its canonical Hellenistic-period organization: a *cavea* (steps for the audience), orchestra (originally the area for the chorus, later radically transformed, along with its function), and the stage and wings.

Opposite:
A Second Style fresco representing a theatrical mask discovered at the villa at Oplontis that belonged to Poppaea Sabina, wife of the emperor Nero.

Pages 96–97:
A Fourth Style marble bas-relief found in the peristyle of the House of the Gilded Cupids depicts a group of theatrical masks. The relief is especially interesting for the refined play of perspective deriving from the varied depths of the sculptural planes.

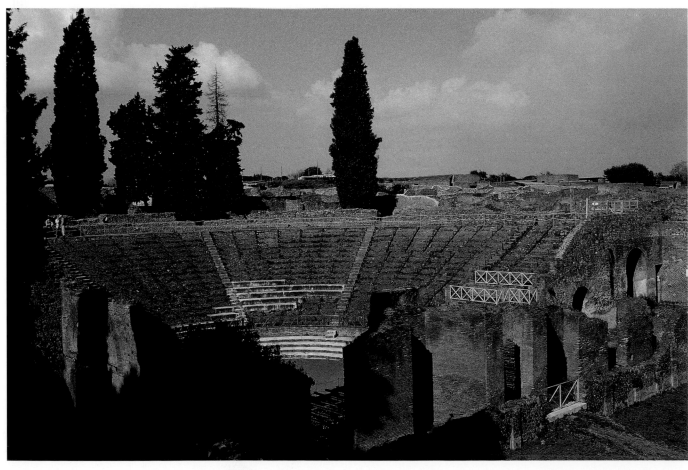

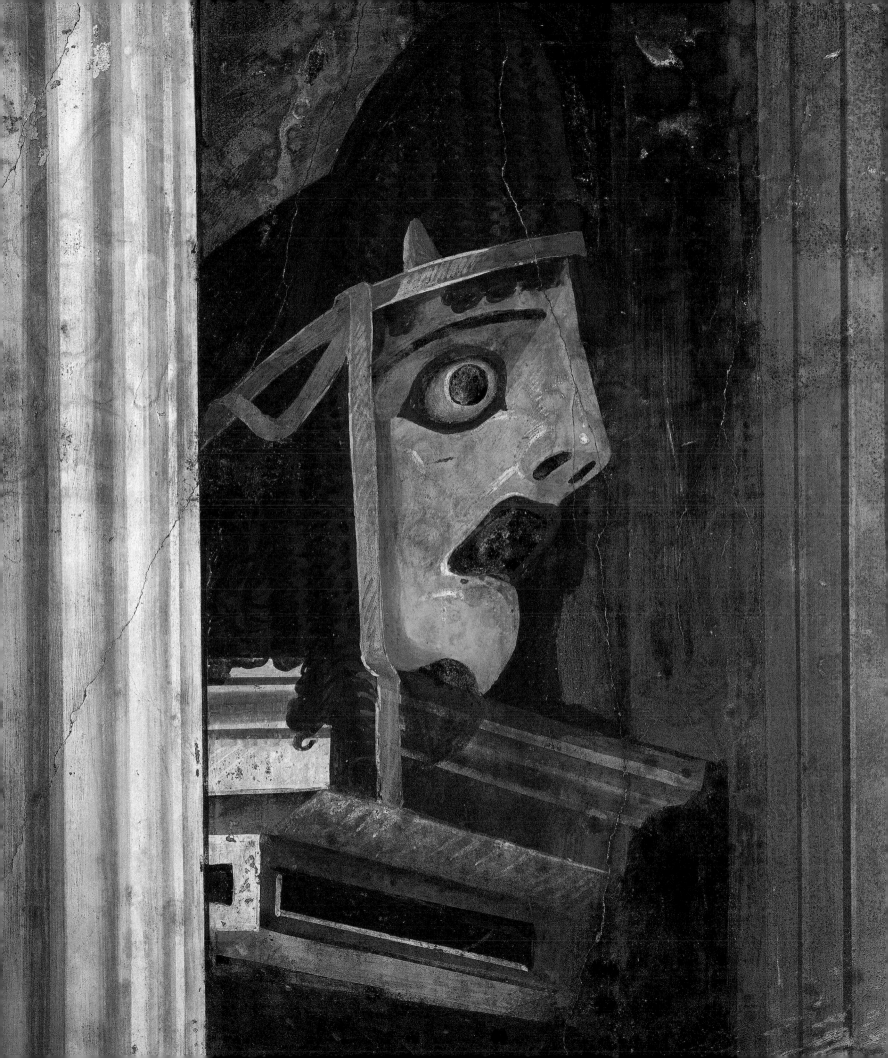

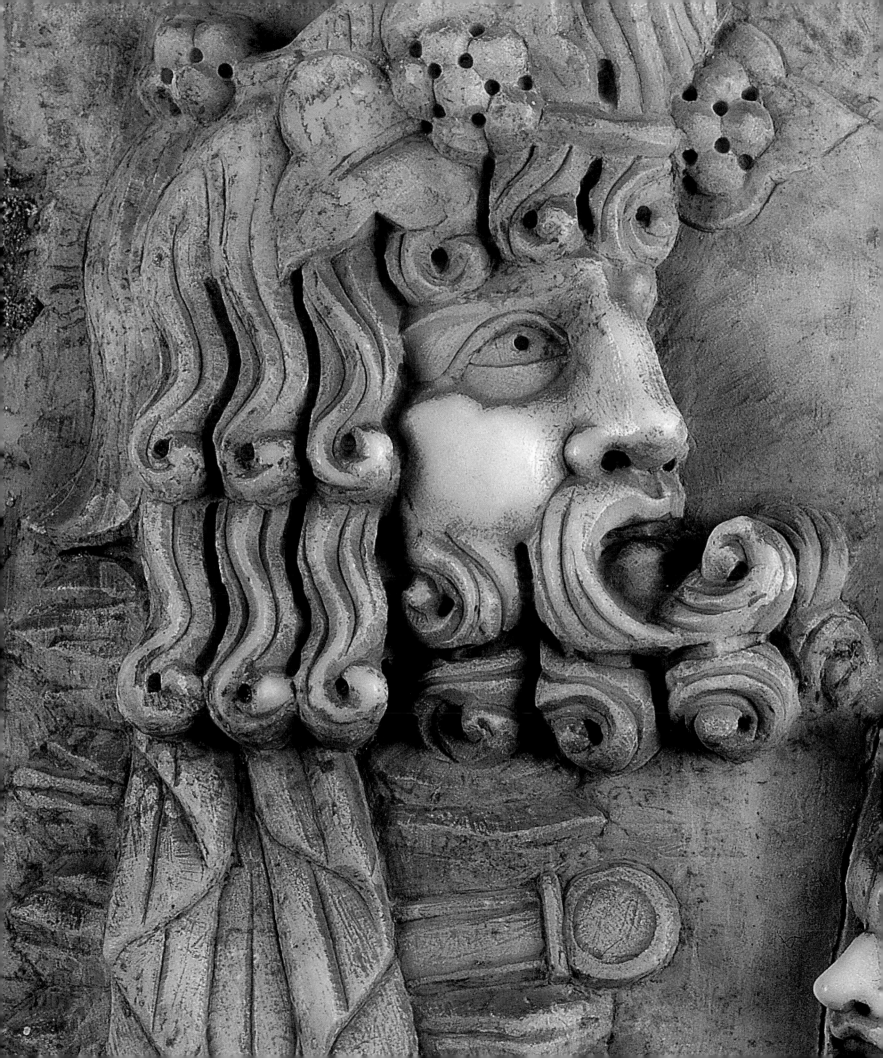

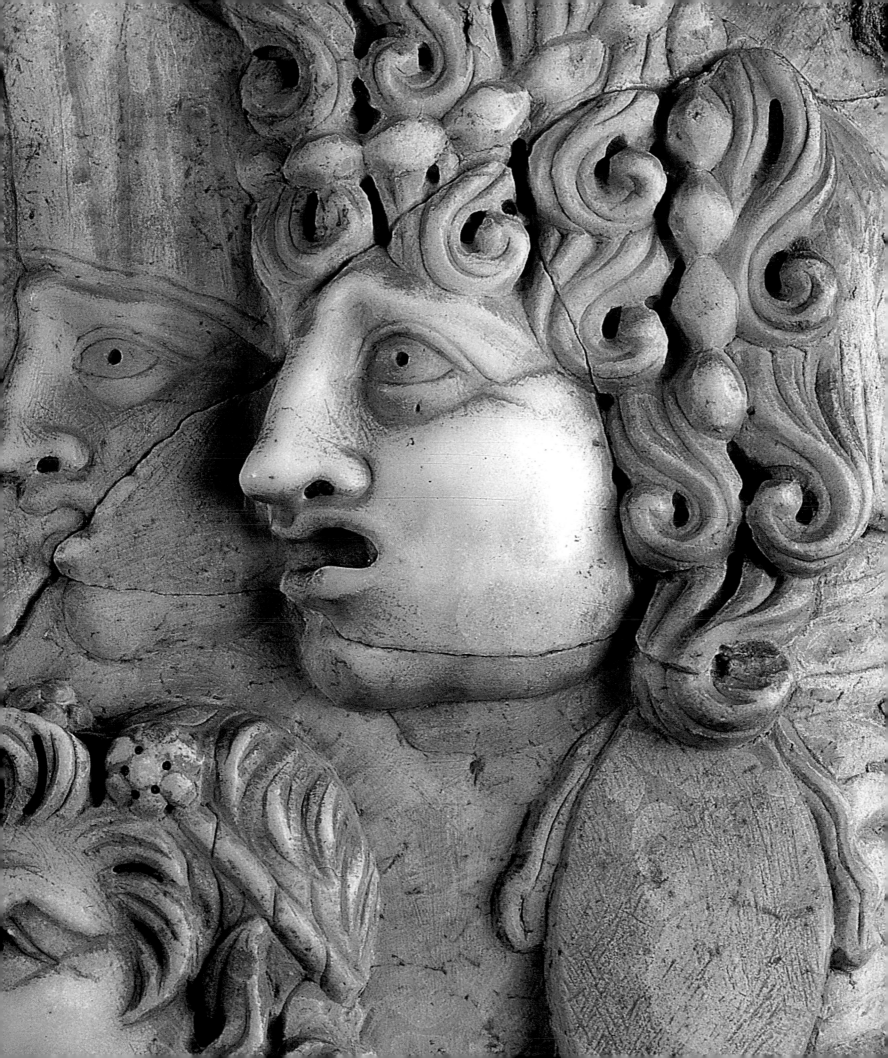

One of two vigorous kneeling telamones, carved from tufa and placed at the ends of the walls defining the *cavea* at the Odeon, or Small Theater.

The Odeon was built in the early colonial period. As the inscriptions, which are still in place, tell us, it was covered, primarily in order to provide good acoustics. It was, in fact, designed specifically for poetry and music recitals. The roof was most likely supported by the perimeter walls defining the *cavea*. Like the Large Theater, the Odeon had an *ima cavea*, the steps of which were lower and wider to allow for the *bisellia*, the chairs reserved for the decurions. There are kneeling telamones at the ends of the walls around the *cavea*.

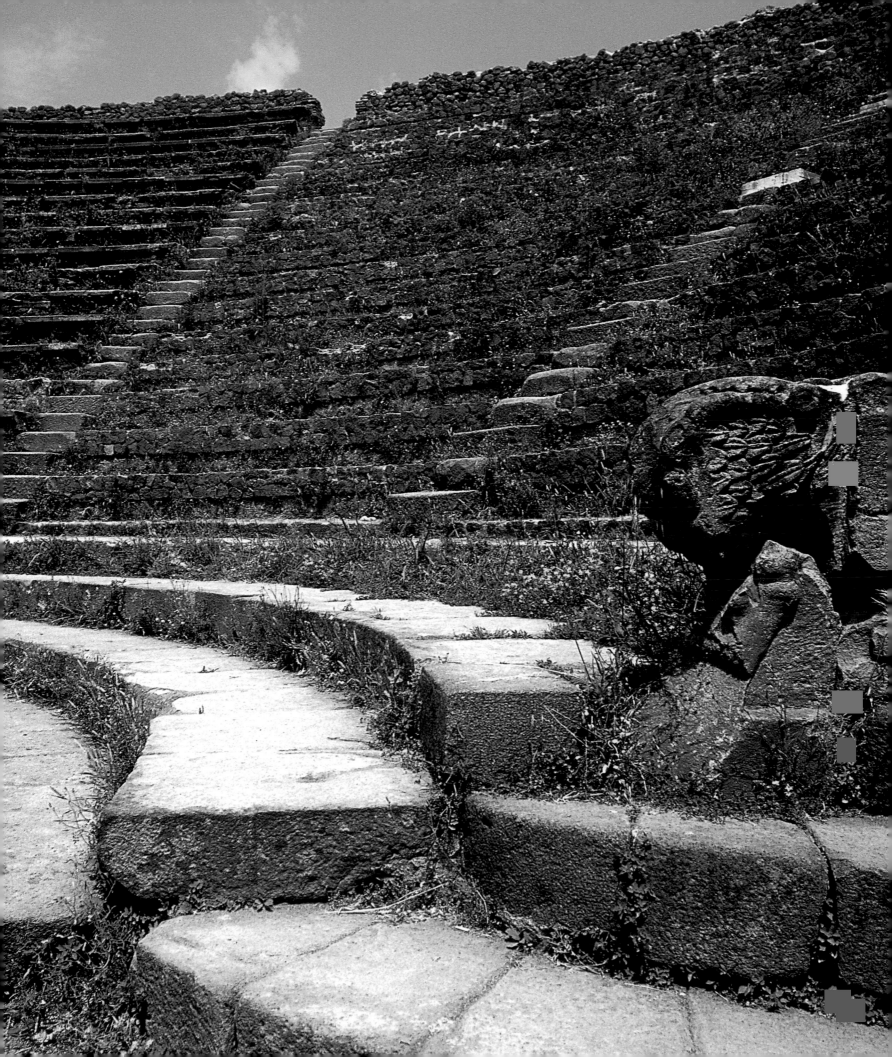

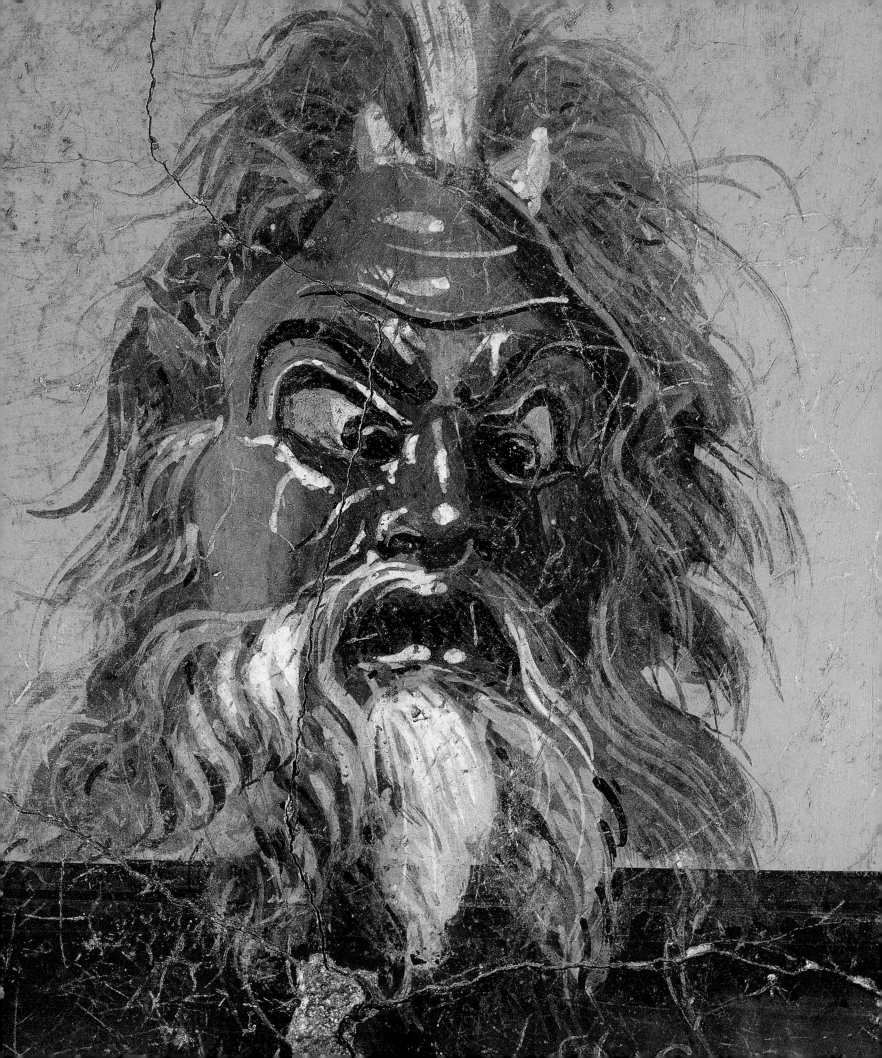

MUSIC IN DRAMATIC SPECTACLES AND IN EVERYDAY LIFE

As we have seen in the case of pantomime, music played much more than a supporting role in theatrical productions. This is true not only of pantomime but of the entire range of stage performances. We know that tragedies and comedies called specifically for musical interludes, and some scenes also included singing. The roofed Odeon was constructed during the colonial period at Pompeii specifically to host musical performances and poetry readings, the latter of which were also normally accompanied by instrumental music.

Nor should we imagine that music at Pompeii was limited to theatrical productions. In gladiatorial contests, for example, the powerful sounds of a water organ and the insistent invitation of flutes spurred on the combatants. Small orchestras often played at private parties such as banquets, introducing each important moment of the feast. Although meant to enliven the event, they sometimes, as Martial noted in passing (*Epigrams* 9.77.5), only served to annoy the guests. In his extraordinary comedy of manners describing a dinner party given by Trimalchio, a wealthy freedman, to show off his status with shameless impudence, Petronius emphasized that the master of the house made his entrance at the party accompanied by bombastic music. He then described how the meat was served, "and the servant who was to do the carving appeared immediately. Timing his strokes to the beat of the music he cut up the meat in such a way as to lead you to think that a gladiator was fighting from a chariot to the accompaniment of a water-organ" (*Satyricon* 36.6). Small troupes of musicians and dancers not infrequently performed at more humble inns, where they would have entertained patrons with pleasant—and sometimes, perhaps, not-so-pleasant—music.

Opposite:
A fresco with a theatrical mask from Pompeii, now in the National Archaeological Museum in Naples.

Musical instruments used in cult celebrations—especially Eastern ones—and in theatrical productions. The sistrum (*near right*), discovered in the Temple of Isis, would have produced rhythmic, intensely hypnotic sounds. The panpipes, a wind instrument, were cast in bronze and decorated.

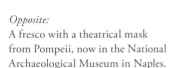
ST. JOHN THE BAPTIST PARISH LIBRARY
2920 NEW HIGHWAY 51
LAPLACE, LOUISIANA 70068

Bronze cymbals from Pompeii. These musical instruments were used mostly in Eastern cult rites.

A colorful mosaic from the Villa of Cicero in Pompeii shows a jubilant group of strolling musicians. Although signed by Dioskourides of Samos, it is undoubtedly a late-second-century-B.C. copy of a third-century-B.C. original.

Following pages:
A mosaic from the House of the Tragic Poet represents preparations for a satyr play. The actors and musicians are about to go onstage.

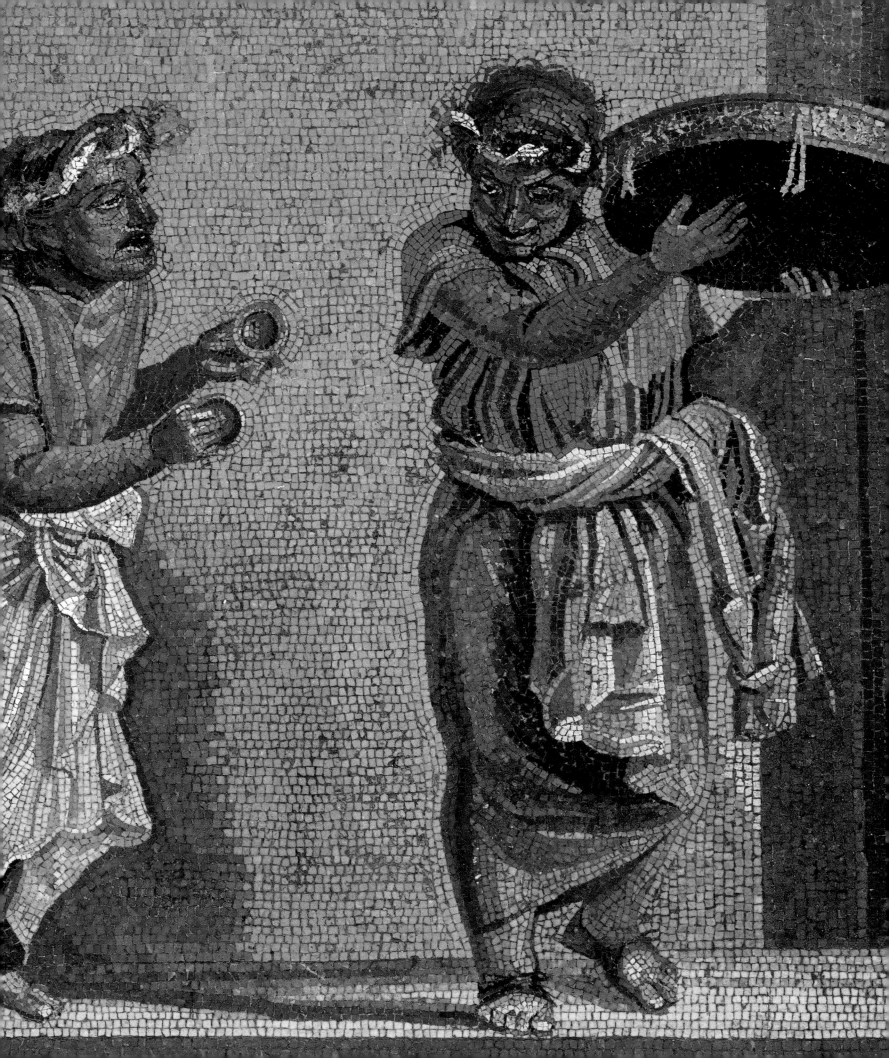

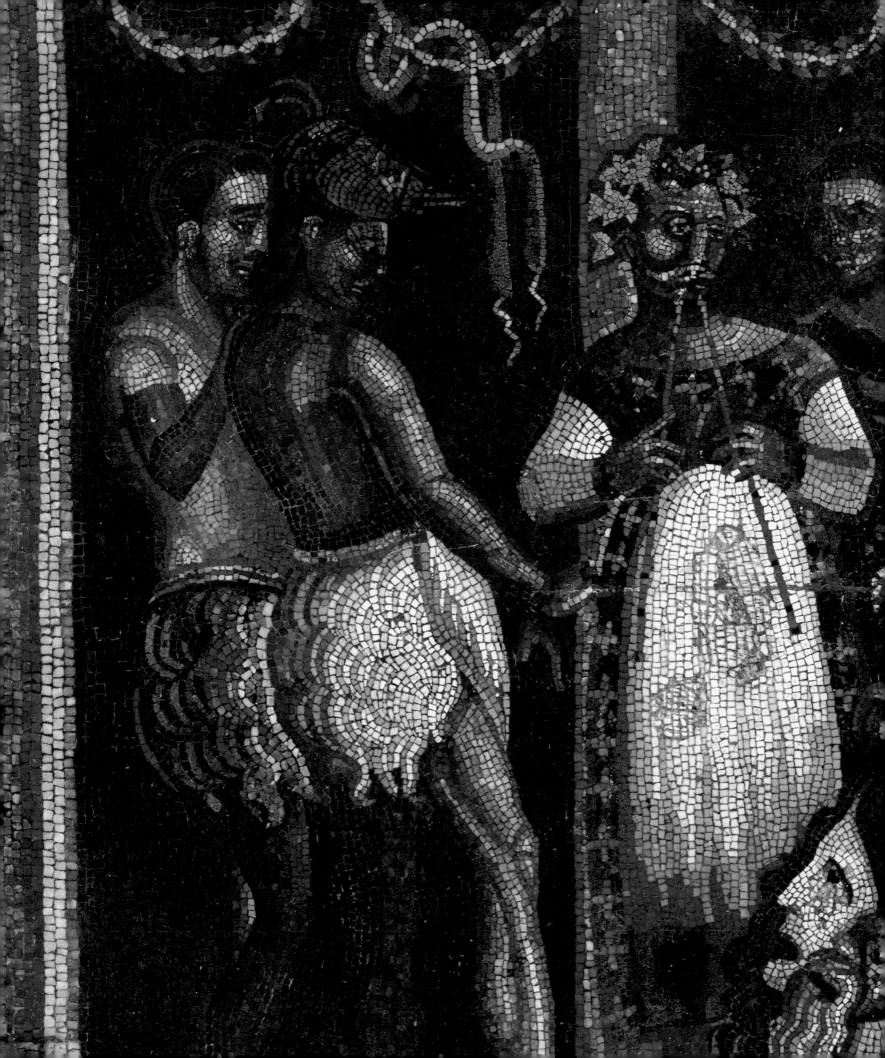

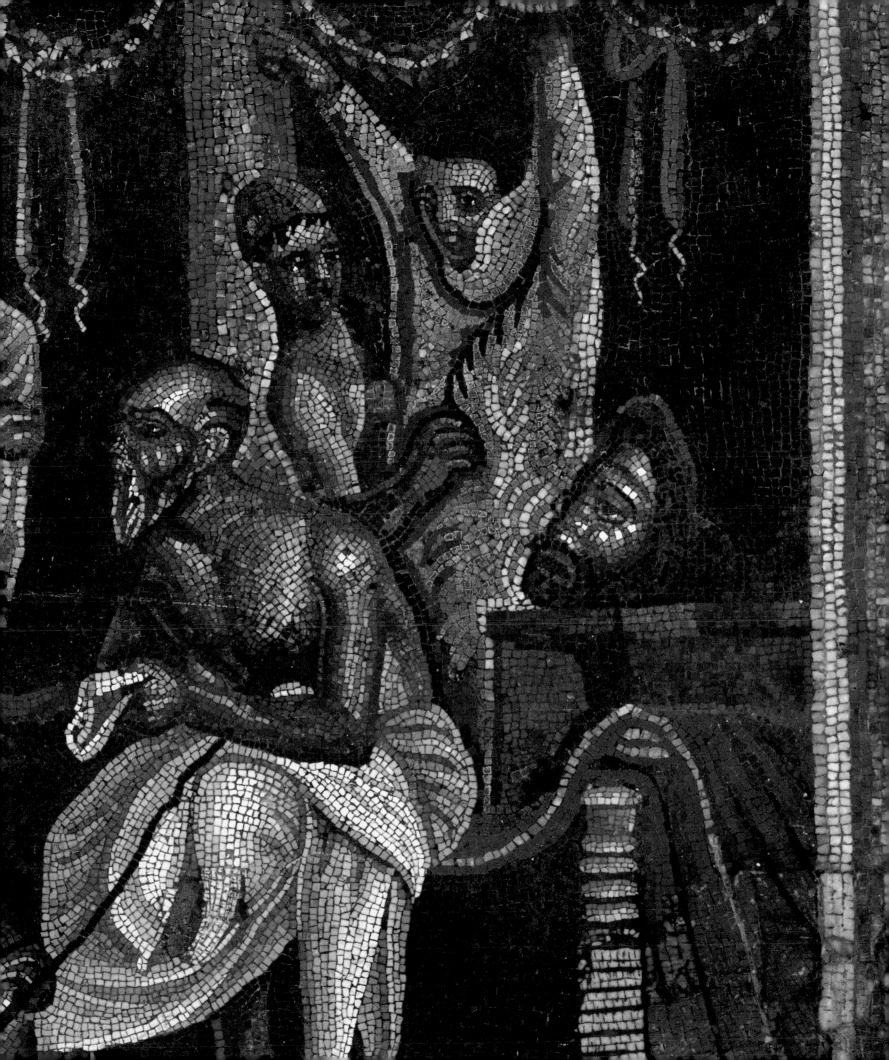

VI

THE MARKET, SHOPS, AND TAVERNS

THE MACELLUM IN
POMPEII, AN EXAMPLE
OF A MULTIUSE
BUILDING

SHOPS, COMMERCE, AND
ARTISANS' WORKSHOPS

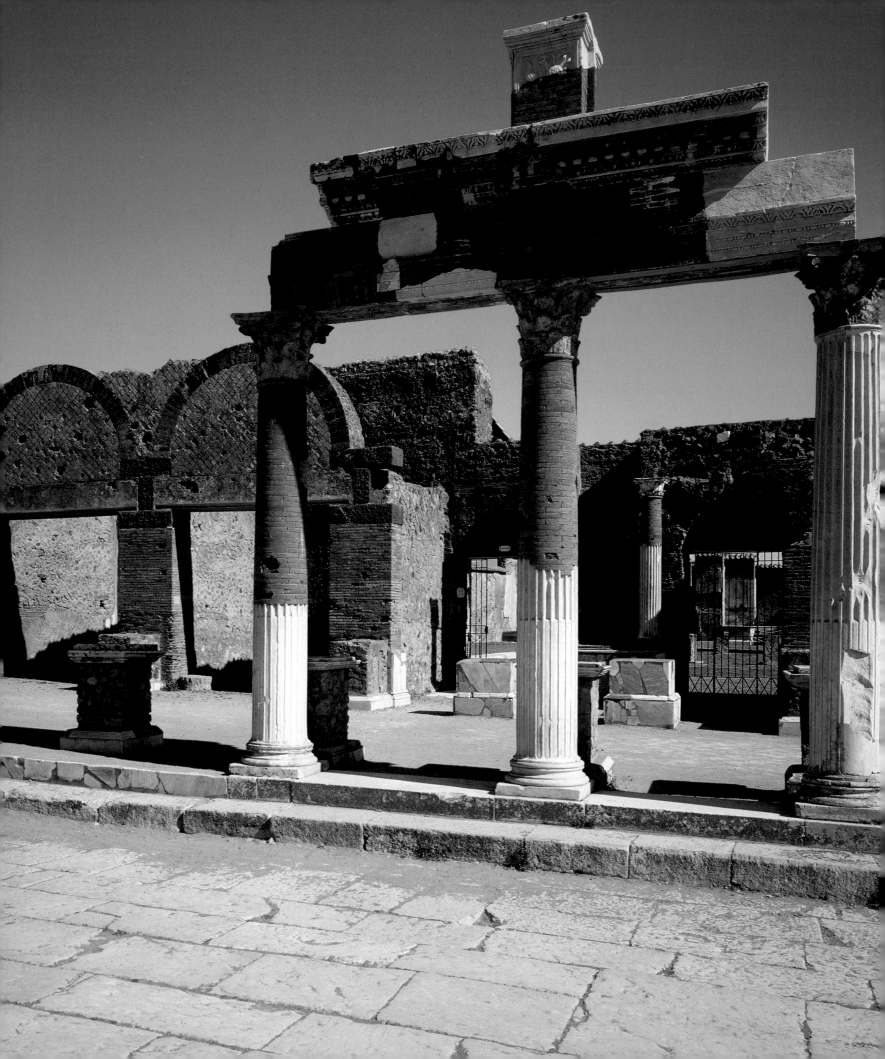

THE MACELLUM IN POMPEII, AN EXAMPLE OF A MULTIUSE BUILDING

Until the latter part of the Samnite period, food shopping in Pompeii was done in the vast open space of the Forum. There were many shops there, though traces of them are now found only in the deepest excavation trenches at the site. The construction of the Macellum profoundly altered the way people did their shopping for food and other necessities. Located at the northeast corner of the Forum but physically separate from it, the Macellum was a large commercial space distinguished by the chaotic activity that took place there on a daily basis. The place must have been filled with the shouts of shopkeepers relentlessly hawking the merchandise on their counters, answered by customers offering what they thought was fair and arguing about prices and the quality of what they were buying.

Three sources give us an idea of what was sold in and around the Macellum for at least two centuries, until the building was badly damaged by the earthquake of A.D. 62. They are an analysis of the building's supporting walls, the archaeological evidence gathered in its gutters or in the spaces once occupied by the shops, and the series of refined paintings, unfortunately only incompletely preserved, that decorated the Macellum's interior. The heart of the complex was a large circular structure, conventionally called a *tholos*, with fountains; it stood at the center of a broad open area. The large quantity of fish scales found in its drains tells us that this part of the Macellum was used to clean and prepare the fish to be sold in the market, an

Preceding pages:
A polychrome glass cup.

Opposite:
The entrance into the Macellum, the city's fish and meat market, is flanked by shops and sheltered on the Forum side by colonnaded porticoes. The porticoes were originally two stories high and decorated with commemorative statues, of which only the bases remain.

A detail from one of the frescoes that embellish the rooms of Poppaea's villa at Oplontis. Still lifes were as popular in Pompeii as they were throughout the rest of the Roman Empire. The objects portrayed, however, were not limited to fruit but could include other foods, such as fish or game.

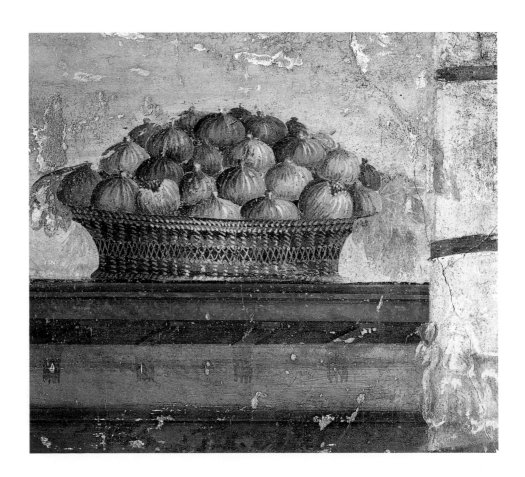

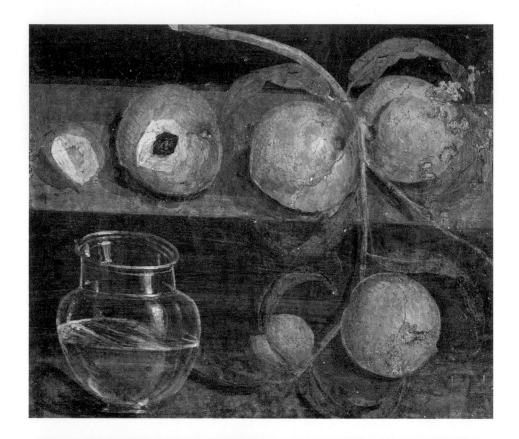

A Fourth Style still life with a glass pitcher from Pompeii.

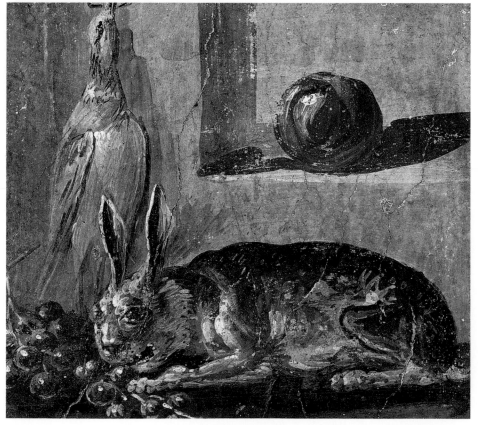

A Fourth Style still life set in a kitchen, with crockery, dried fruit, and, below, a rabbit.

Opposite:
The interior of the Macellum with the scant remains, in the foreground, of the central tholos. It originally housed a fountain that was especially useful to fishmongers.

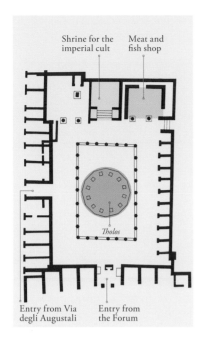

Shrine for the imperial cult Meat and fish shop

Tholos

Entry from Via degli Augustali Entry from the Forum

Plan of the Macellum.

activity that took place in a different area, that is, the large room at the southeast corner of the building. That room had a horseshoe-shaped counter divided into two distinct areas, one, provided with extra plumbing, where fish was sold and the other where meat was purveyed.

Ancient shoppers at the Macellum could also purchase a huge variety of other foodstuffs; excavations have revealed the remains of chestnuts, figs, grain, lentils, grapes, bread, and pastries, as well as animal bones. The building, in fact, had multiple uses, and its wide variety of shops was able to satisfy the needs of customers who came there daily. Some of the wall paintings that decorated the Macellum make reference—albeit in mythological guise—to the range of merchandise for sale in the hall. These works were executed in the late Julio-Claudian period and include still lifes that, had they been known at the time, would have delighted seventeenth-century European art lovers. The artists' quick brushstrokes capture the sense of changing light, while the murals presented an alluring array of chickens, fish, fruit, and other foods to the viewer/shopper at the Macellum. It is not too far-fetched to suggest that these pictures, representing the same rural land- and seascapes from which the real merchandise came, were painted to further urge by subtle persuasion the existing predisposition to shop.

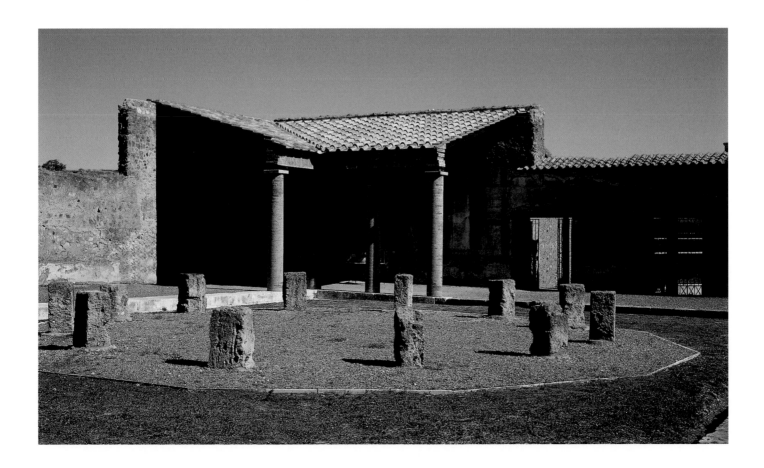

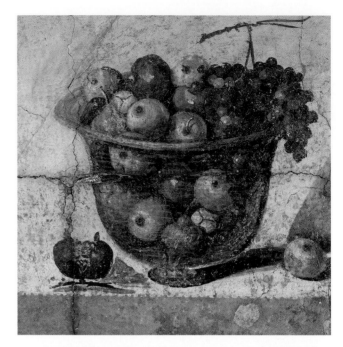

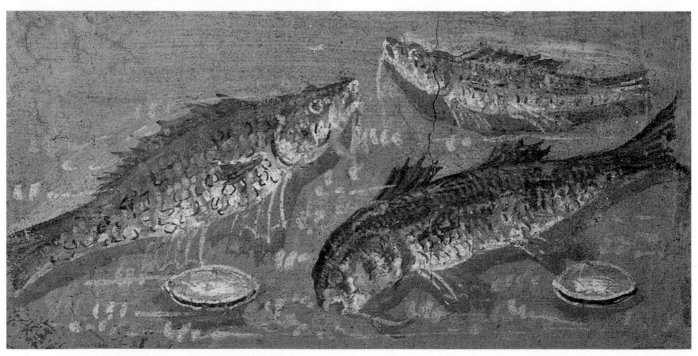

Top:
Fresco still lifes from Pompeii. Meat and fish were sold in the Macellum, along with vegetables and other foodstuffs.

Above:
A still life with fish celebrates the home owner's wealth and the opulence and abundance of his table.

Opposite:
This striking example of Second Style wall painting with a gastronomical subject comes from the Insula Occidentalis. It represents two deer and a bag of ducks, all captured alive and destined to be enjoyed at a lavish meal.

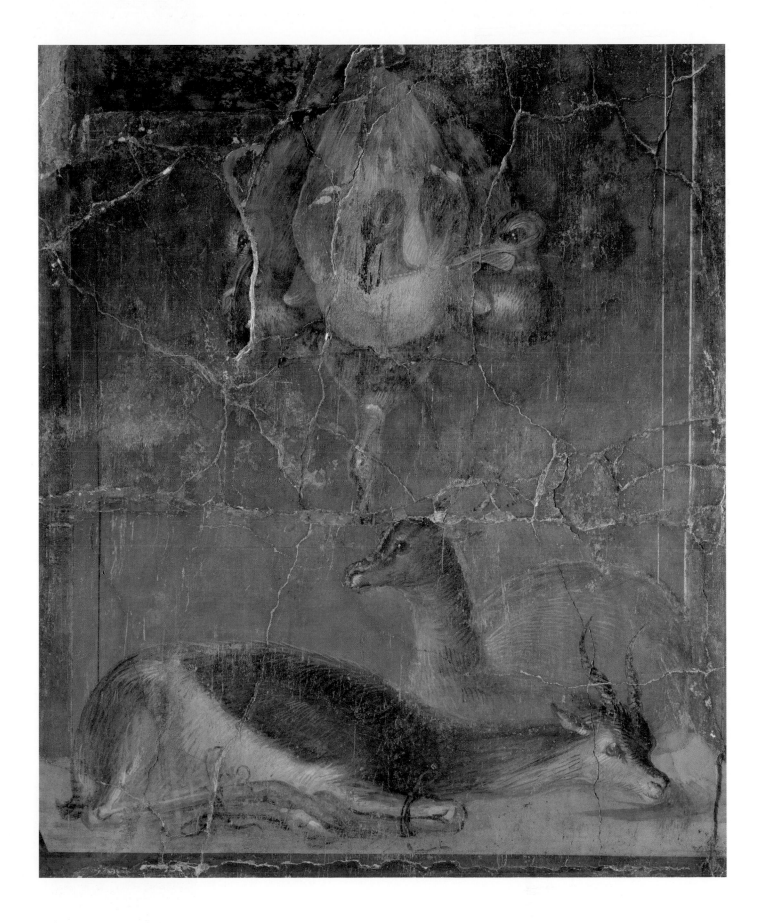

Detail of a mosaic with a marine scene in the dining room to the left of the *tablinum*, or principal reception room, at the House of the Faun.

When the Macellum was planned, the placement of the shops was not left to chance. Whenever possible they face north, and on the north side of the building they open onto the street rather than the building's courtyard. This meant that shopkeepers were less affected by the midday and afternoon heat, especially in the long hot season between late spring and early autumn. Obviously, high temperatures threaten perishable foods, and it was difficult at the time to do much to protect them. The building is typical of Pompeian architecture but also recalls, as the word suggests, similar Punic structures, as well as other contemporary Campanian buildings, such as the so-called Temple of Serapis at Pozzuoli, which was actually a commercial building. The Macellum is also interesting for another reason. The continuous flow of so many shoppers through the building made it an ideal location for a shrine dedicated to the imperial cult. This point was not lost on the political machine that developed with the coming of the empire, and such a sanctuary was built on an axis with the entrance to the Macellum. As was so often the case in the Roman world, the shrine was controlled by members of the merchant class, and especially those of lower rank. The propagandistic message of the shrine, however, was directed toward the entire population.

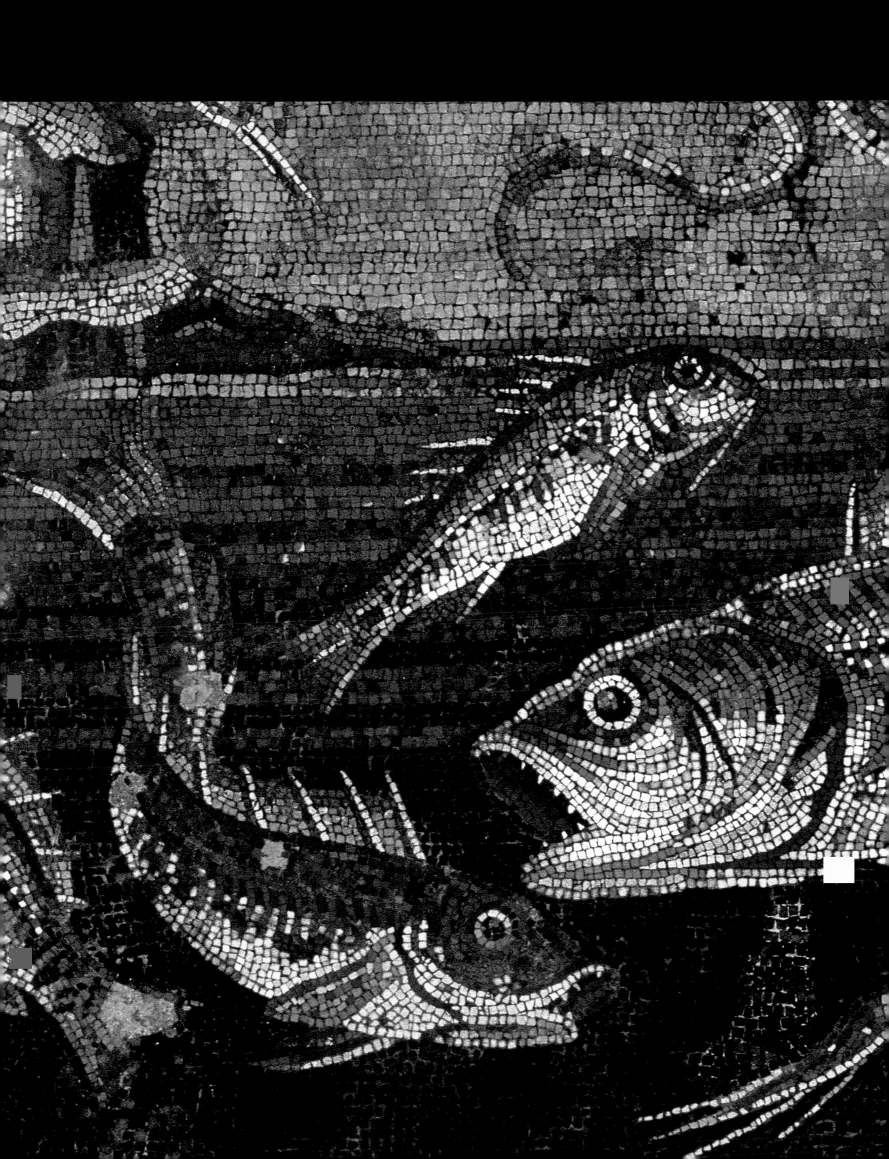

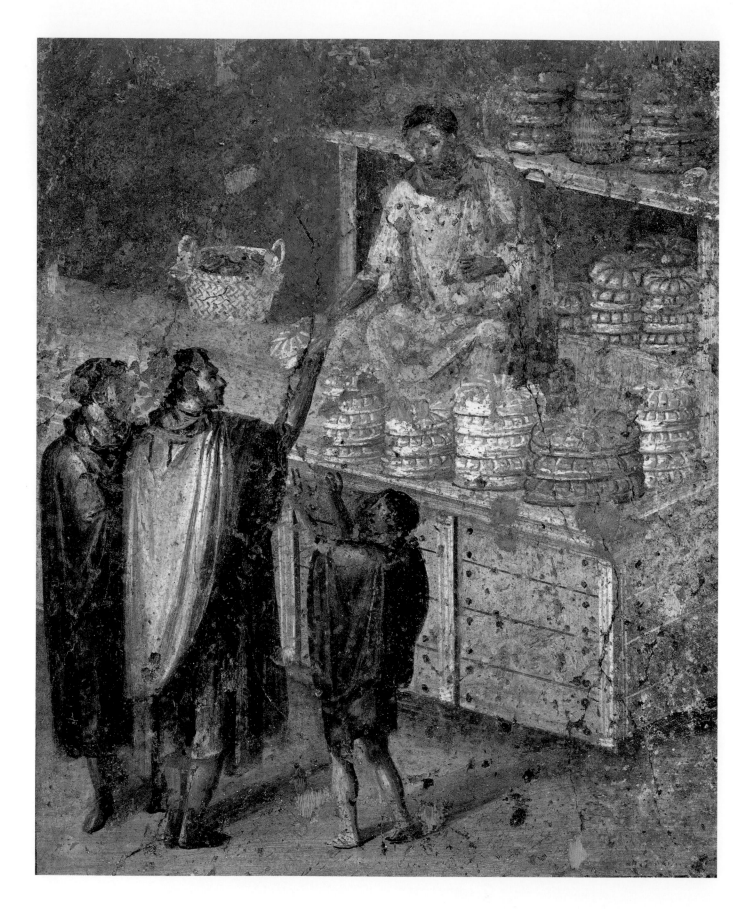

SHOPS, COMMERCE, AND ARTISANS' WORKSHOPS

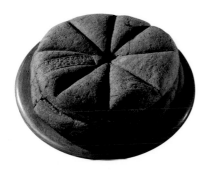

A carbonized loaf of bread that still clearly shows the mark of the baker who made it.

The bakery of Numerius Popidius Priscus, with its bread ovens and stone mills for making flour. The millstones were turned by either slaves or donkeys.

Opposite:
This splendid fresco from the *tablinum* of House VII, 3, 30 in Pompeii and now in the National Archaeological Museum in Naples provides an extremely realistic snapshot of everyday life at the time. It shows bread being sold—important evidence of the wealth of the citizens of Pompeii, who could afford to buy bread at one of the city's many bakeries rather than making it at home.

Pompeii's situation was ideal: it was located along principal highways, had a major port at the mouth of the Sarno River, was surrounded by fertile agricultural land, and was favored by historical circumstances it was able to exploit. This last condition was especially significant in light of the social and economic dynamics that accompanied the expansion of Roman imperialism in the late republican and early imperial period. The city had enjoyed a long and largely uninterrupted commercial prosperity, despite periods of stagnation and economic recession over the course of its almost-seven-hundred-year history. It was not surprising, then, to find every kind of shop on the city's busiest streets, such as those that stretched across town from one city gate to another. These shops included simple public houses, bakeries, and the workshops of skilled artisans, including blacksmiths, gem carvers, and glassmakers, as well as the textile workers who transformed raw fibers into refined garments. These shops often issued from the great aristocratic houses, in the sense that wealthy home owners might employ a member of the household, often a slave, to sell products from their country estates in a shop that opened onto a public street, while remaining part of the *domus*—the Latin word means "home," "house," and "household." In other cases, shops were owned by men of more modest means, who rented them to even more humble tenants, who slept with their families in uncomfortable mezzanines built over the shop. Of course, owning a small retail enterprise or practicing some modest craft did not guarantee an automatic step up on the socioeconomic ladder. Pompeii also had numerous street vendors who came into town from the countryside to try to sell the fruits of their own labor directly. Other

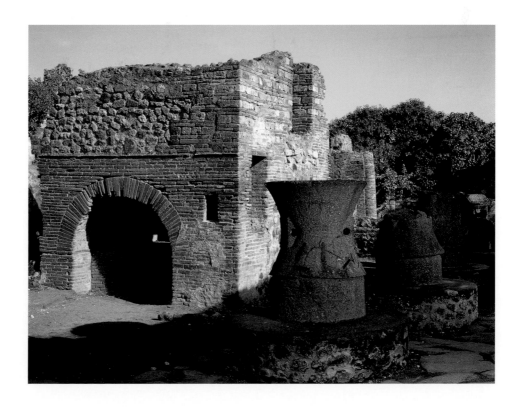

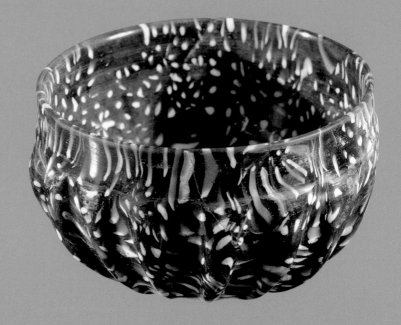

Examples of glass vessels from Pompeii. The art of glassmaking reached an extraordinary level in the early imperial period. According to Pliny the Elder, the great naturalist who perished tragically during the eruption of A.D. 79, most people now preferred glass to metal vessels.

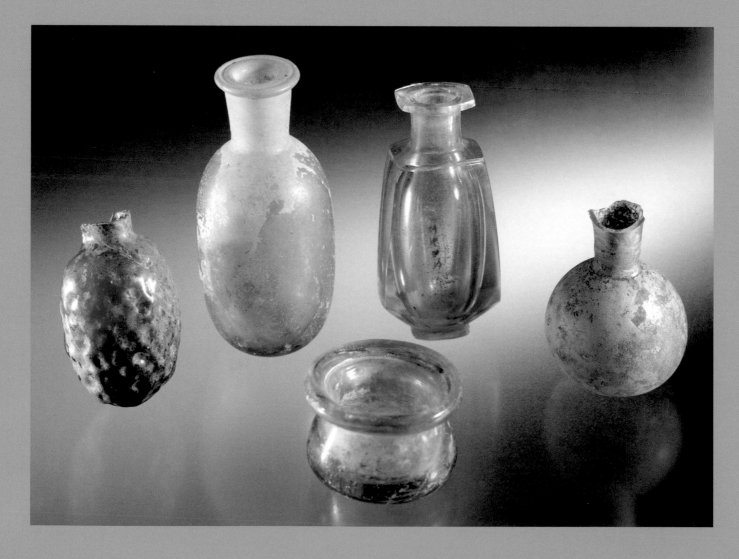

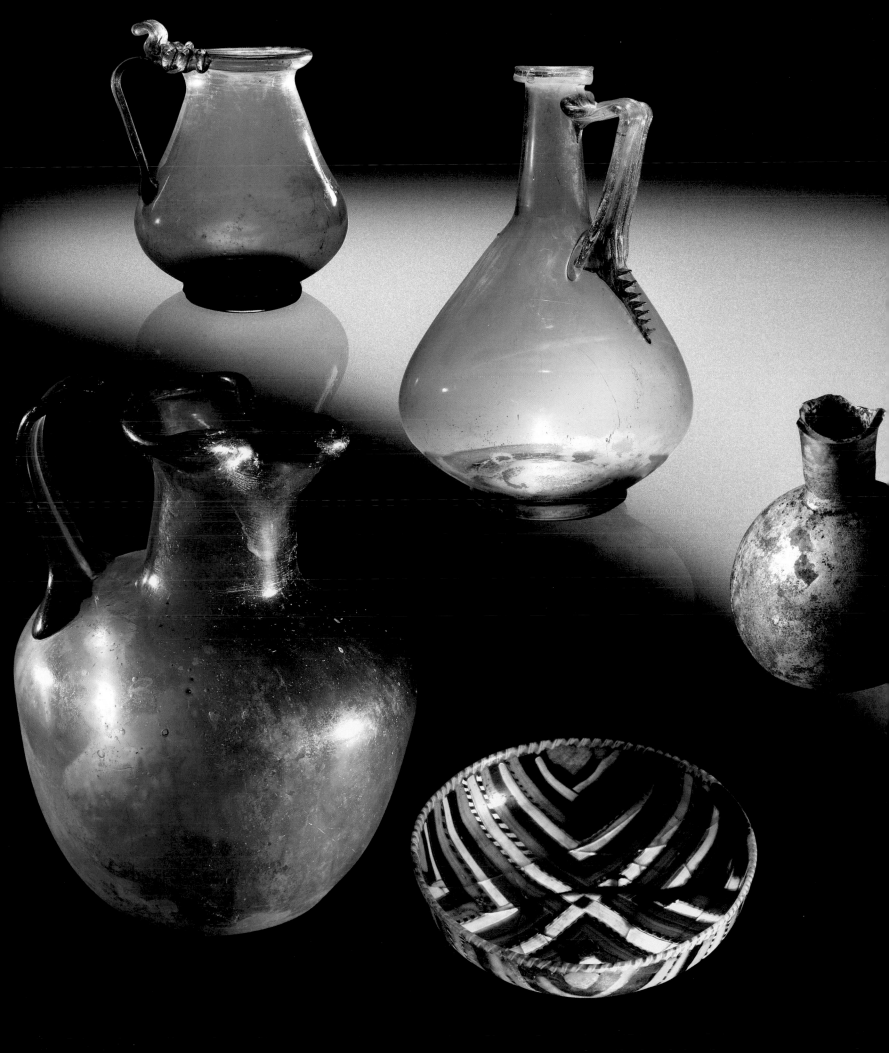

This relief of a ship heading into port appears on a funerary monument, undoubtedly not by chance: it is an obvious metaphor for the precariousness of all life, in which the only real certainty is its end. The marble is the central element of a monumental cenotaph dating to the reign of Nero and raised in honor of Caius Munatius Faustus and the freedwoman Naevoleia Tyche.

These two clay jugs, commonly used to carry water, belong to a more mundane world.

This meticulously detailed model, now in Rome's Museo della Civiltà Romana, was made in the 1930s and shows the rural Villa della Pisanella near Boscoreale. Note the general layout of the house as well and the well-designed wine cellar, with its partially buried large clay vats in which wine was aged.

Plan of the rural Villa della Pisanella (Boscoreale).

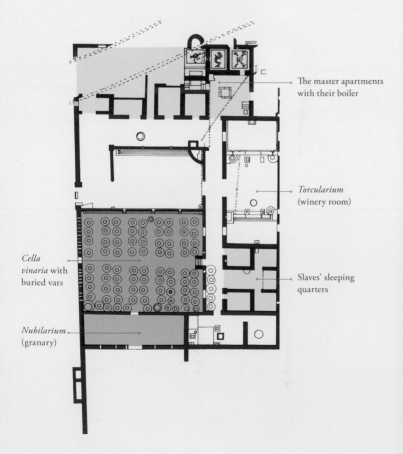

The master apartments with their boiler

Torcularium (winery room)

Cella vinaria with buried vats

Slaves' sleeping quarters

Nubilarium (granary)

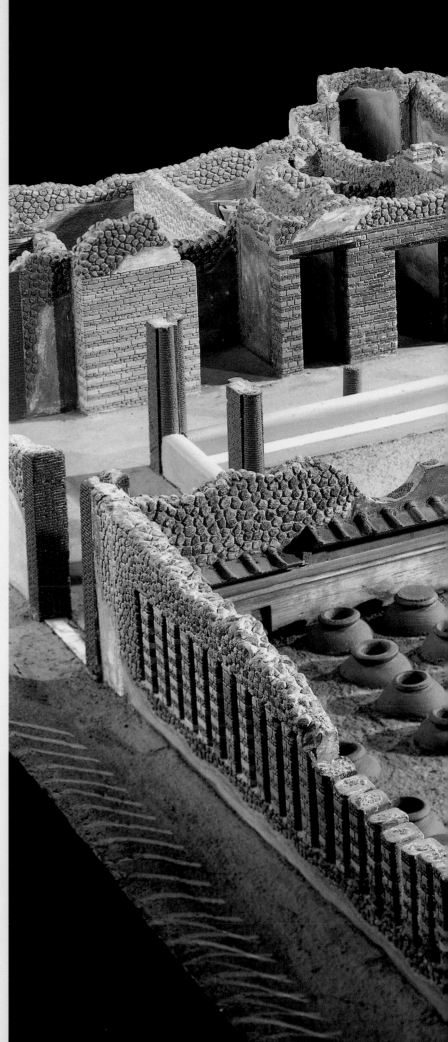

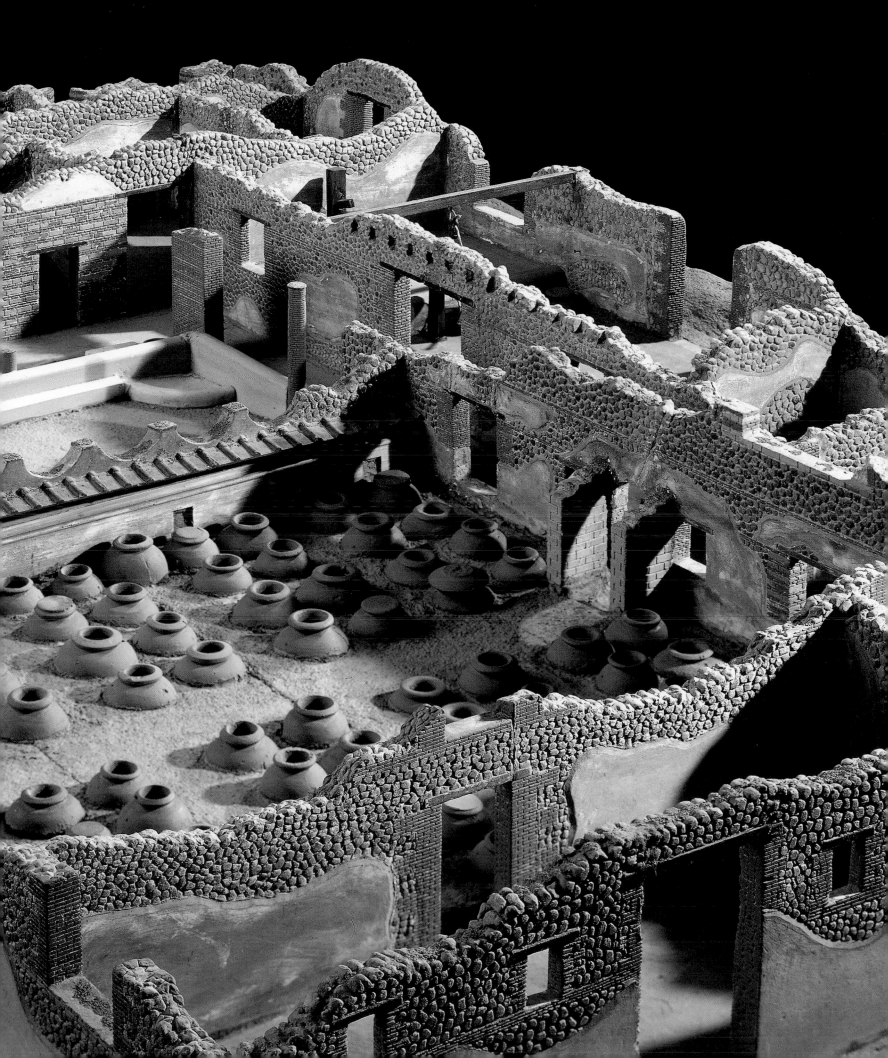

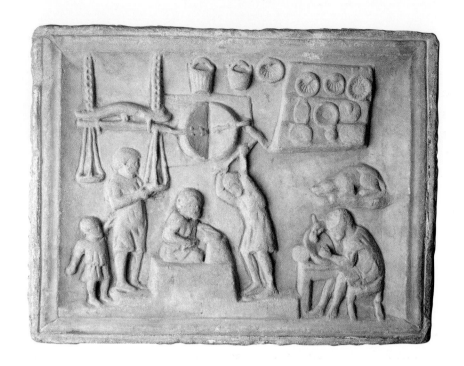

Left:
This lively marble bas-relief, which can be dated to the first century A.D., is most likely the sign for a Pompeian coppersmith's shop. We can see three stages in the process of crafting the product: weighing the metal, beating it on an anvil, and finishing the object.

Below:
The Thermopolium in Pompeii, a shop that sold prepared hot food, has a masonry counter with inset containers for food and drink.

Opposite:
Gold earrings with freshwater pearls set in basket mounts. From the House of Menander, they are examples of a rare early imperial style. The gold and pearl diadem, of the same exquisite manufacture, must certainly have been the pride of a rich Pompeian matron.

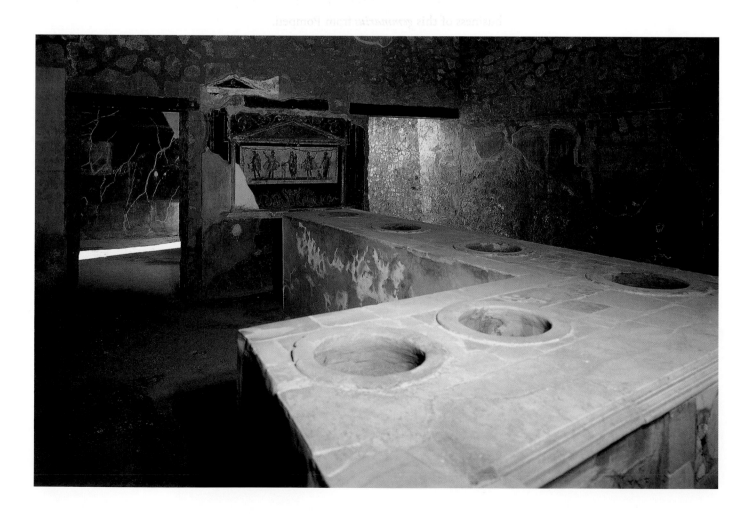

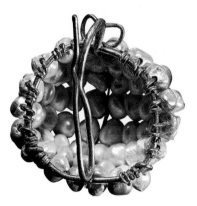

vendors moved their stalls around town following the largest crowds, for example, to the area by the amphitheater when the very popular gladiatorial games were held.

The most skilled craftsmen and merchants did make notable profits from their businesses, because of either the high demand for the goods and products, as with bakers and blacksmiths, for example, or the intrinsic value of what was offered for sale, by merchants such as jewelers. Archaeological remains, surviving objects, and certain famous frescoes offer direct evidence of this variegated social and economic reality. One could point, for example, to Pompeii's many bakeries, with their large ovens and the lava-rock millstones for which the city was known and which it exported far and wide; these were sturdy commercial enterprises with a fair number of employees. There is a famous picture in the *tablinum* of a house in Regio VII that shows us exactly what such a bakery looked like, its counter laden with all sorts of tempting breads and other baked goods. The Pompeian jeweler Pinario Ceriale is famous today for the small chest with more than one hundred semiprecious stones that was discovered in his otherwise rather modest house (though it was decorated with some interesting Fourth Style wall paintings); these include a sardonyx and a variety of amethysts, carnelians, and agates, some of them worked and others waiting to be cut. The chest provides interesting evidence of both the craft and the business of this *gemmarius* from Pompeii.

That the production of cloth was a significant element in the economic and manufacturing fabric of the city is indicated by the many *fullonicae*, or cloth-dyer's shop, within its walls. Especially at the end of the city's history, these small-scale factories sometimes occupied older buildings, onetime aristocratic homes, proof of how

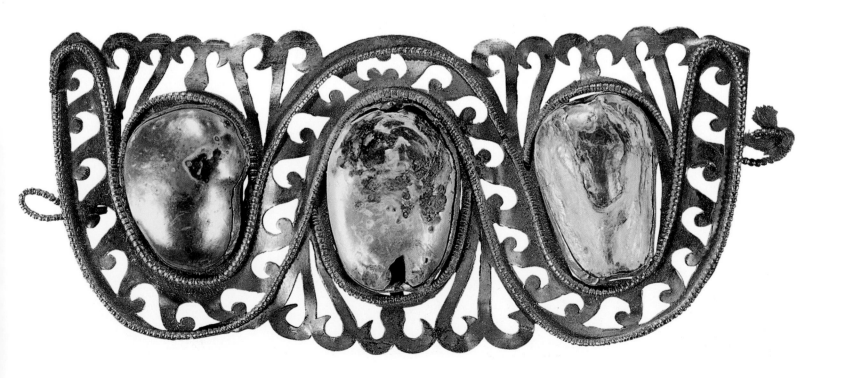

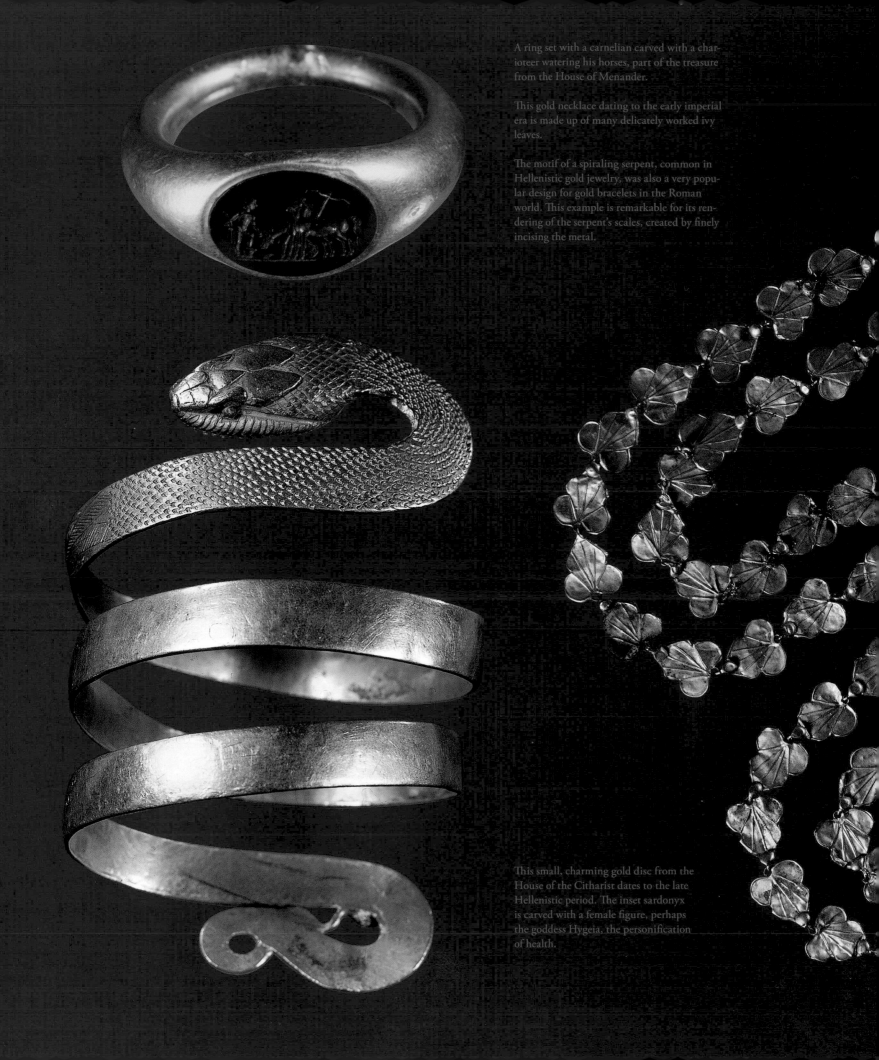

A ring set with a carnelian carved with a charioteer watering his horses, part of the treasure from the House of Menander.

This gold necklace dating to the early imperial era is made up of many delicately worked ivy leaves.

The motif of a spiraling serpent, common in Hellenistic gold jewelry, was also a very popular design for gold bracelets in the Roman world. This example is remarkable for its rendering of the serpent's scales, created by finely incising the metal.

This small, charming gold disc from the House of the Citharist dates to the late Hellenistic period. The inset sardonyx is carved with a female figure, perhaps the goddess Hygeia, the personification of health.

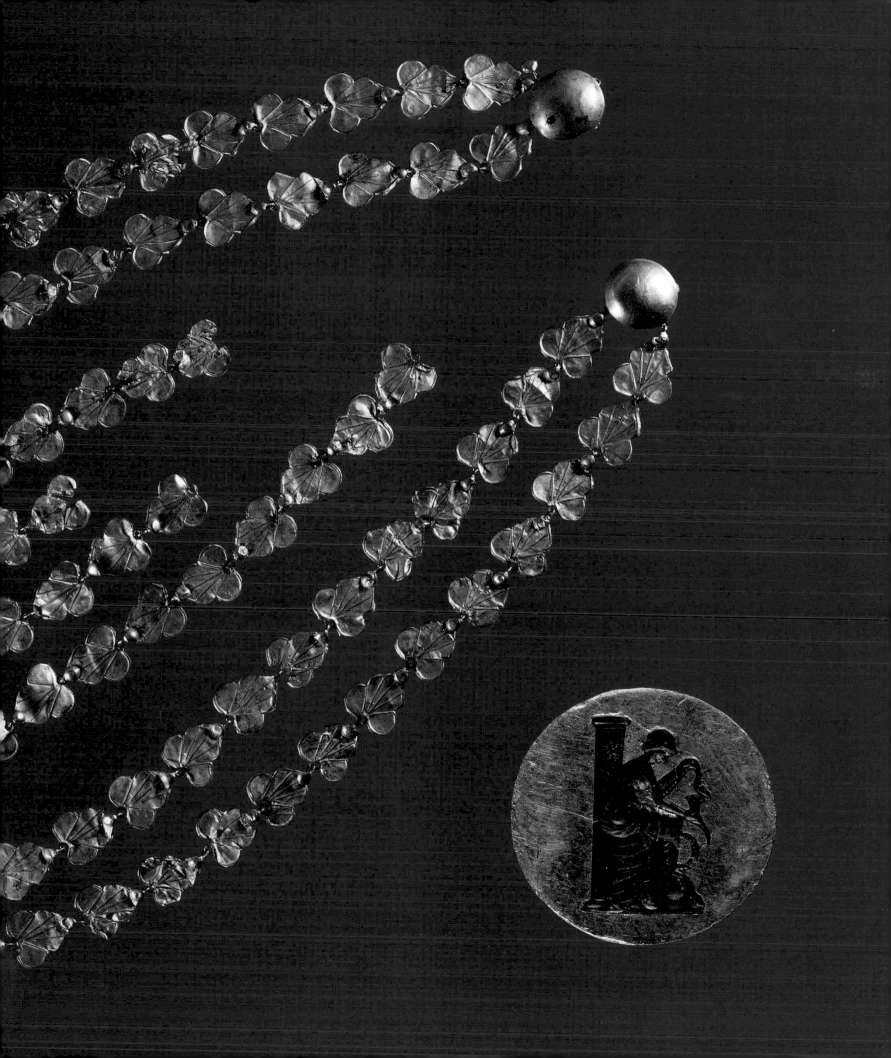

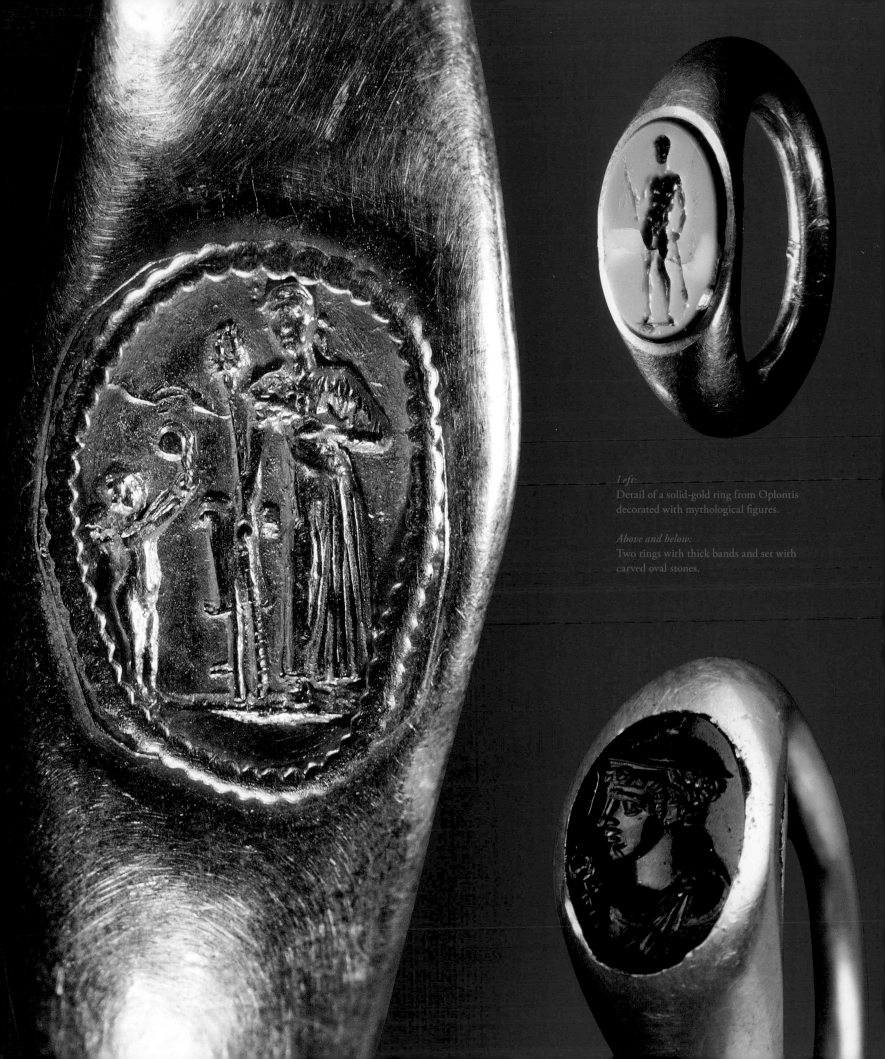

Left:
Detail of a solid-gold ring from Oplontis
decorated with mythological figures.

Above and below:
Two rings with thick bands and set with
carved oval stones.

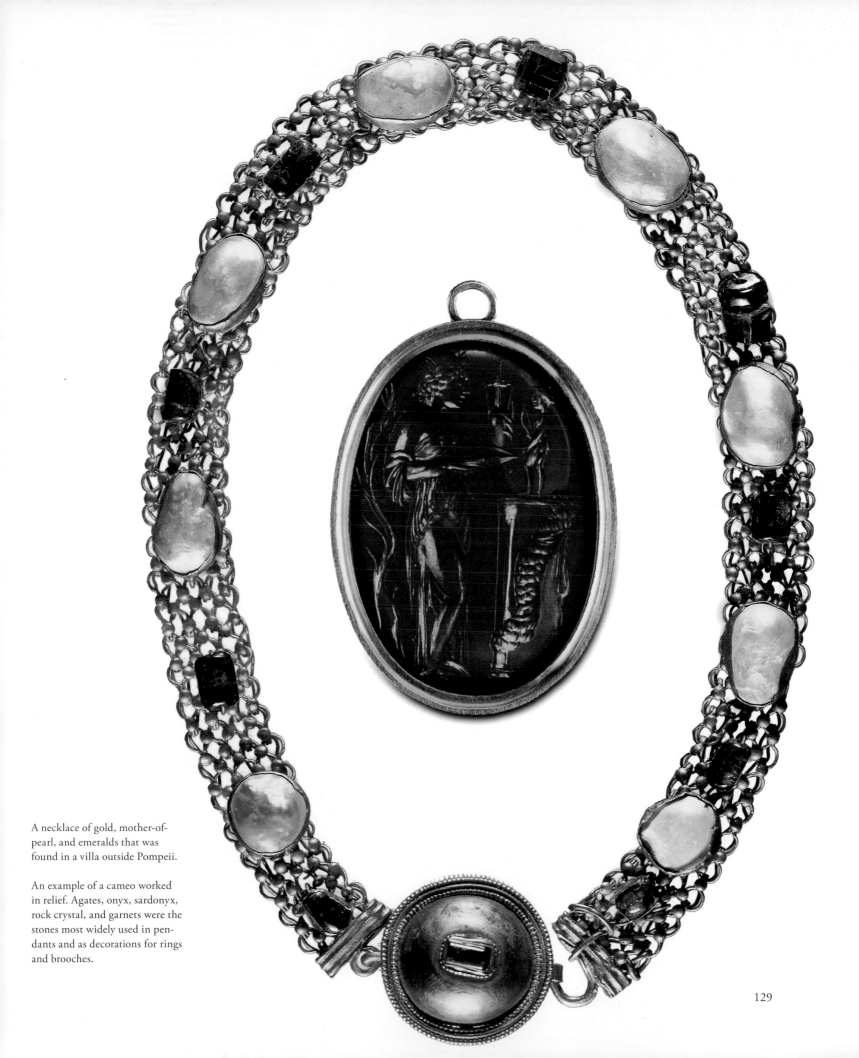

A necklace of gold, mother-of-pearl, and emeralds that was found in a villa outside Pompeii.

An example of a cameo worked in relief. Agates, onyx, sardonyx, rock crystal, and garnets were the stones most widely used in pendants and as decorations for rings and brooches.

129

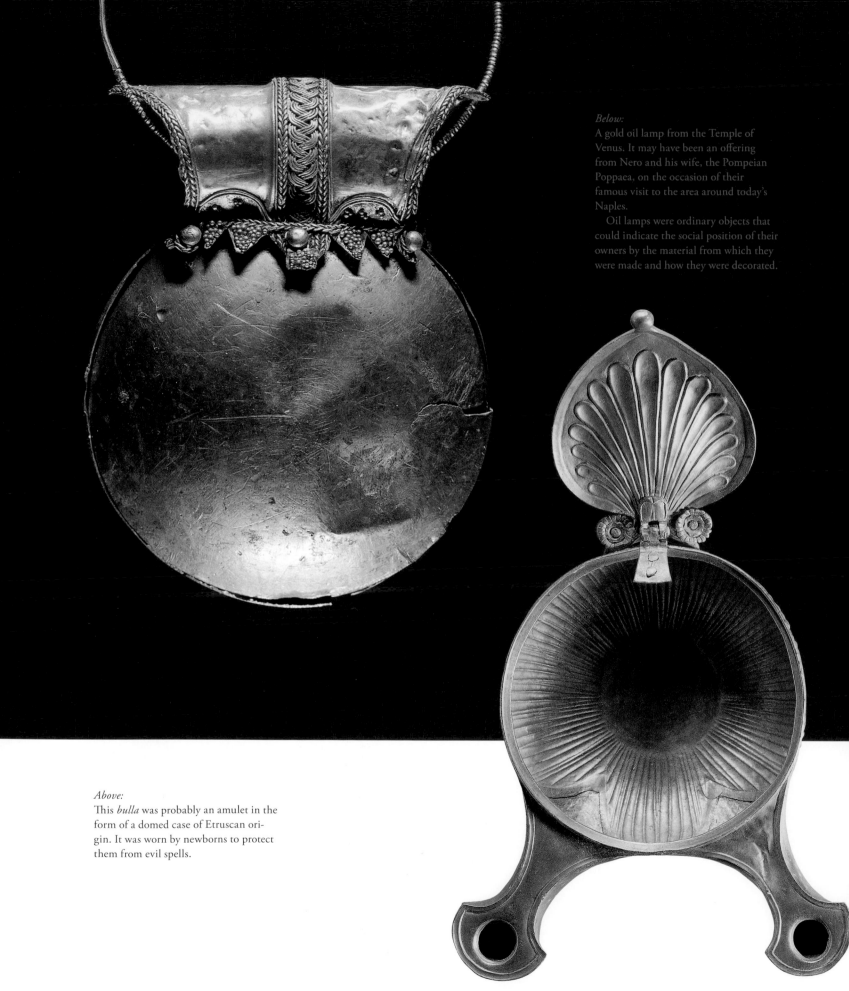

Below:
A gold oil lamp from the Temple of
Venus. It may have been an offering
from Nero and his wife, the Pompeian
Poppaea, on the occasion of their
famous visit to the area around today's
Naples.

Oil lamps were ordinary objects that
could indicate the social position of their
owners by the material from which they
were made and how they were decorated.

Above:
This *bulla* was probably an amulet in the
form of a domed case of Etruscan ori-
gin. It was worn by newborns to protect
them from evil spells.

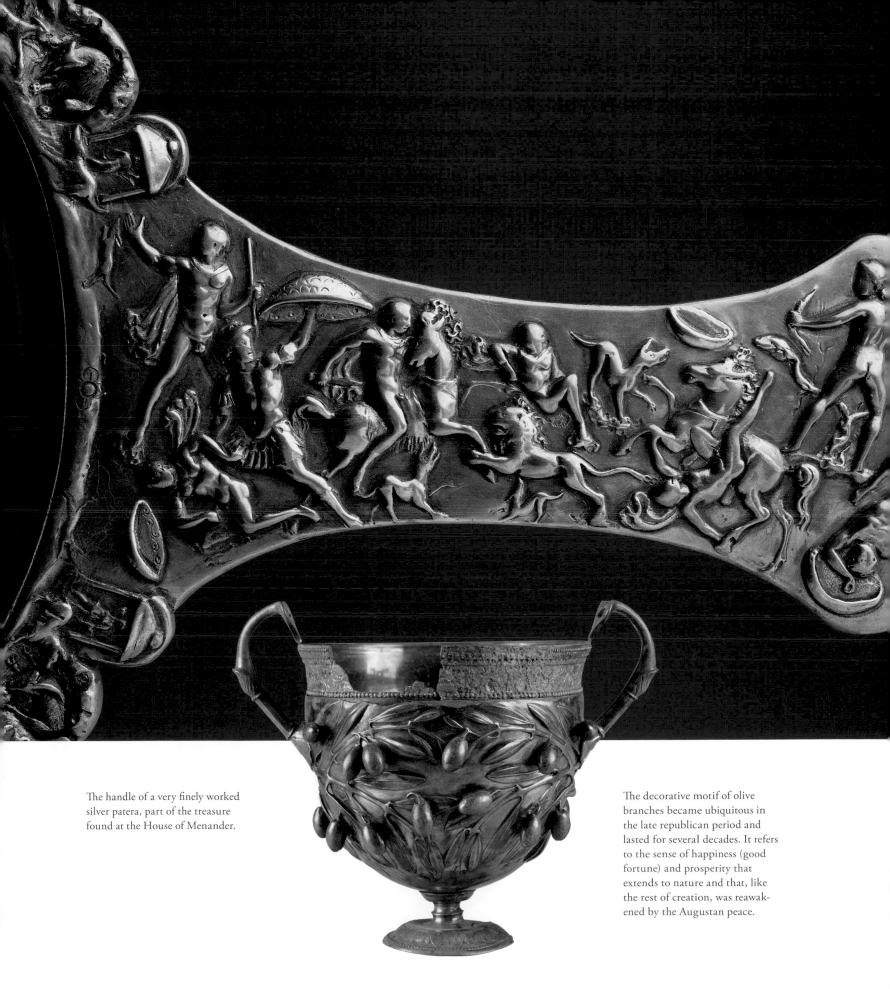

The handle of a very finely worked silver patera, part of the treasure found at the House of Menander.

The decorative motif of olive branches became ubiquitous in the late republican period and lasted for several decades. It refers to the sense of happiness (good fortune) and prosperity that extends to nature and that, like the rest of creation, was reawakened by the Augustan peace.

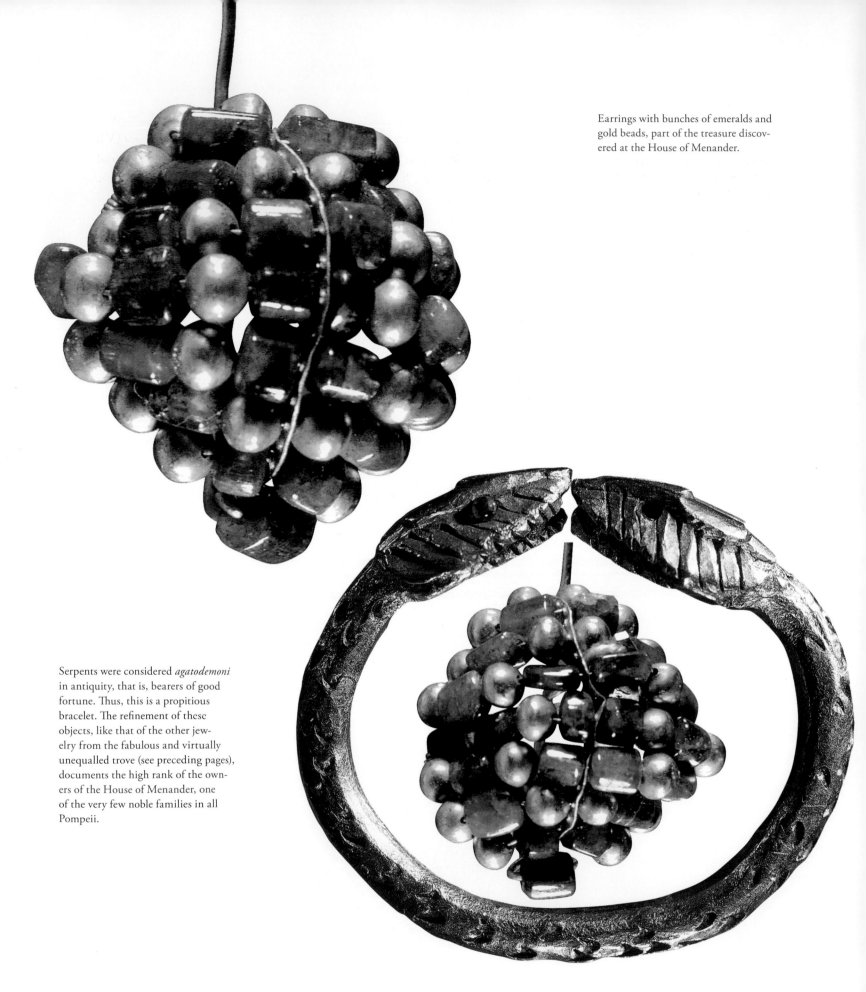

Earrings with bunches of emeralds and gold beads, part of the treasure discovered at the House of Menander.

Serpents were considered *agatodemoni* in antiquity, that is, bearers of good fortune. Thus, this is a propitious bracelet. The refinement of these objects, like that of the other jewelry from the fabulous and virtually unequalled trove (see preceding pages), documents the high rank of the owners of the House of Menander, one of the very few noble families in all Pompeii.

One of the famous Fourth Style frescoes found in an important *fullonica*, or cloth-dyer's shop, in Pompeii. The painting illustrates various aspects of the ancient processes of working cloth. In this scene a youth is busy carding a tunic while another worker carries a reed cage. Cloth was laid over such cages then steamed with sulfur vapor to whiten it.

many of the rich had abandoned the city after the earthquake of A.D. 62. The activity in these shops is also splendidly illustrated in a fresco cycle from a *fullonica* (VI, 8, 20). Women's clothing at the end of the republican and into the early imperial period consisted of only a few types of garments, though differences in economic class were easily discerned in the quality and cut of the cloth. The basic item of clothing was the tunic, a linen or white wool dress that reached down to the ankles and was made from two pieces of cloth sewn together. It was then belted at the hips, though at home it would generally have been worn without a belt, giving rise to the term *discinta*, literally, "unbelted," or "scantily dressed," implying licentiousness. The stola was a particularly elegant and ample version of the tunic, worn by well-to-do Roman matrons. It was usually accompanied by a cloak that prevented men from too easily admiring the woman's figure, as Horace himself noted in one of his witty verses: "the long robe hanging down to the ankles, and covered with an upper garment; a multiplicity of circumstances that will hinder you from having a fair view" (*Satires* 1.2.99–100).

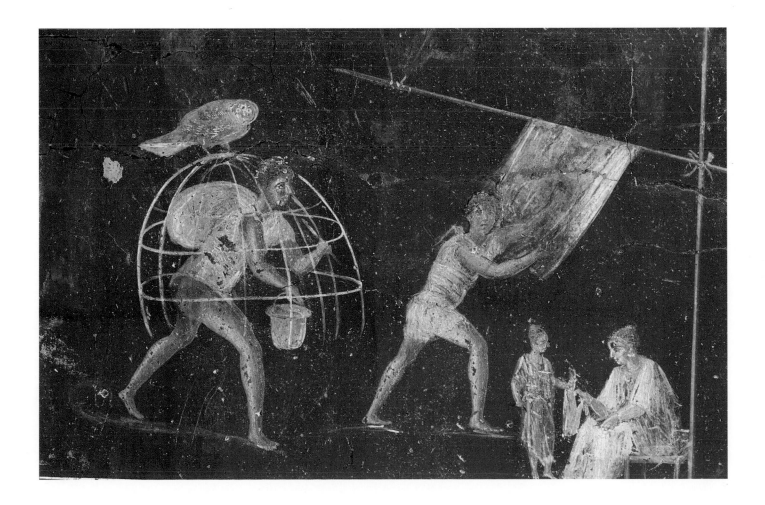

HOUSES OF PLEASURE

IN THE SERVICE OF VENUS:
BROTHELS AS PLACES OF
BUSINESS, PLEASURE, AND
THE EXPLOITATION OF SLAVES

IN THE SERVICE OF VENUS: BROTHELS AS PLACES OF BUSINESS, PLEASURE, AND THE EXPLOITATION OF SLAVES

This fresco depicting Priapus with two phalluses was detached from the north wall of the Lupanare, Pompeii's most famous brothel.

Opposite:
Even the most ordinary household objects were often decorated with erotic scenes. The explicit relief on the bottom of this bronze basin is one example.

Preceding pages:
A first-century-A.D. marble bas-relief with the sexual position known as Venus Pendula, from the dining room of a *caupona*, or tavern.

It is challenging to offer a balanced historical and social evaluation of a phenomenon like prostitution, as widespread in antiquity as it is today. And, as in our own time, prostitution in the ancient world was subject to value judgments that may have been overly colored by moral prejudices and disapproval, rather than acknowledged as an institution essential to a full affirmation of human liberty and dignity. The Romans certainly practiced the double standard, as we see in the works of one of the greatest figures of that culture, Cicero. In the second of his famous philippics, which he wrote in 44–43 B.C. to destroy Mark Antony's political and moral reputation, Cicero accused his enemy of, among many other things, hosting a slew of orgies in one of his houses—formerly the home of the cultivated and respectable Varro—during which it was supposedly impossible to tell the prostitutes from the respectable women. Yet only a little more than ten years earlier Cicero had defended his young friend Marcus Caelius, accused, again among other things, of consorting with prostitutes. On this earlier occasion, Cicero's language was far more sympathetic and indulgent; he said, in effect, that only an abstract ethical sensibility could construe frequenting prostitutes as improper, since the practice was widely tolerated by more elastic public opinion.

It was easy to procure a woman in Pompeii for very little money—the average cost of a "regular" session was about the same as for a jug of ordinary wine—and this was true throughout the ancient world. Nor was it difficult to arrange for sexual episodes with adolescent boys, a habit both widely accepted and quite commonly practiced. What prostitutes did varied, of course, according to economic and erotic demand, and those who practiced the trade were available in the so-called pleasure houses. Pompeii's famous Lupanare, to which we shall return shortly, was only one of many. A well-to-do client could afford the luxury of house calls, but many inns and taverns also provided their patrons with these "services" sacred to Venus. Some prostitutes sold themselves directly, working in tiny, single-purpose rooms called *cellae meretriciae*—prostitutes' cells—which opened directly onto the street. In the end, though, any place that attracted heavy traffic for whatever reason—the amphitheater, the baths, even the cemeteries just outside the city walls—would serve for these commercial encounters.

The Lupanare was the best known of Pompeii's many brothels. It was located close to the Forum at the intersection of two side streets (VII, 12, 18–20) and consisted of ten small rooms arranged on two floors. Although it had been remodeled shortly before Vesuvius erupted, as the impression in plaster of a coin dated A.D. 72 proves, it provided only the most basic of comforts: simple pallets for copulation, doors providing some limited privacy, and a communal latrine on the ground floor. Its clients, however, must have been satisfied with the service they received, if the great deal of graffiti praising the erotic skills of the Lupanare's male and female prostitutes is to be believed. It is interesting, too, that some of these inscriptions mention the risk of contracting a venereal disease like *destillatio*, that is, the clap.

The images painted in the corridors outside the various rooms apparently fulfilled a practical purpose: they constituted a catalogue of the different sexual positions that might be requested. They therefore suggest that the pagan idea of eroticism as an impulse unfettered by ethical or religious scruples extended even into the squalor of a brothel. The building was under the protection of the god Priapus, whose erect penis had a dual significance, including the power to ward off danger or other bad luck. Generally, female prostitutes in a place like this were either slaves or freedwomen from the East, though there were certainly free Roman women employed in the profession. The *meretrices* turned over most of their earnings to the bordello's owner, the *leno*, who built a successful business by exploiting the daily needs of his many clients and the lack of any real protection for his workforce. Under the emperor Caligula the Roman state imposed a tax on prostitutes amounting to the price of one copulation a day for each worker. The tax confirms the widespread moral indifference to the phenomenon of prostitution, which was, moreover, as unenforceable then as it would be in many modern societies.

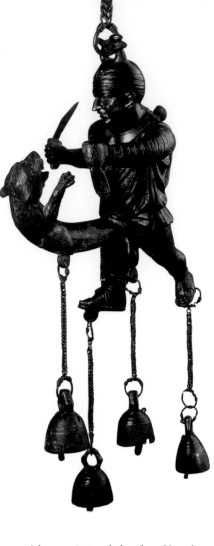

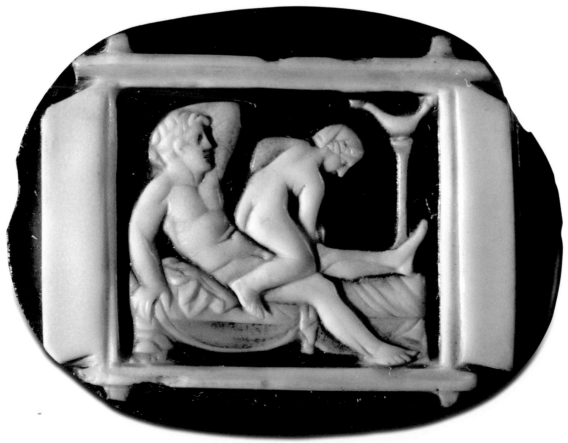

A bronze *tintinnabulum* from Herculaneum. A gladiator fights his own phallus, here in the guise of a ferocious panther.

A cameo showing a *pinax* (a small panel painting) with shutters with an erotic scene consummated on an elegant bed.

Opposite:
A room in the Lupanare. A pallet is visible through the doorway, and above the lintel is one of the many frescoes that decorated the brothel.

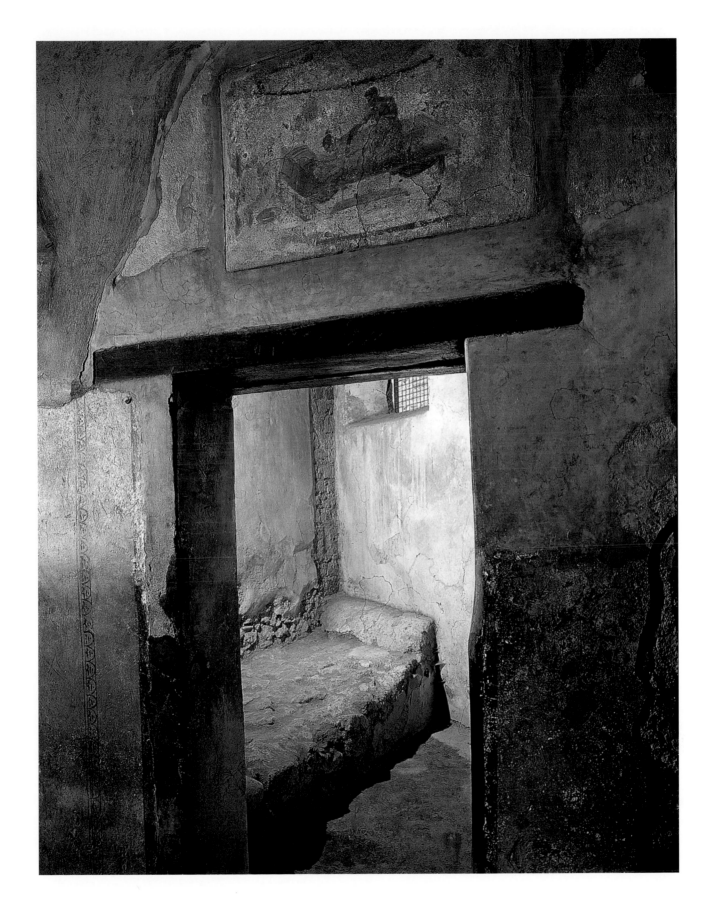

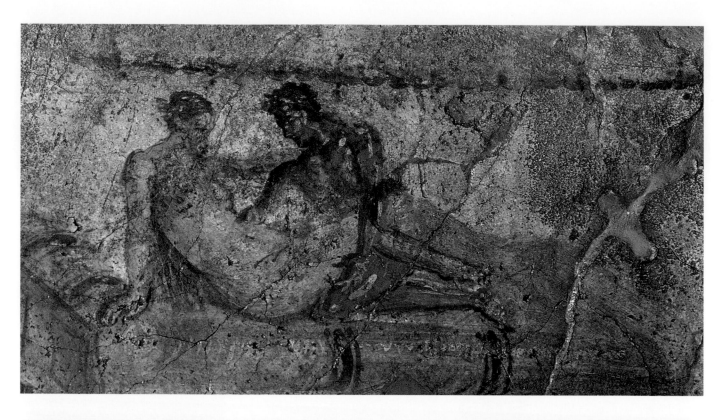

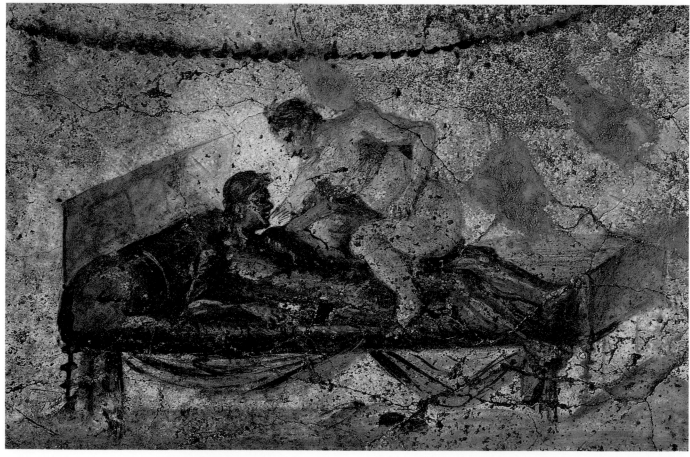

Two small paintings of erotic scenes. They represent sexual positions: the first was called "the man standing," and the second "coitus from behind."

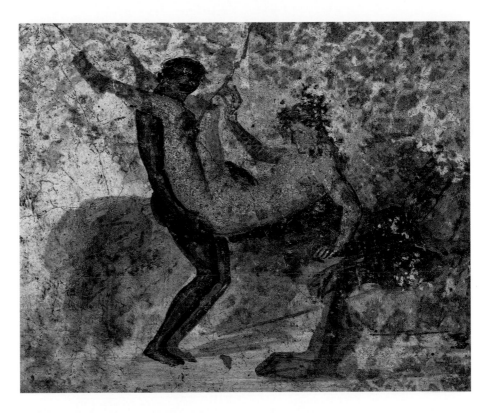

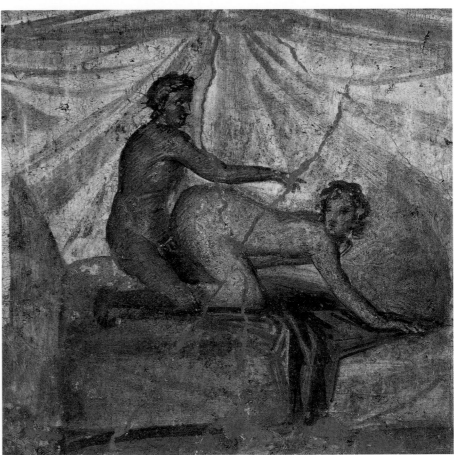

Opposite:
More examples of amorous positions. These small paintings of erotic subject matter were very widespread, found even in the homes of the wealthy. They were meant to excite the libido and suggest new games and sexual positions.

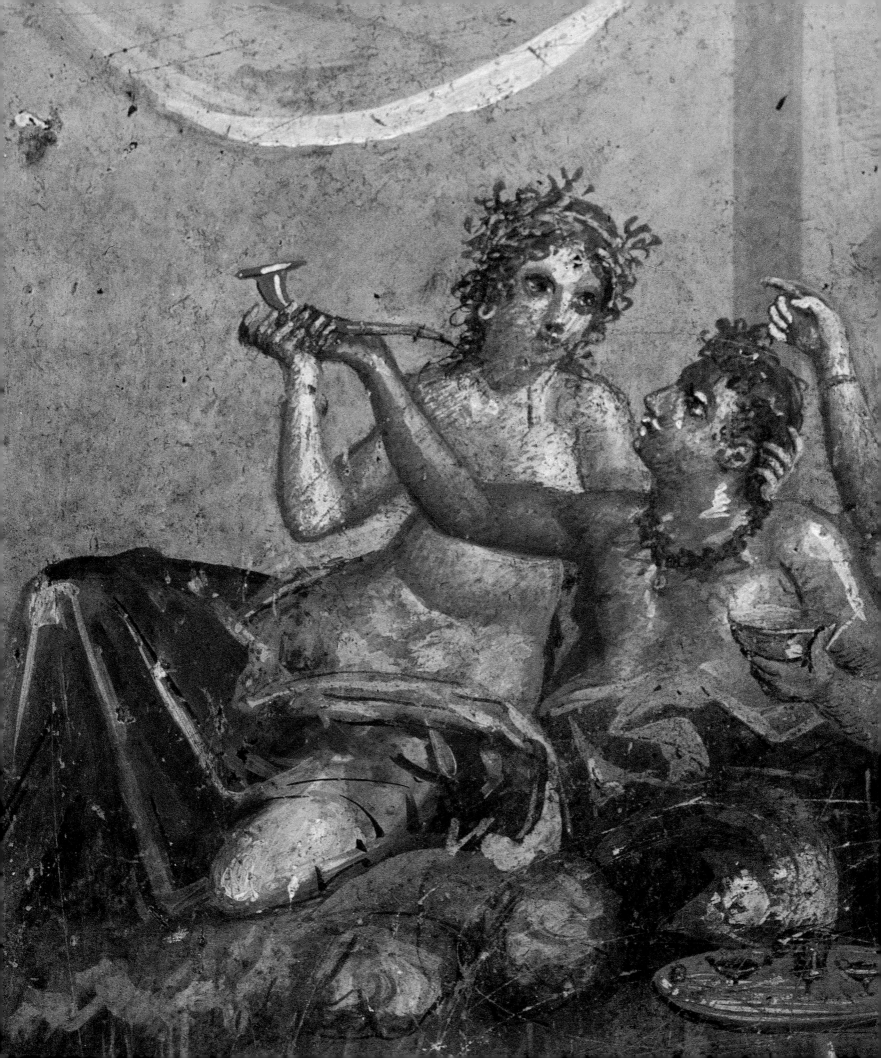

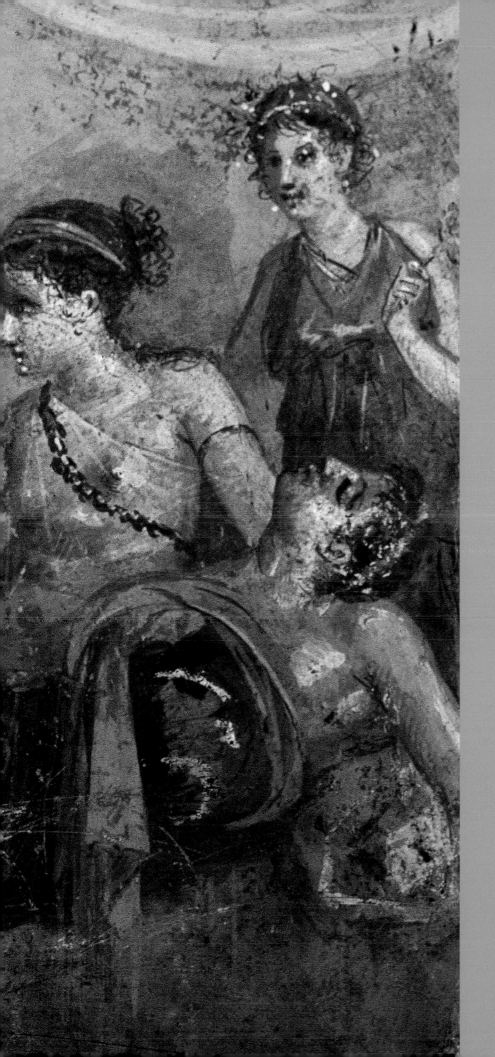

Banquets were gatherings that not infrequently became sexual. The delicious food and wine invited guests to relax and to enjoy fully the pleasures of life. This fresco from the House of the Casti Amanti is a sophisticated example of such a turn of events.

VIII

THE HOUSES

THE DECORATION OF
HOUSES AT POMPEII

LIFE AT HOME

THE DECORATION OF HOUSES AT POMPEII

Preceding pages:
A corner of the exedra in the House of the Vettii and the fresco *The Infant Hercules Strangling the Serpents Sent by Juno, in the Presence of Alcmene, Amphitryon, and His Father, Jupiter.* Partially visible on page 145 is the painting *King Pentheus About to Be Killed by the Maenads.*

Opposite:
Detail of a mosaic found in the House of the Faun, showing two ducks on the Nile. Their location is suggested by the lotus flower one of the two birds holds in its beak.

This mosaic was found in the master bedroom in Pompeii's luxurious House of the Labyrinth. The scene at the center represents the battle between Theseus and the Minotaur; it is surrounded by the labyrinth motif for which the house was named.

The houses of Pompeii have yielded a huge amount of information about life in antiquity since excavations there began in earnest in the eighteenth century. They have also attracted a huge amount of attention from both the general public and scholars—though sometimes with paradoxical results. These results derive, on the one hand, from a search for a refined sense of decoration perceived as intrinsic to classical culture (and which may turn out to be different from what one expects), and, on the other, from a desire to define a standard model for the ancient house, an effort that also depends on literary sources as well as other archaeological sites in the Italic and Roman worlds. As a result, research has often focused on only the large, richly decorated houses, certainly often with spectacular results. Vernacular architecture, however, has been largely neglected in the scholarly literature, even though it was, of course, a fundamental part of the residential fabric of a city like Pompeii. It is only in the past few decades that scholars have begun to study the range of houses belonging to a broad cross section of economic classes. Pompeii was a city of minor importance in antiquity, but because of the nature of its tragic end it offers us a clear picture of the built environment and incredible information on its residences. An analysis of Pompeian houses and information from comparable

A striking view of the House of the Labyrinth. In the foreground, the high-walled tetrastyle atrium; the airy colonnaded peristyle is visible across the *tablinum*, or principal reception area.

Plan of the House of the Labyrinth.

Sitting room

Master bedroom

Corinthian *oecus*, or hall

Small room

Exedra

Sitting room

Oecus

Bedroom

Peristyle

Tetrastyle atrium

Tuscan atrium

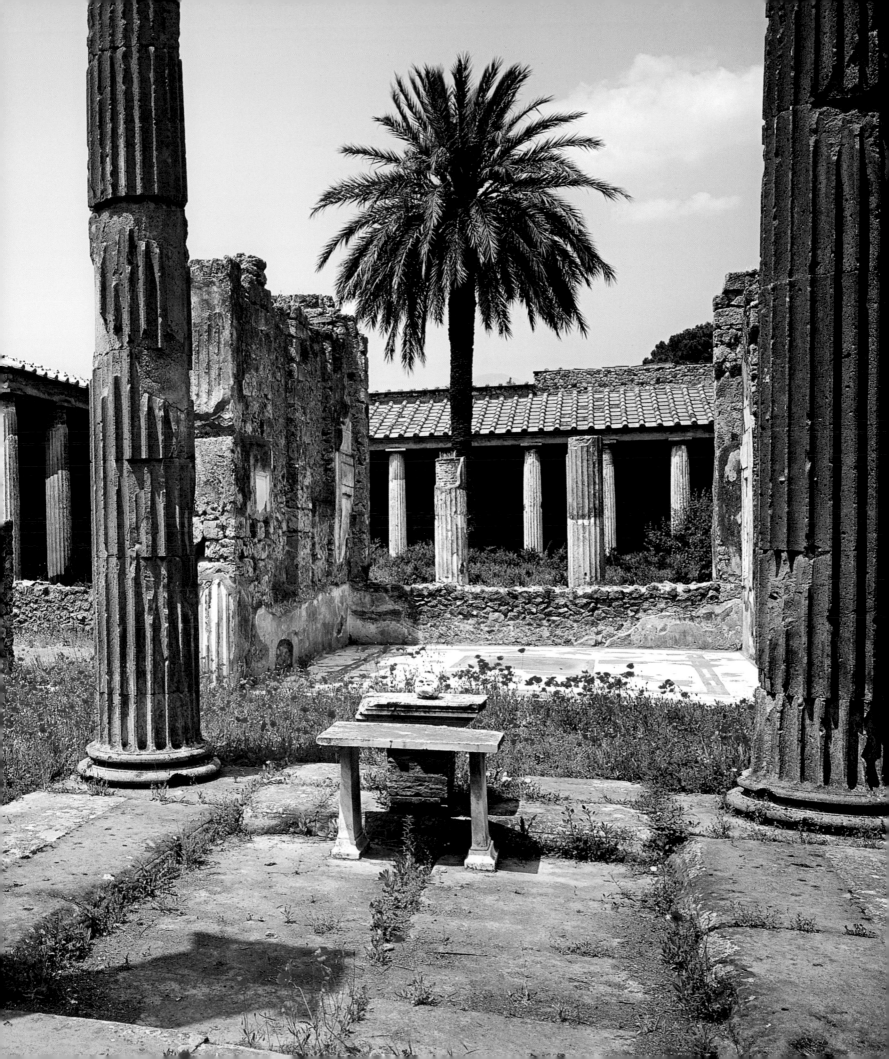

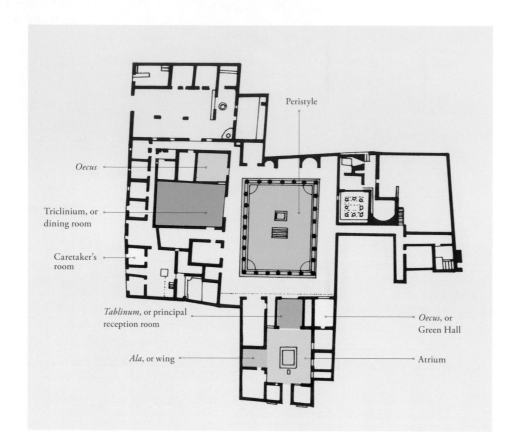

Peristyle

Oecus

Triclinium, or
dining room

Caretaker's
room

Tablinum, or principal
reception room

Oecus, or
Green Hall

Ala, or wing

Atrium

sites have definitively debunked the notion of a single, ideal type of Roman house accepted passively by architects and patrons alike. There were certainly recurring elements in domestic architecture that we can identify by their function and their ideological implications, but it is much more interesting to try to understand both the remarkable range of possibilities in the design and decoration of houses and the social and historical significance of this variety.

A statistical analysis done some time ago of Regio I, a residential district of Pompeii, calculated that mosaic pavements with figural motifs constituted only about 2.5 percent of the total number of mosaics in that part of the city. This figure seems to suggest that in ancient Pompeii this specific kind of decoration was restricted to a relatively small group of privileged people, and this statistic is cited in most discussions of the decorative motifs and ornamental devices in Pompeian houses. In many unpretentious homes, however, the occupants' social status required no display of luxurious furniture. From the middle and late Samnite period, we find a multitude of examples of an in-between situation, in which the house becomes a showcase for the owner's socioeconomic status, and many instances when design and decoration were intended to imitate as closely as possible the luxurious representations of richer people. A good example is provided by middle- and even upper-middle-class houses that include colonnaded courts in imitation of the peristyles of wealthier residences, even though there was not really enough room for such architectural elements. The

Opposite:
The *lararium*, or family shrine; atrium; and peristyle of the House of Menander, excavated by Amedeo Maiuri from 1926 to 1932. It was one of the most luxurious residences within the walls of the city of Pompeii.

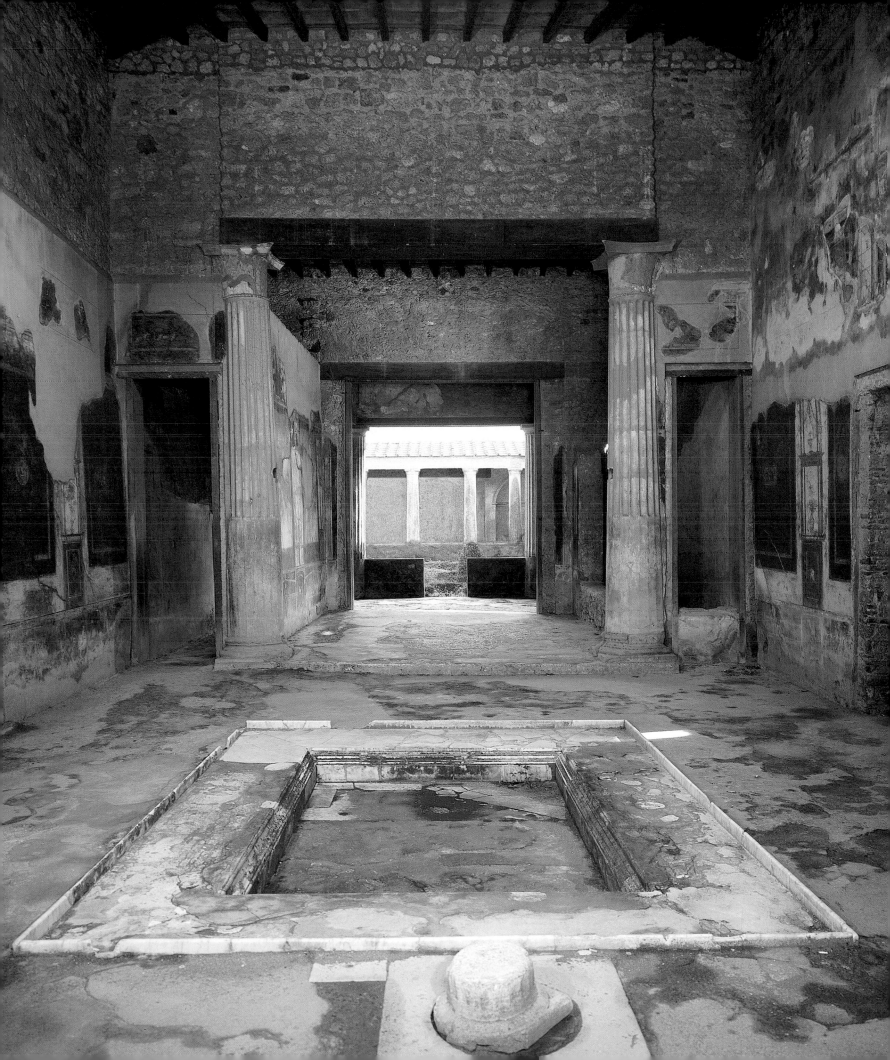

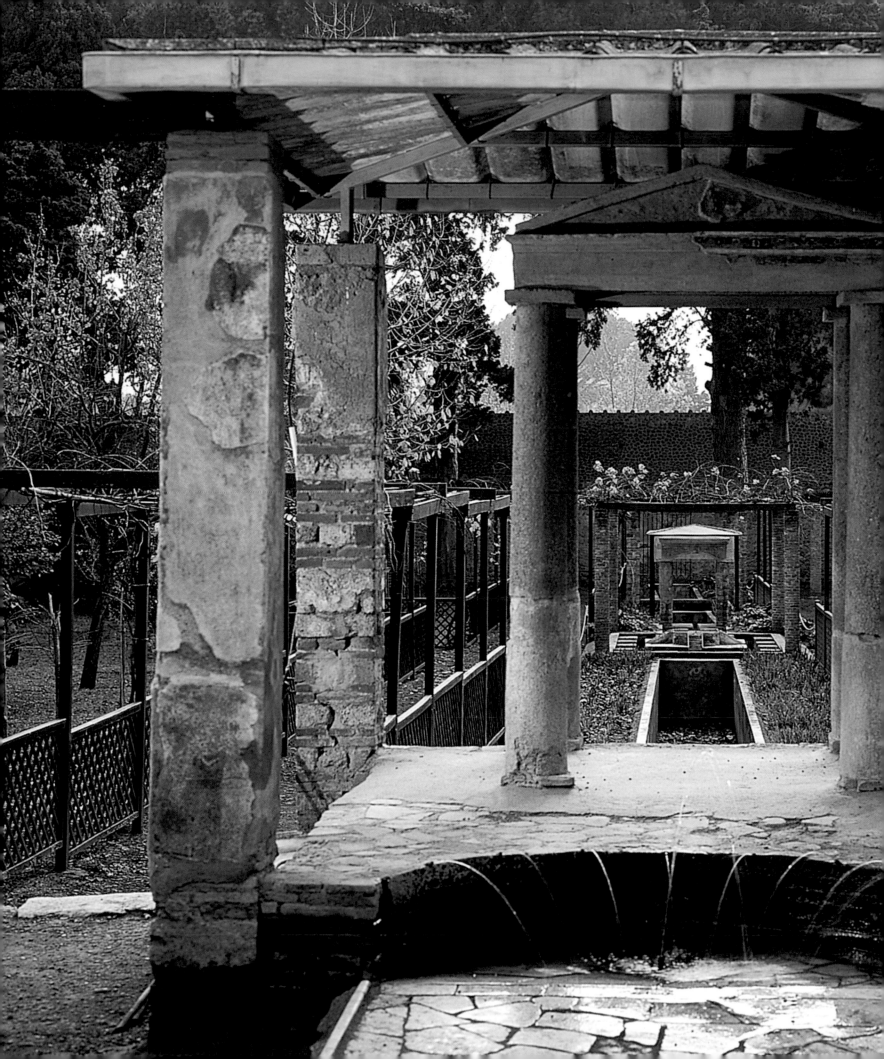

View of the channel (*euripus*) at the heart of the peristyle of the opulent Pompeian residence, *praedia*, or estates, of Julia Felix. This complex was much like an urban villa, with modifications in that style already begun in the late republican period and carried out after the earthquake of A.D. 62. Three bridges crossed the channel, which had niches for fish eggs. The garden as a whole was also designed to evoke the feeling of a Greek gymnasium.

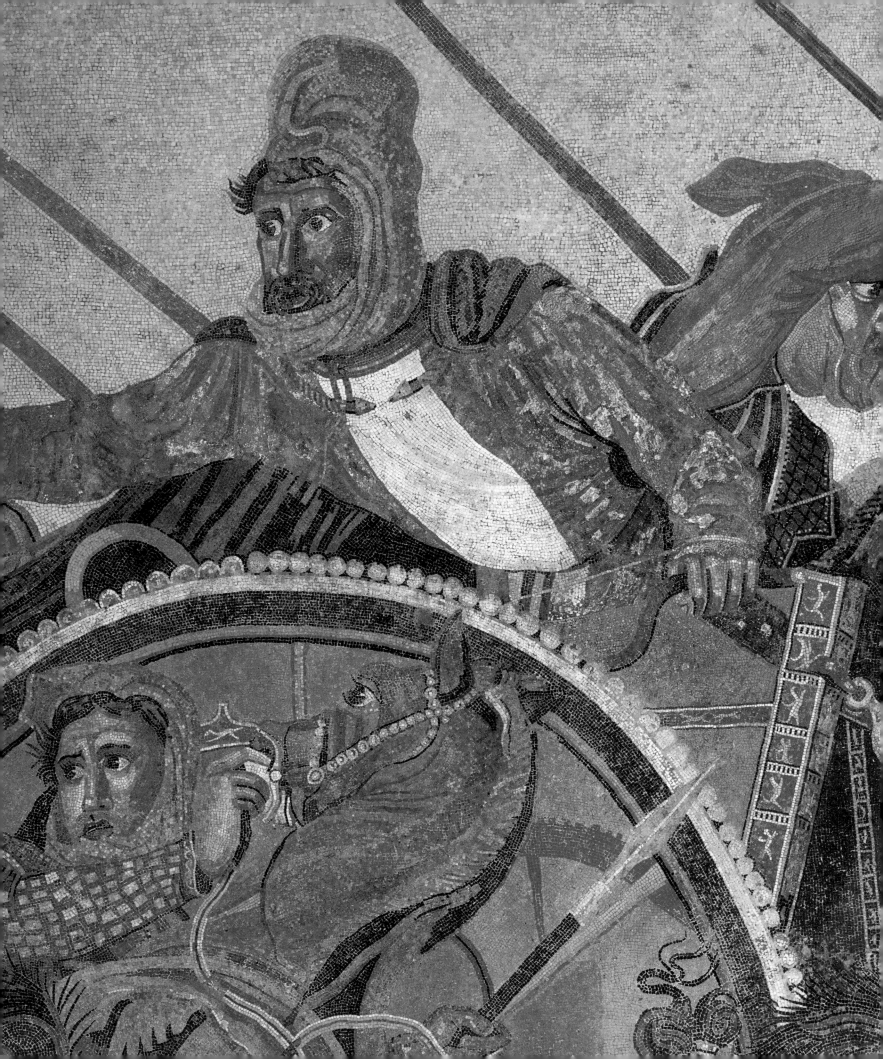

Opposite:
A detail of the famous mosaic found at the House of the Faun and portraying the terrified face of Darius III, king of Persia, as he was about to be overcome by Alexander the Great's surging advance. Behind him, his driver is spurring the horses, trying for a speedy escape.

lack of available space meant that the colonnades could not extend around all four sides of the court. This was the case in the House of the Tragic Poet (VI, 8, 3), where an older garden behind the house was converted into a courtyard.

The oldest decorative style found in Pompeii is the so-called First Style, based on a typology formulated by the great nineteenth-century historian August Mau and still useful despite changes made to its specifics over time. What is problematic is the term "style," which has great currency but is less precise than it should be. A better phrase would be "ornamental scheme," since what we see in the paintings at Pompeii follows decorative models developed elsewhere, not locally. Semantics aside, the First Style consists essentially of stuccowork meant to imitate *opus isodomum*, a type of decorative masonry consisting of courses of stones mortared into a wall. This scheme originated in Greece and spread to Pompeii because of its close commercial ties with the eastern Mediterranean world. At the height of Samnite Pompeii's prosperity, in the second century B.C., we find an extraordinary development in First Style decoration. Over time it had become common practice to paint faux colored-marble revetment on walls, creating compositions in vivid hues, where once the preference had been for "classically" white walls. The First Style period was also the golden age of *opus signinum*. This flooring was composed by inserting black, white, or black-and-white tiles in decorative patterns into a stucco bed made of terracotta fragments mixed with lime. Some of the most elegant houses in the city at this time went further, with their floors displaying embedded representational scenes fashioned from tiny colored tesserae produced by master craftsmen from the Greek East. The most famous example of this kind of work is a mosaic from the House of the Faun that depicts the victory of Alexander the Great over the Persian emperor Darius at the Battle of Issus.

Wall decoration at Pompeii changed quite radically in the colonial period; it was marked by the popularity of a decorative system that had first appeared in Rome as early as 110 B.C. The so-called Second Style animated the wall with fictive architecture, landscape scenes, or both, into which were inserted disparate decorative elements such as masks, vases, and small pictures with illusionistic shutters. The effect of this decorative system was to expand the real space of the room by means of sophisticated theatrical devices originating in the equally flamboyant tradition of Hellenistic stage-set designs. Many examples of this decorative style, at Pompeii and at the Villa of the Mysteries and Boscoreale in its suburbs, have exceptional pictorial friezes with large-scale figures. At the end of the Second Style period, between the reigns of Julius Caesar and Augustus, painting was enriched with fantastical elements like candelabra and herms; these took the place of fictive architecture, rendering the decoration less integrated into the physical space. Contemporary critics, preferring the classicizing taste of Vitruvius, found fault with this development, and such critiques would lead to the development of the Third Style, which was to express the impulse toward classical balance in the visual arts and other areas promoted by the new regime of Caesar Augustus. During the first century A.D., polychrome

Detail of the face of Briseis from a
fresco found on the south wall of the
atrium of the House of the Tragic Poet.
The painting recounts the story of
Achilles and Briseis.

Pages 158–59:
A broad section of one of the most
famous of the large-scale paintings
from the area around Mount Vesuvius.
Found at Boscoreale and dating to the
mid-first century B.C., it is a copy of a
Greek original. It shows several figures
from the Macedonian court who can
perhaps be identified as the young
Prince Antigonus Gonatas; his mother,
Phila; and his tutor, the philosopher
Menedemus of Eretria.

Pages 160–61:
This handsome detail with three lively
sea horses is an interesting example of
"sketch painting," a style that was com-
mon in Roman art by the late republi-
can period (but was certainly originally
Hellenistic). It is a rapid technique of
painting in which tonal gradations are
more important than outlines.

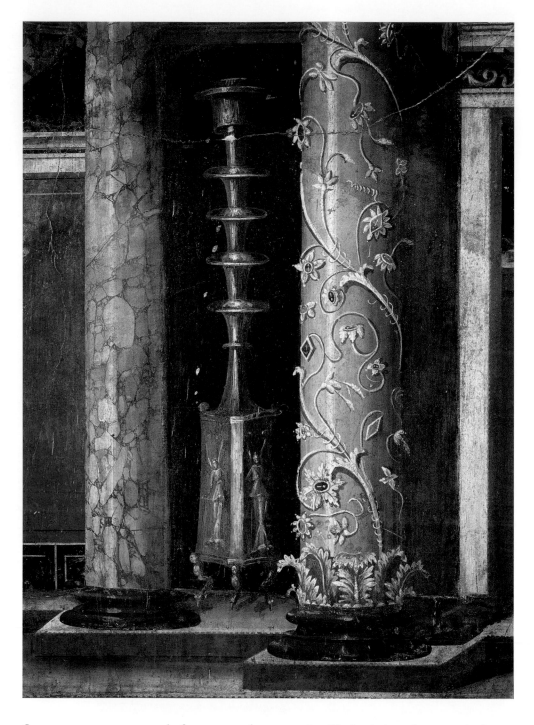

A fresco of a slender column decorated with spiraling vines and flowers like precious stones. The painting comes from the Villa of Poppaea at Oplontis.

Opposite:
Detail of a fresco from the Villa of Poppaea at Oplontis depicting a lush garden rendered even richer by statues and fountains decorated with anthropomorphic elements.

Following pages:
The paintings in the seaside villa at Oplontis, which can be dated to about 50 B.C., are among the best surviving examples of the Second Style. Note the subtle plays of transparency and of contrasts between light and shade.

floor pavements composed of tesserae and representing illusionistic and perspectival scenes became more common. Ultimately, however, the style that prevailed would be the austere black-and-white-tiled floors that first appeared in Pompeii about A.D. 50 and would eventually dominate Augustan production throughout the Roman world.

The Third Style, dating to the Augustan period, is characterized by large fields of a single color and a gradual disappearance of perspectival elements. The latter became gradually less important, until as decorative motifs they finally vanished altogether in the

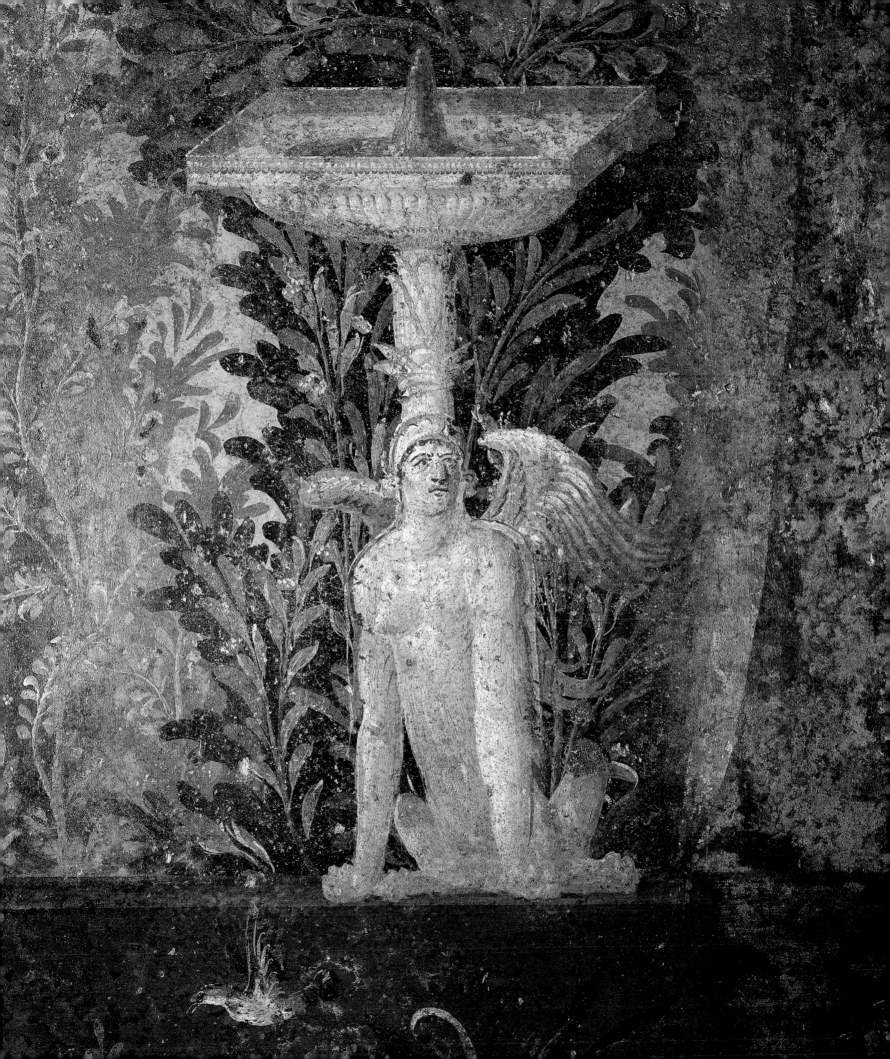

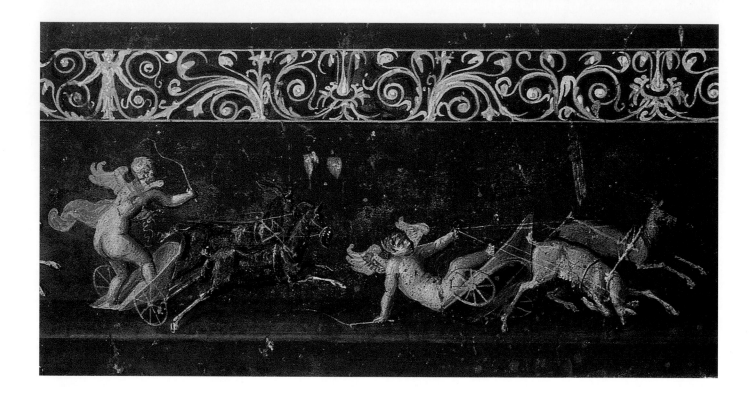

last decades of the first century B.C. Copies of famous Greek paintings constituted the primary element in this style of decoration; the prevailing taste of the period was for works from the Classical period—the fifth to the fourth century B.C.—though there were also many copies of early Hellenistic paintings. These images were placed at the center of the wall, framed by monochromatic fields of color, a compositional balance meant to suggest the values of moderation promoted during the Augustan period. The most classicizing phase of the Third Style, however, was already out of fashion by the first decades of the first century A.D., when timid perspectives and fantastical decorative elements began to reappear in murals and especially on the upper parts of the wall. These included very slender columns and thyrsi, that is, thin staves surmounted by pinecones or similar elements. The motifs recall aspects of the late Second Style but also prefigure the return to a gaudy aesthetic that would characterize Fourth Style painting. The developing Fourth Style would also be marked by a renewed enjoyment of theatrical effects reflecting the ideological leanings of the emperors Caligula and Nero, who were inspired by the models of Eastern absolutism.

The Fourth Style, which burgeoned in the mid-first century A.D., encompassed the last phase of Pompeii's existence. The style is characterized by the perspectival articulation of the wall and by paintings done in garish colors, though it also displays traces of an earlier taste for fantastical elements that stand in for real architectural elements. The copying of famous Greek paintings continued, though now the originals tended

Decorations in the large hall of the House of the Painters, with cupids in goat-drawn chariots.

Opposite, top:
This atmospheric image of a seaside villa appears on a wall in the *tablinum* of the House of Marcus Lucretius Fronto, where we find one of the best ensembles of late Third Style painting.

Opposite, bottom:
Detail of a naval battle represented in a wall painting in the House of the Vettii—an interesting example of "sketch painting."

to be from the Hellenistic period and sometimes took up the entire surface of the wall. Simpler, late Third Style murals, without copies of earlier works of art, were still being painted, alongside the more luxurious Fourth Style productions. A more popular decoration appeared on the facades of buildings and in shops and brothels, among other lower-brow places, that almost always trades perspectival and spatial coherence for a certain narrative freshness. Floor pavements made during the periods of the Third and Fourth styles followed the general trend of keeping to black-and-white tesserae in most mosaics.

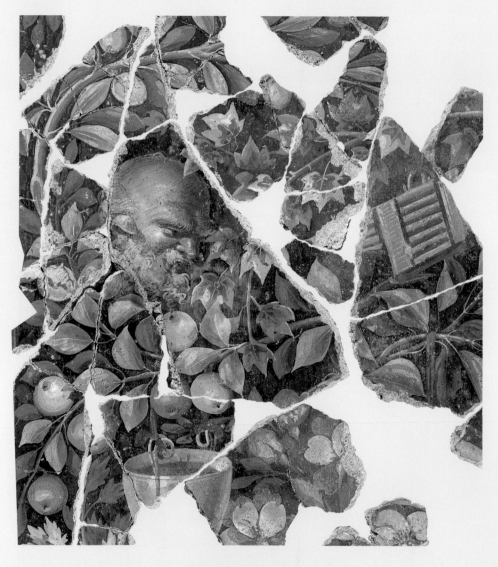

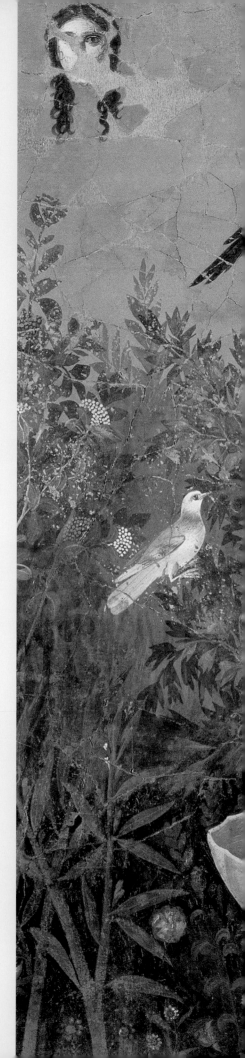

Two details of the splendid painted garden (*hortus conclusus*) that decorated a room in the House of the Golden Bracelet. These frescoes, dating to the Julio-Claudian period, document the strong connection between nature and culture that endured throughout antiquity. In this environment the house's sophisticated owner would certainly have enjoyed feelings of psychological and physical well-being and inner serenity.

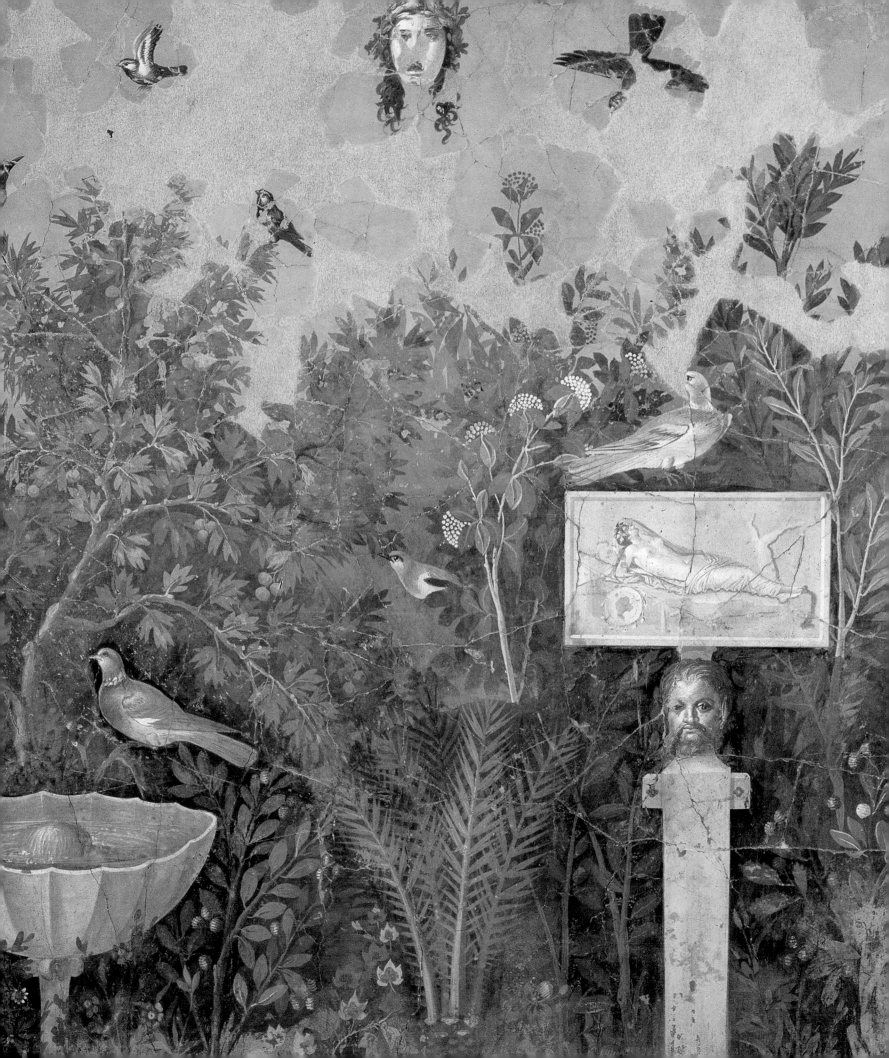

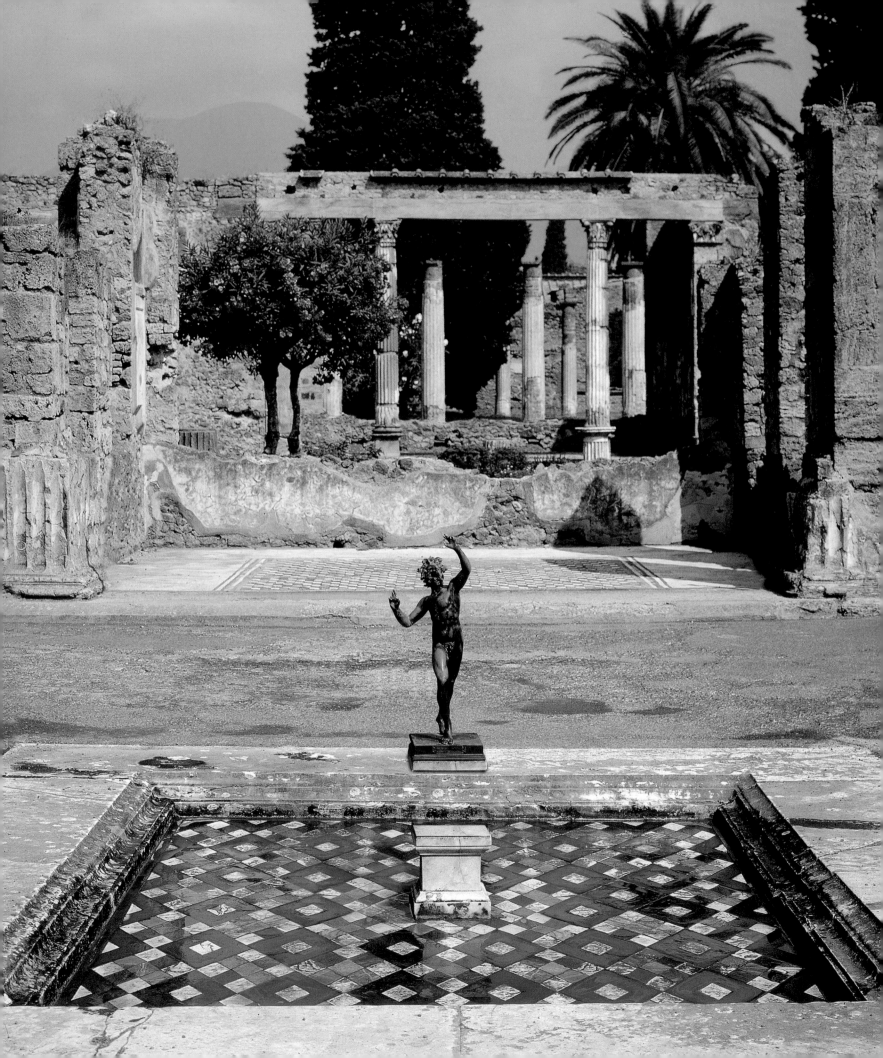

LIFE AT HOME

Opposite:
The atrium of the House of the Faun with its lovely *impluvium*, or pool for collecting rainwater, worked in *opus sectile*, a form of inlay using colorful rhombus-shaped stones. The bronze statue of a dancing faun (the original of which is now in the National Archaeological Museum in Naples) should be on the marble edge of the basin rather than in the center.

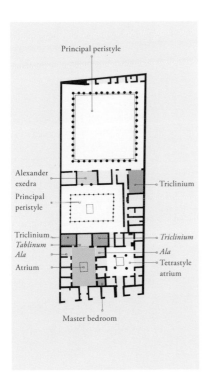

Plan of the House of the Faun.

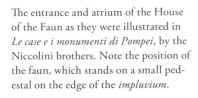

The entrance and atrium of the House of the Faun as they were illustrated in *Le case e i monumenti di Pompei*, by the Niccolini brothers. Note the position of the faun, which stands on a small pedestal on the edge of the *impluvium*.

Whether luxurious or more modest—the latter possibly consisting of only a few, often damp and poorly illuminated rooms—the kind of house one occupied obviously mirrored class distinctions and social relationships. Vitruvius wrote his architectural treatise, *De architectura*, about 40–30 B.C.; it is the only ancient book on architecture to survive to the present day. A very famous passage in it advises, among other things, that one should include

> in private buildings spaces reserved for the head of the household [*loca propria*] as well as public spaces [*loca communia*] for strangers. In the private areas people can only enter if invited; they are the bedroom, the dining rooms, the baths, and all the other rooms with similar purposes. The *loca communia* are instead spaces that even the common

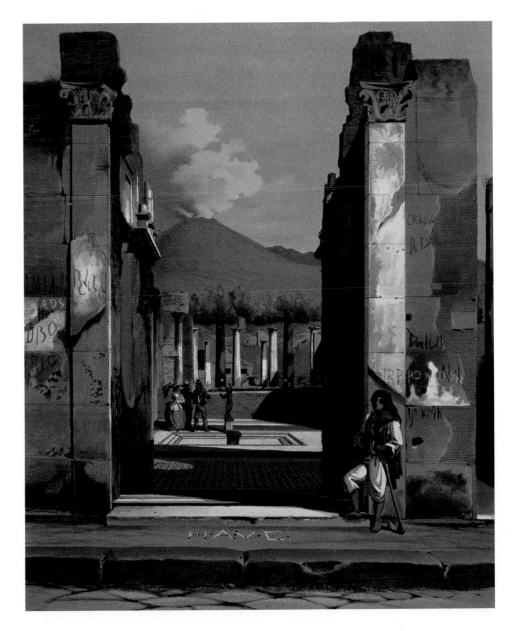

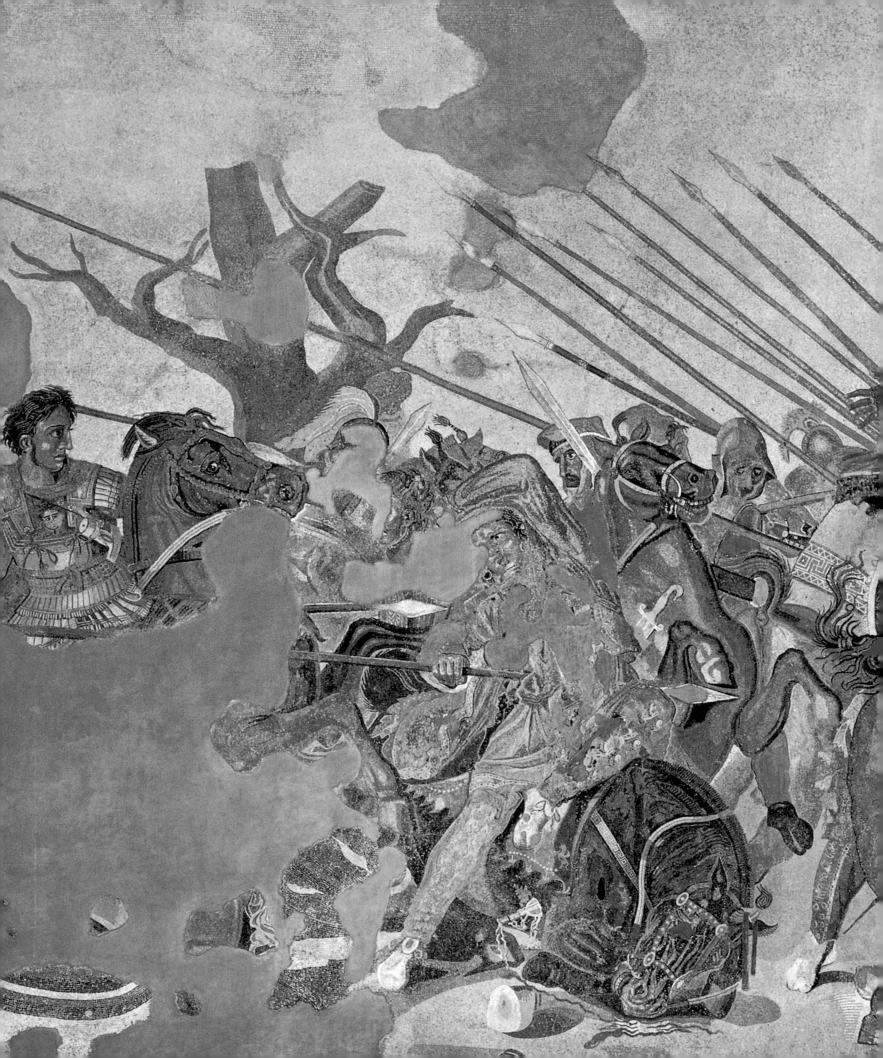

people can enter by right and without invitation, and they include the vestibules, atria, peristyles, and all other similar areas. Yet people of the lower social classes have no use for either vestibules, tablina, or large atria, since these are to be visited and not vice versa. (5.5.1–2)

Vitruvius's observations provide a nice explanation of the general structure of residences like Pompeii's House of the Faun, which were built to show off the owners' status and power. These houses, distinguished by an ostentatious display of magnificence, could withstand comparison with Greek palaces. Yet even in aristocratic residences like the House of the Faun there are extensive *loca communia*, public areas consisting of rooms one might enter without permission. The ancient practice of patronage helps us to understand more fully at least some of the importance of these spaces. The social mechanism of patronage is well known in its general shape: free men—the clients—offered services to a patron in exchange for protection. Patrons were far more influential figures than their clients; their social position and political power were rooted in their wealth and rank but also depended on their clients, whom they controlled economically and as voters.

Preceding pages:
The most important figural mosaic from the ancient world comes from the House of the Faun. It shows the Battle of Issus, fought between Alexander the Great and Darius III, king of Persia. It is composed of about one and a half million tesserae and covers an area of almost 20 square meters, or some 215 square feet. In this detail, Darius, aware of his impending defeat, turns his chariot toward the enemy, followed by his army, which can no longer offer any resistance.

An example of a polychrome mosaic pavement with geometric designs that create powerful three-dimensional effects. From *Le case e i monumenti di Pompei*, by the Niccolini brothers

Opposite:
The lost painting *Hercules and Dejanira* was in the House of Queen Caroline (VIII, 3, 14); the illustration here is from the Niccolini brothers' *Le case e i monumenti di Pompei.*

Those who did not belong to the upper class had much more modest houses, on a scale that matched their status, down to the so-called disinherited, the poor who lived in bare mezzanines built above shops. Pompeii provides many examples of these structures. These spaces, generally called *pergulae*, were lit by low windows placed on an axis with the shop entrance below. In his *Satyricon*, Petronius quotes a well-known Latin proverb: "He who was born in a *pergula* cannot imagine a house" (74.14). This architecture reveals better than anything else what it meant to belong to the lower social classes in the ancient Roman world.

The peristyle of the House of the Vettii, photographed at night. The exedra is visible in the background.

Opposite:
A view of the city of Herculaneum.

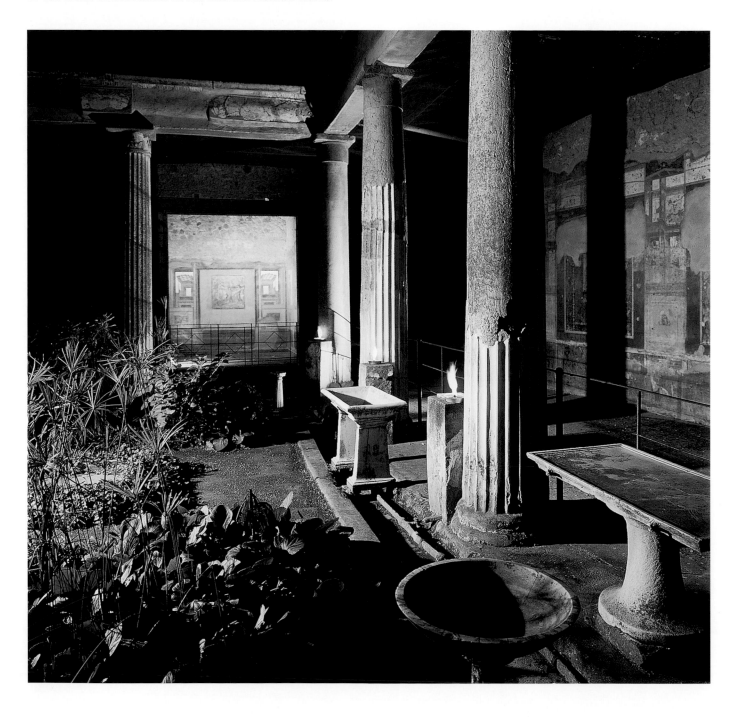

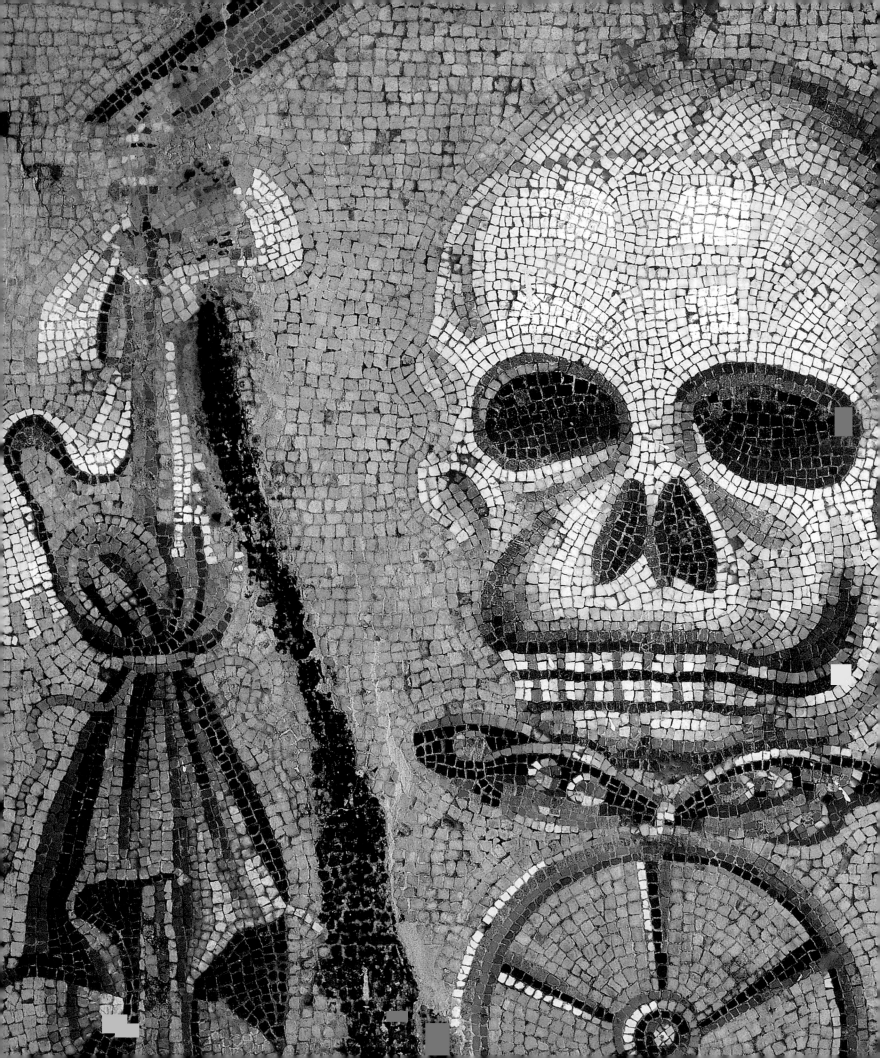

THE
NECROPOLI

TO DIE RICH: THE FUNERAL
AS STATUS SYMBOL

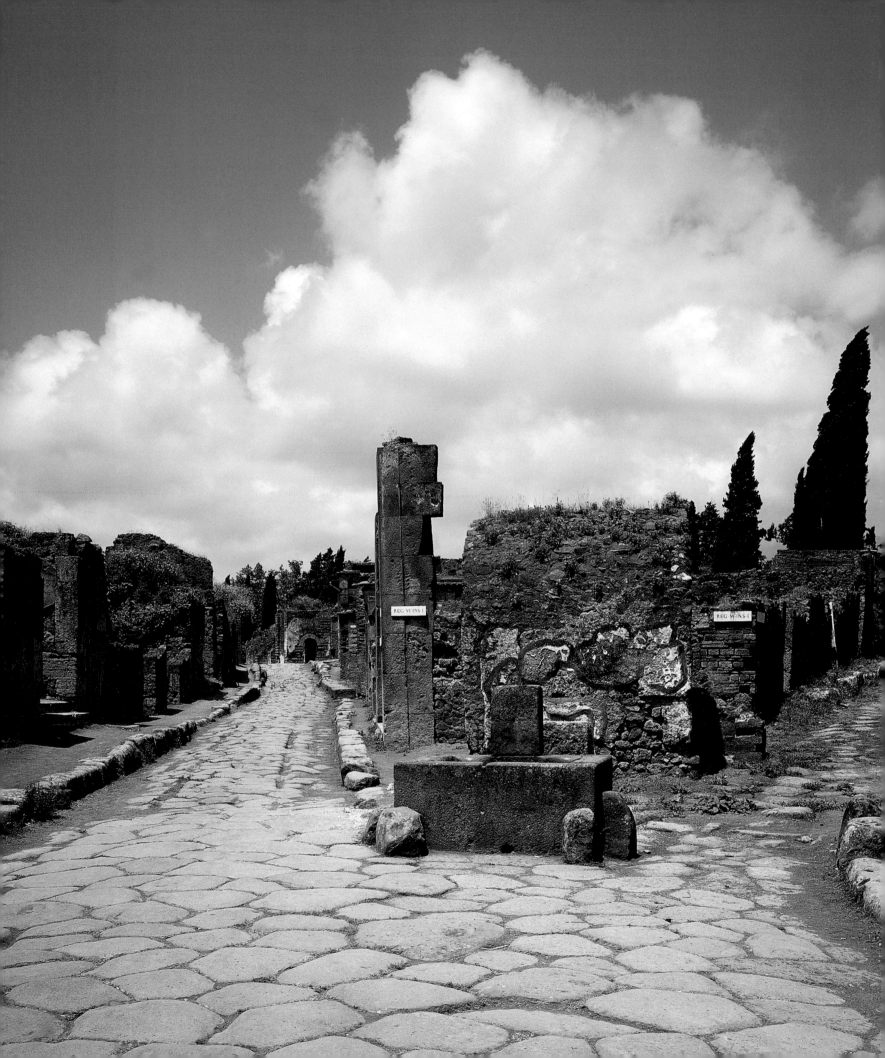

TO DIE RICH: THE FUNERAL AS STATUS SYMBOL

Preceding pages:
A mosaic from the Augustan period that decorated the open-air dining room at House I, 5, 2. It represents an allegory of the fleeting nature of earthly pleasures and the leveling power of death. The butterfly and the wheel under the skull represent the soul and destiny, respectively. On the left and right of the composition, the figurative symbols of wealth—a scepter and a purple robe—and poverty—a beggar's stick and knapsack—are mirror images balanced from a scale above the skull.

Opposite:
The intersection of Via Consolare and Vicolo di Narciso with its rectangular stone fountain. The Porta Ercolano, the entrance into Pompeii's largest necropolis, can be seen in the distance on the left.

In a famous passage from his *Odes*, Horace, the great Epicurean poet who lived in the time of Julius Caesar and then the emperor Augustus, conjured up Death and its mastery over human beings: "Pale Death knocks just the same at the hovels of poor men and the palaces of kings" (1.4.13–14). Horace's lucid awareness of the common fate that awaits all human beings regardless of their status—a vision of the world shared by other intellectual greats of Roman culture, such as Seneca—does not represent the more common feelings this particular ethical and existential theme evokes. As in many historical periods, only a few chosen spirits—like Horace or Seneca—can truly accept all the consequences of death's egalitarian nature. Many people, by contrast, try to distinguish themselves and especially in death, deliberately negating its leveling force and perhaps exorcising its great sway over those who fear its permanence. Especially for the well-to-do, funerals and tombs become a way to set oneself apart, and to assert and celebrate the privileged status one enjoyed in one's lifetime.

Ancient funeral customs, known from the rich literary tradition, differed greatly according to the socioeconomic status of the deceased. In Pompeii, as elsewhere in the Roman world, dying poor meant a hurried burial without pomp or circumstance, at night, almost secretly, and very soon after death had occurred. As the Augustan poet Propertius noted in his *Elegies*, usually only the closest relatives attended the funeral of a man of humble origins (2.13). The practice was very different when a member of the upper class died. The body of the deceased, suitably prepared with unguents and perfumes, might be exhibited for as long as a week in the atrium of his house. Returning to Pompeii, it is easy to imagine the melancholy activity and solemn display in the luxurious atrium of a house appropriately decorated for the funeral of a rich and powerful man.

Funerals affirmed the existing social hierarchy. The long procession attracted a great deal of public attention, led as it was by musicians playing flutes and horns, creating an intentional mix of pomp and sadness. No less conspicuous were the various hired figures who followed, such as the famous *preficae*—women who feigned mourning the deceased with loud lamentations and dirges—or the actors who used masks to evoke the dead person's features and movements. Funeral processions also underscored the importance of the cult of ancestors. Other actors, seated on special wagons, wore the wax death masks of the ancestors, the famous *imagines maiorum* that were normally kept in the *domus* and exhibited publicly during the funeral rites of family members. The public eulogy was one of the most solemn and ideologically important moments of the funeral. It came before the body reached the burial place; usually delivered at the Forum by a relative of the deceased, it was intended, at least in part, to affirm the family's social status.

Tombs also served to exhibit the prestige and wealth of those who could afford them. There is no better evidence of the profound social differences that existed in Pompeii—as everywhere else in the ancient world—than a comparison between

a grandiose and pompous funerary monument and a humble grave. One of the notable tombs at the cemetery at the Porta Nocera is that of Eumachia, a priestess of Venus who died during the reign of Tiberius and who wished to build herself an actual mausoleum. It was shaped like a large exedra with a spacious enclosed precinct in front of it. Above the burial chamber in the hemicycle there was once a larger-than-life statue of the priestess, confirming the monument's celebratory intention. More modest are thirty tombs of poor people, dating to the same period. These small funerary urns without portraits are marked only with simple *cippi*, or stone markers, or by graffiti scrawled on the nearby city walls. Despite Horace's and Seneca's noble musings on the evenhanded nature of death mentioned at the beginning of this chapter, the glaring disparities between these tombs show more clearly than anything else the markedly hierarchical structure of Roman society.

Opposite and preceding page:
This splendid glass-cameo vase of the Julio-Claudian period gave its name to the tomb where it was found—the Tomb of the Blue Vase. It was discovered in the necropolis at Porta Ercolano, and its quality is the result of extraordinary craftsmanship. It was made using a special technique that involved superimposing two layers of glass, one a very deep color, the other white. The latter could be removed in areas as the design dictated. The vase, shaped like an amphora for wine, is decorated with Dionysian scenes

This striking Augustan-period tomb is located in the necropolis at Porta Ercolano. The priestess Mamia was buried here, and Johann Wolfgang von Goethe paused for contemplation here in 1787, as he recounts in his *Italian Journey*. The monumental ruins of the Tomb of the Istacidi, which also dates to the Augustan period, stands behind Mamia's burial site.

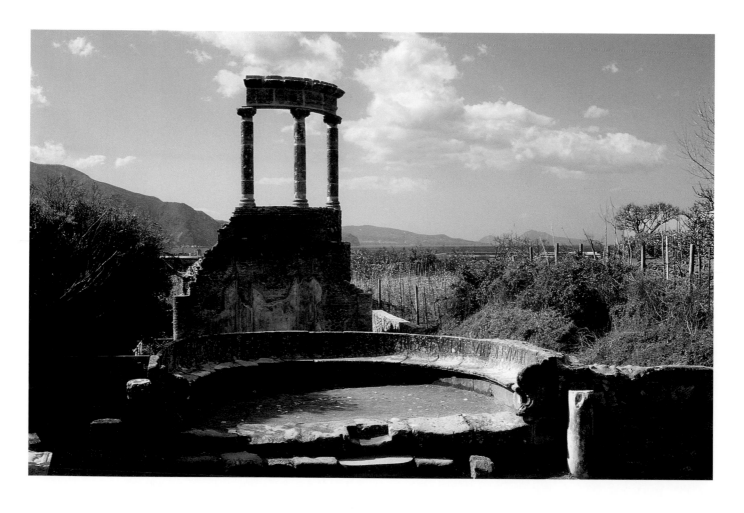

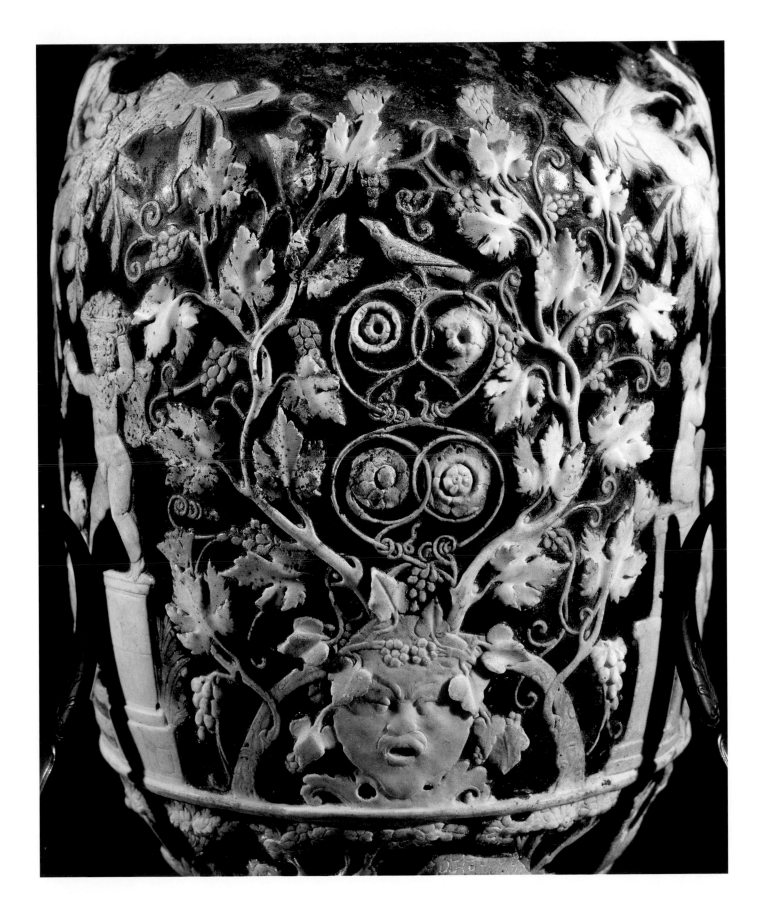

Preceding pages:
A panoramic view of the north-west section of the necropolis at Porta Nocera displays the customary mix of different architectural styles, decorative tastes, and social ranks. The large tomb with an exedra belonged to the priestess Eumachia, who also erected the imposing building facing the Forum that bears her name.

Left:
View of the complex of the tomb of Publius Vesonius Phileros. It is well known for its brick aedicule containing three tufa statues. They represent the deceased, his patron, and the friend who betrayed him.

Opposite, top left:
This cenotaph from the Neronian-Flavian period belonged to Caius Calventius Quietus and is located in the necropolis at Porta Ercolano. It has the form of an altar with pulvini and was appropriate for a person who had received the honor of *bisellium*, that is, the right to sit in specially reserved places during theatrical performances.

Opposite, top right:
This altar-like tomb with pulvini (in reality a monumental cenotaph) was built during Nero's reign in honor of the freedwoman Naevoleia Tyche and of Caius Manatius Faustus. The bas-relief illustrated here shows a ship headed toward port, a resonant metaphor for the descent of the soul into Hades at life's end.

Opposite, bottom:
An evocative image of the necropolis at Porta Ercolano with its collection of tombs. The ancient cities of the dead were usually located along the roads radiating out from the city and as close to the gates as possible.

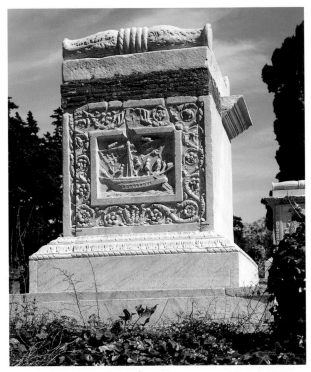

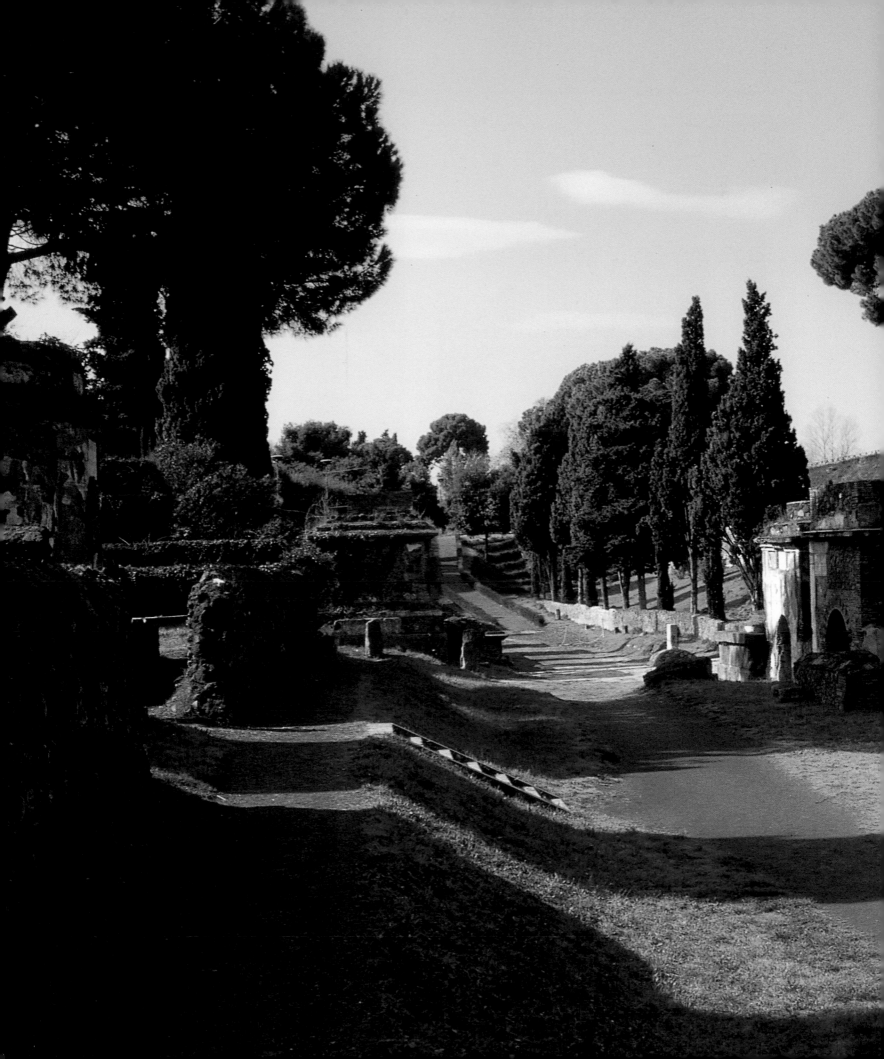

A view of the necropolis at Porta Nocera. Its rows of tombs of various types are located very close to the southeast section of Pompeii's walls.

Following pages:
This fresco, which survives in situ, shows the Flavian-period tomb of the aedile Caius Vestorius Priscus in the necropolis at Porta Vesuvio. It shows a table set with valuable silver tableware, clear evidence for posterity of the deceased's wealth.

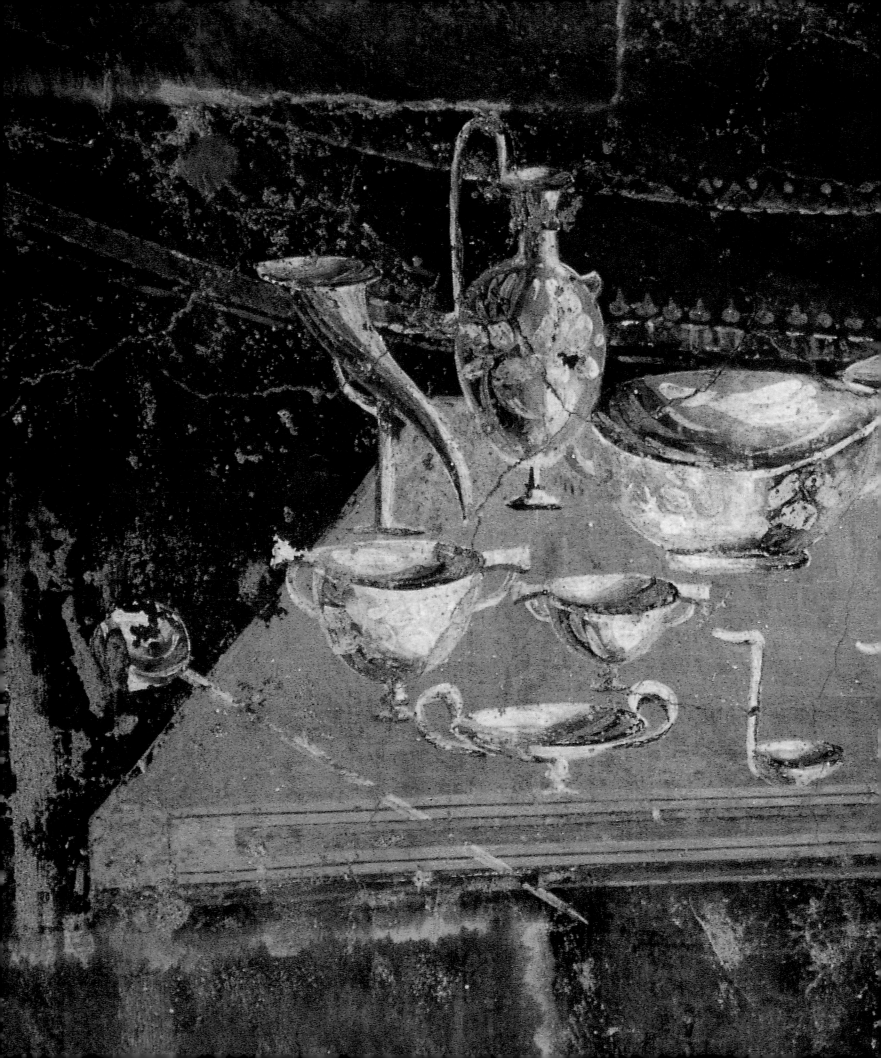

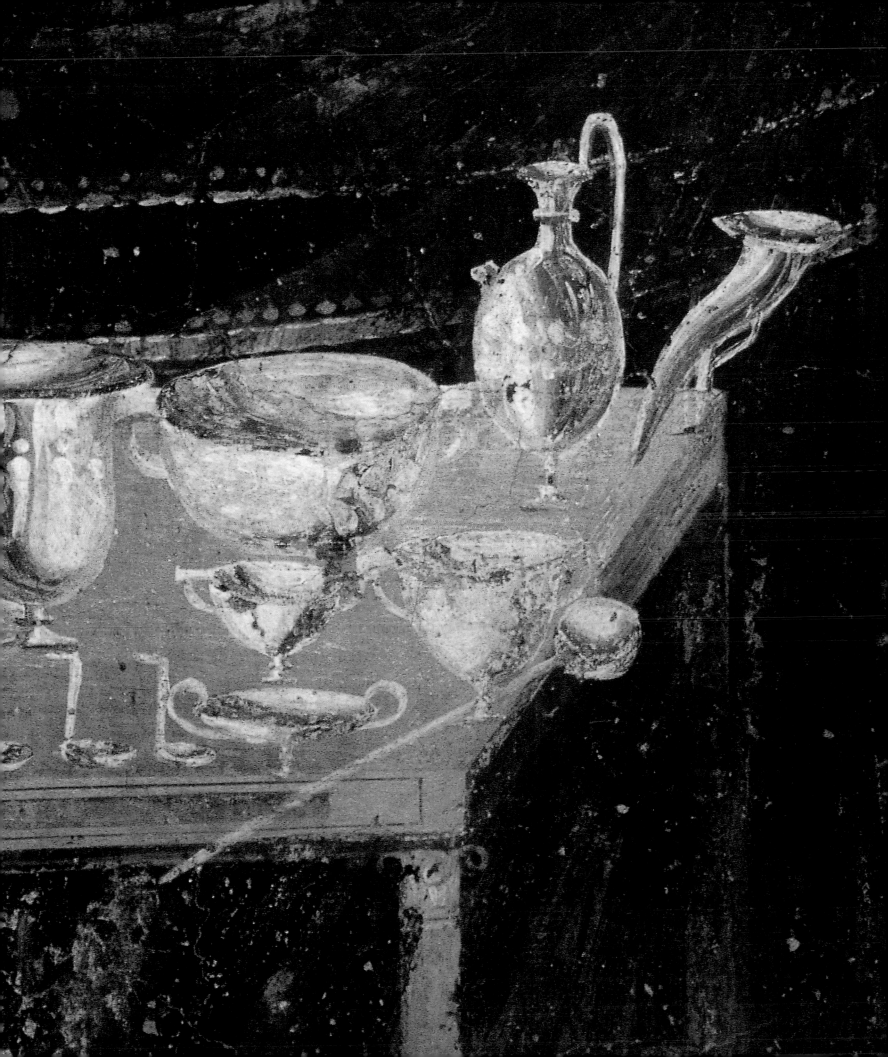

PLAN OF POMPEII AND LOCATION OF THE PRINCIPAL STRUCTURES

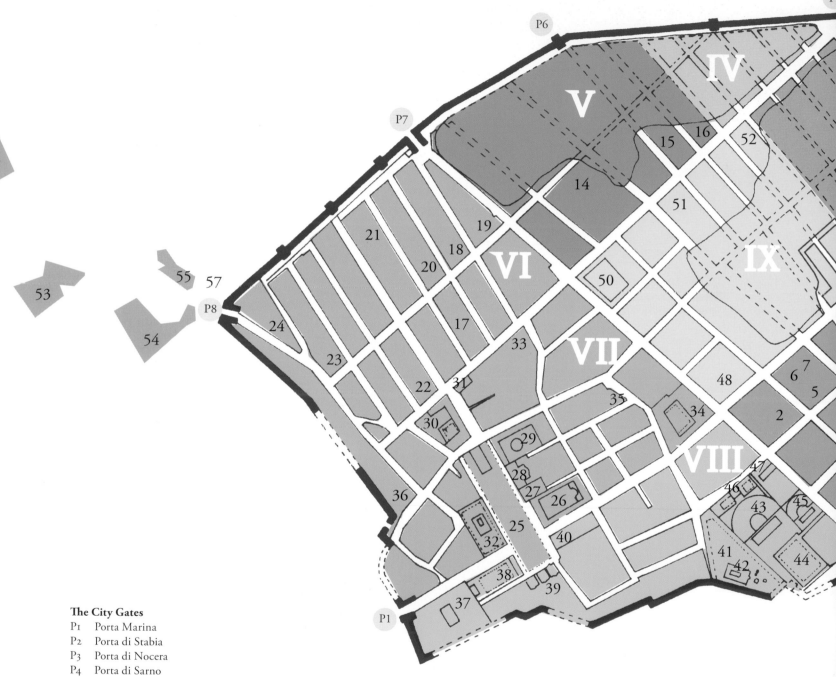

The City Gates

P1 Porta Marina
P2 Porta di Stabia
P3 Porta di Nocera
P4 Porta di Sarno
P5 Porta di Nola
P6 Porta di Capua (presumed)
P7 Porta del Vesuvio
P8 Porta di Ercolano

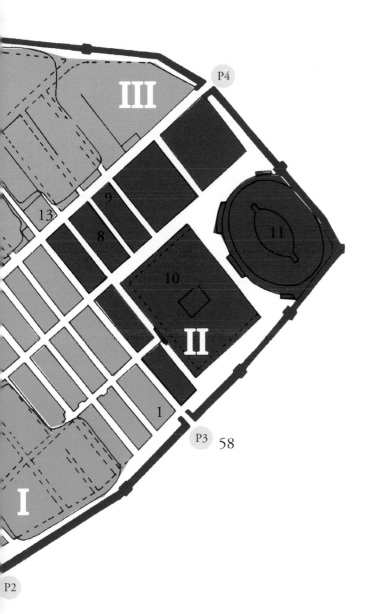

	Regio I
	Regio II
	Regio III
	Regio IV
	Regio V
	Regio VI
	Regio VII
	Regio VIII
	Regio IX

Regio I

1 Garden of the Fugitives
2 House of the Citharist
3 House of Menander
4 House of the Lovers
5 House of the Ceii
6 House of Publius Casca Longus
7 Fullonica of Stephanus

Regio II

8 House of D. Octavius Quartio
9 House of the Marine Venus
10 Large Palestra
11 Amphitheater

Regio III

12 House of A. Trebius Valens
13 House of the Moralist

Regio V

14 House of the Silver Wedding
15 House of Marcus Lucretius Fronto
16 Gladiators' Barracks

Regio VI

17 House of the Faun
18 House of the Vettii
19 House of the Gilded Cupids
20 House of the Labyrinth
21 House of Meleager
22 House of the Tragic Poet
23 House of Sallust
24 House of the Surgeon

Regio VII

25 Forum
26 Building of Eumachia
27 Temple of the Genius of Augustus
 (so-called Temple of Vespasian)
28 Temple of Augustus
 (so-called Sanctuary of the Lares Publici)
29 Macellum
30 Forum Baths
31 Temple of Fortuna Augusta
32 Temple of Apollo
33 House of the Ancient Hunt
34 Stabian Baths
35 Lupanare (brothel)
36 House of M. Fabius Rufus

Regio VIII

37 Temple of Venus
38 Basilica
39 Government Buildings
40 Comitium
41 Triangular Forum
42 Doric Temple
43 Large Theater
44 Quadriporticus behind the Large Theater
45 Odeon, or Small Theater
46 Temple of Isis
47 Temple of Aesculapius

Regio IX

48 House of the Diadumeni
49 House of C. Julius Polybius
50 Central Baths
51 House of the Centenary
52 House of M. Obellius Firmus

Outside the City Walls

53 Villa of Diomedes
54 Villa of Cicero
55 Villa of the Mosaic Columns
56 Villa of the Mysteries
57 Necropolis at Porta di Ercolano
58 Necropolis at Porta di Nocera

GLOSSARY

Apse (from the Medieval Latin *absīda –ae*, and Latin *absis –ĭdis*, Greek *hapsís –ĭdos*, "crossing, arch, vault"): A niche-shaped architectural structure that is semicircular, polygonal, or square in plan and surmounted by a partial bowl-vault; used in classical architecture (especially in Rome, though with significant Greek precedents), the apse has been particularly common in Christian architecture from its origins through the present day.

Architectural terracotta: A typical element in the decoration of sacred buildings in the Etrusco-Italic tradition. These terracotta elements, usually molded, were used as revetment for the wood frame of a roof. In addition to serving an important protective function, these very decorative terracotta elements came in a variety of shapes (figurative, geometric, and stylized).

Atellan farce (from the Latin *[fabula] atellana*, "from Atella," an Oscan town in Campania): A comic genre in Latin literature, its period of formation uncertain (ca. 300 B.C.?); at the time of the Social War (first quarter of the first century B.C.) it acquired respectability thanks especially to the works of Quintus Novius and Lucius Pomponius. The plots of these spirited, realistic farces were usually based on comic intrigues full of salacious jokes and allusions and with subject matter taken from the lives of country folk and the urban working classes.

Client (from the Latin *cliens –entis*): In Roman society a citizen who, though free, found himself dependent on a more powerful person (his patron), who offered him protection in exchange for political support.

Evidence of vases: In Italian *testimonianza vascolare*, a term that refers to all the data (historical, artistic, antiquarian, etc.) that can be deduced from the ancient production of painted pottery.

Gymnasium (from the Latin *gymnasium*, Greek *gymnásion*, derived from *gymnázo*, "to do gymnastic exercises," from *gymnós*, "nude"): Originally, the place in ancient Greece where youths engaged, nude, in athletic contests; later, the gymnasium became a center for spiritual education, as well as a meeting place where banquets, parties, theatrical presentations, lessons, lectures, and so on were held.

Hellenization (derived from the verb "to hellenize"): The phenomenon of attracting people or a territory into the Hellenistic or, more generally, Greek sphere of culture.

In situ: A Latin expression that can be translated as "in place." In archaeological terms, it refers to an object found in its original location rather than one that has been moved elsewhere.

Nucleus: The top layer in the complex process of constructing a masonry floor. Laid above the *rudus*, the *nucleus* was a layer of cement usually about 12 centimeters (4¾ in.) thick and made of lime, sand, and pieces of brick. It could also constitute either the floor itself (in which case it was mixed with large ceramic or marble fragments) or the bed on which mosaic tiles were laid.

Partition wall: A thin structure with no load-bearing function used to divide a room into two areas.

Pìnax: A Greek term meaning "panel" or "board"; in particular it referred to a wood tablet used by the ancient Greeks to keep accounts or, coated with wax, to write or paint on.

Praefurnium: An oven or boiler used to heat ancient public and private baths.

Prostyle (from the Latin *prostŷlos*, the Greek *próstylos*, composite of *pro-* "in front," and *stŷlos*, "column"): A classical temple type with a row of at least four columns only in front of the building's entrance.

Quadriporticus (from the Latin *quadrĭporticus*, composite of *quadri-* "four," and *porticus* [a word related to *porta*, "door" and *portus*, "port"]): A portico that runs around all four sides of a quadrilateral courtyard.

Repositorium: A Latin term for a room used for storage.

Sacellum (from the Latin *sacellum*, a diminutive of *sacrum*, "sacred space," the neuter noun from the adjective *sacer*, "sacred"): In classical architecture a small round or rectangular enclosure open to the sky and with an altar consecrated to a god or goddess; by extension, the name for other spaces reserved for cult purposes, such as niches, aedicules, caves, and so on.

Salutatio: A courtesy visit to someone's home, used especially of a client's visit to the home of his patron (*see* Client) as an act of deference.

Samnites (from the Latin *Samnites*): An ancient Italic people from Samnium in southern Italy.

Sinopia (from the name of the Black Sea city of Sinope, where the color originally came from; from the Latin *sinōpis* and Greek *sinōpís*, with the same meaning): A reddish color used in antiquity (its composition and gradations now uncertain) especially for large-scale preparatory drawings for frescoes on the *arriccio* and over a first charcoal sketch; the term also refers directly to the preparatory drawing made

in this way, which was then covered with *intonaco* and painted. The sinopia can be recovered using modern restoration techniques.

Stratigraphy (composite of the Latin *stratum*, a neuter noun from *stratus*, past participle of *sternĕre*, "to stretch" and *–graphía*, in the sense of "study"): A method of analysis in archaeological excavations that permits the study of material deposits at successive levels, thereby distinguishing and documenting the different periods in the history of a culture, allowing for the creation of a relative chronology.

Strigil (from the Latin *strigĭlis*, and most likely from the Greek *stlengís*). A bronze or iron tool used in antiquity to cleanse the body of sweat and oil after bathing or exercising in the gymnasium. It has a straight handle with a curved, concave end that was scraped across the skin.

Tabula picta: Literally, "painted panel," a synonym for "painting" or "picture."

Telamon (from the Latin *telămo(n) –onis*, the Greek *telamón –ônos*, close to the Greek *tlênai*, "to support," and the Latin *tollere*, "to lift"): In architecture a sculpted male figure, also known as an "atlas," used in place of a column or pilaster to support architectural members.

Tripod (from the Latin *tripus –pŏdis*, the Greek *trípous* [or *trípos*] *–podos*, composite of *tri-*, "three," and *poús*, "foot"): A three-footed support, generally made of bronze but sometimes of gold, copper, marble, or terracotta, and used since antiquity to hold braziers, candelabra, containers, and so on. The tripod of Delphi was famous in antiquity; it was a three-legged stool used by the Pythia, the oracle and priestess consecrated to Apollo.

Trivium (from the Latin *trivium*, a composite of *tri-*, "three," and *via*, "road"): The intersection of three roads.

Tuscan order (from the Latin *tuscanĭcus*, "from Tuscia" or "Etruscan"): An architectural order deriving from Etruscan architecture and distinguished by smooth and slightly tapered column shafts that stand on large and variously profiled bases and whose capitals resemble those of the Doric order.

Note: For reasons of typographical convenience, the Greek words in the etymologies above have been transliterated into the Latin alphabet. The correct accents for words that may be unfamiliar (and in some cases for familiar words) have been provided to help with their pronunciation.

BIBLIOGRAPHY

The archaeological excavations at Pompeii began officially in 1748 (exactly ten years after those at Herculaneum) at the behest of Charles III, the Bourbon king of Naples, and the scholarly publications on the city buried by the devastating eruption of Mount Vesuvius in A.D. 79 have multiplied exponentially ever since. Specialists from all over the world continue to study every aspect of Pompeii, and the number of books and articles published shows no sign of slowing down.

Readers seeking an introduction to this immense body of literature may profit from the following two useful, recent, but already somewhat out-of-date catalogues:

García y García, L. *Nova Bibliotheca Pompeiana. 250 anni di bibliografia pompeiana*, vols. 1–2. Rome, 1998.

Van der Poel, H. B. *Corpus Topographicum Pompeianum. Pars IV. Bibliography*. Rome, 1977.

A significant part of the vast bibliography on Pompeii consists of archaeological guides. The most recent and complete publication of this type in Italian is

Pesando, F., and M. Guidobaldi. *Pompei Oplontis Ercolano Stabiae (Guide Archaeologiche Laterza)*. Rome, 2006.

Readers interested in daily life in Pompeii and in its archaeology—the principal subjects of the present volume—will find further information in the following studies:

Aspetti della vita quotidiana a Pompei. La suggestione del restauratore. Turin, 2007.

Cantarella, E., and L. Jacobelli. *Un giorno a Pompei. Vita quotidiana, cultura, società*. Naples, 2000, 2003.

Coarelli, F., ed. *Pompei. La vita ritrovata*. Udine, 2002.

Corti, E. *The Destruction and Resurrection of Pompeii and Herculaneum*. London, 1951. (The original German edition was published by Bruckmann [Munich] in 1940.)

Étienne, R. *La vita quotidiana a Pompei*. Milan, 1973. (The original French edition was published by Hachette [Paris] in 1966.)

_____. *Pompeii: The Day a City Died*. London, 1992.

Ling, Roger. *Pompeii: History, Life and Afterlife*. Stroud, Gloucestershire, 2005.

Maiuri, A. *Pompei ed Ercolano fra case ed abitanti*. Florence, 1998. (First edition published by Le Tre Venezie [Padua] in 1950; the second, expanded, edition by Martello [Milan] in 1958.)

_____. *Pompeii*. 6th ed. Rome, 1953.

Rinaldi Tufi, S. *Pompei. La vita quotidiana*. Florence, 2001.

Varone, A. *Eroticism in Pompeii*. Los Angeles, 2001.

_____. *Pompei. I misteri di una città sepolta. Storia e segreti di un luogo in cui la vita si è fermata duemila anni fa*. Rome, 2000.

_____. *Rediscovering Pompeii*. Exh. cat. Rome, 1990.

Zanker, P. *Pompeii: Public and Private Life*. Cambridge, Mass., 1998.

Photographic credits

All the images in the volume are by Alfredo and Pio Foglia except

Archivio Magnus
pp. 25, 32–33 (drawing), 72, 73, 86–87, 192–93

Luciano Pedicini
pp. 85, 113, 158

However, the publisher remains at the disposal of parties who may hold copyrights for images whose sources are not identified here.

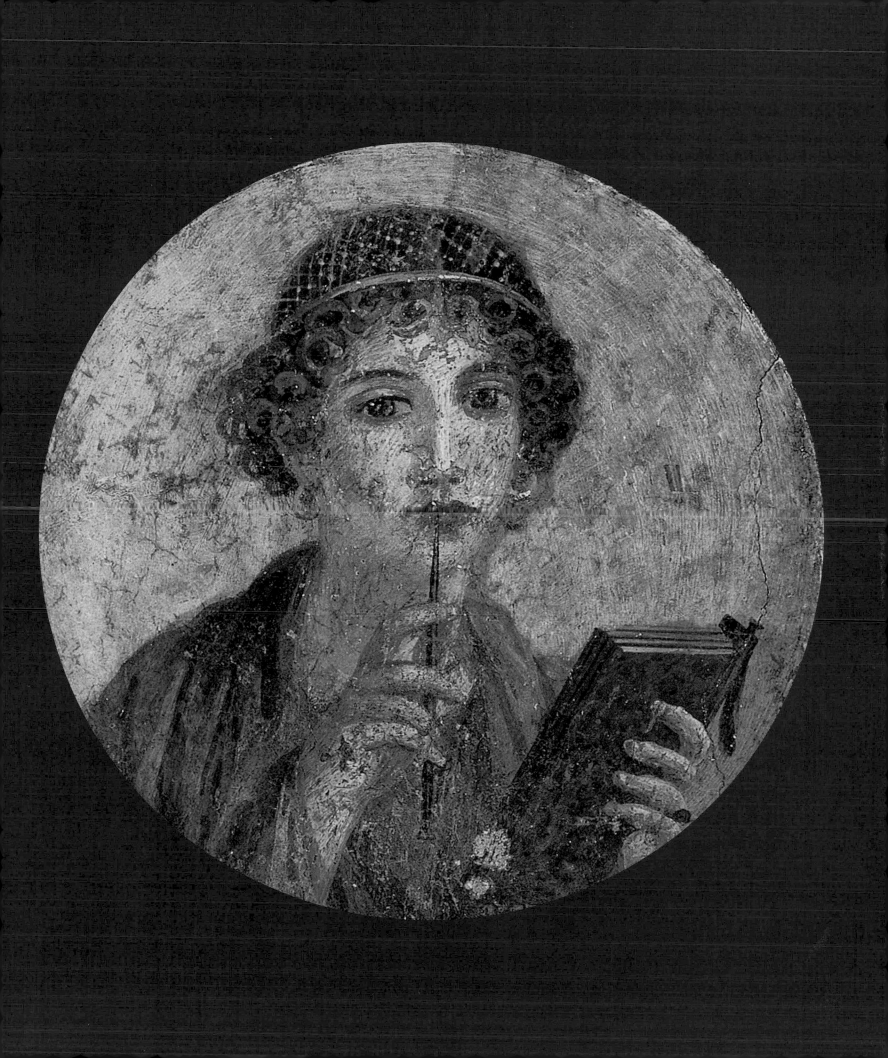

We may imagine this woman's terrified expression conveying all
the fear and anguish caused by the appalling tragedy about to
engulf the city.

Preceding page:
This charming Fourth Style portrait of a young woman is
among the first objects found at Pompeii (it was discovered in
1760, perhaps in the Insula Occidentalis). She is traditionally
identified as the Greek poetess Sappho, but this groundless sug-
gestion comes only from a desire to give the famous name of
a forever elusive figure to the delicate features of this cultured
Pompeian *puella* with her stylus and waxed tablets.

Italian edition © 2009 Magnus Edizioni Srl, Udine
All rights of reproduction, in whole or in part, of the text
or the illustrations, are reserved throughout the world.
Edited by Luisa Chiap
Miriam Dellasorte, Designer

English translation © 2009 J. Paul Getty Trust
5 4 3 2 1

Published by the J. Paul Getty Museum, Los Angeles

Getty Publications
1200 Getty Center Drive, Suite 500
Los Angeles, California 90049-1682
www.getty.edu/publications

Gregory M. Britton, *Publisher*
Mark Greenberg, *Editor in Chief*

Ann Lucke, *Managing Editor*
Mollie Holtman, *Editor*
Alexandra Bonfante-Warren, *Copy Editor*
A. Lawrence Jenkens, *Translator and Editor*
Pamela Heath, *Production Coordinator*
Hespenheide Design, *Graphic Design and Typesetting*
Printed in Hong Kong

Library of Congress Cataloging-in-Publication Data

De Albentiis, Emidio, 1958–
 Secrets of Pompeii : everyday life in ancient Rome / Emidio de
Albentiis ; photography by Alfredo and Pio Foglia ; [edited by
Luisa Chiap].
 p. cm.
 Italian edition to be published later by Magnus Edizioni (Udine,
 Italy) with title I Segreti delle ceneri.
 Includes bibliographical references.
 ISBN 978-0-89236-941-6 (hardcover)
 1. Pompeii (Extinct city)—Civilization. 2. Pompeii (Extinct
city)—Social life and customs. 3. Rome—Civilization. 4. Rome—
Social life and customs. I. Foglia, Alfredo. II. Foglia, Pio.
III. Chiap, Luisa. IV. De Albentiis, Emidio, 1958– Segreti delle
ceneri. V. Title.
 DG70.P7.D3718 2009
 937.7—dc22
 2009008805

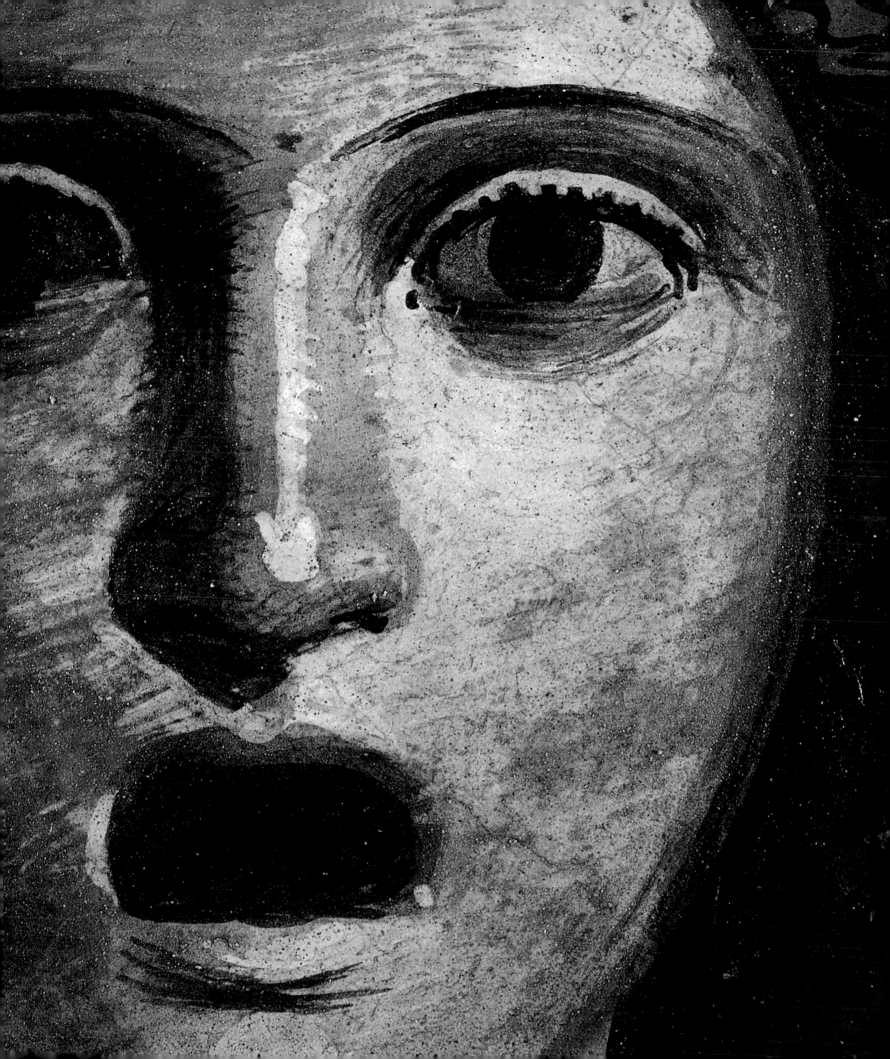